PARIS

FROM THE AIR

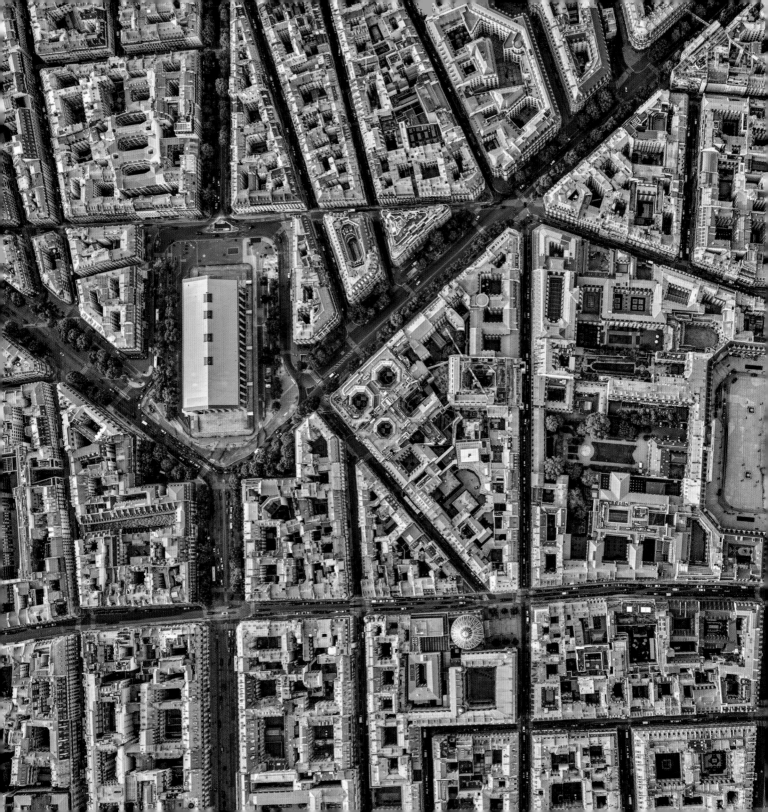

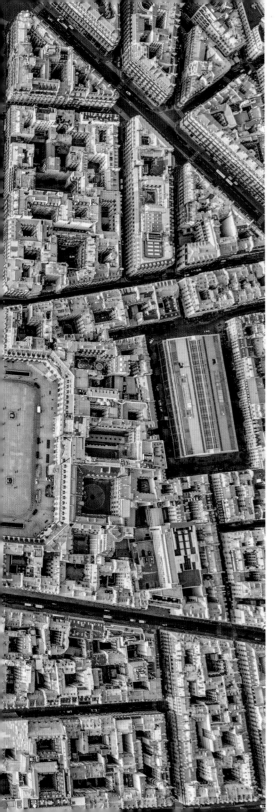

PARIS

FROM THE AIR

JEFFREY MILSTEIN

FOREWORD BY
JAMES CRAWFORD

SELECTED NOTES BY
ROBERT MORTON

RIZZOLI
NEW YORK

New York · Paris · London · Milan

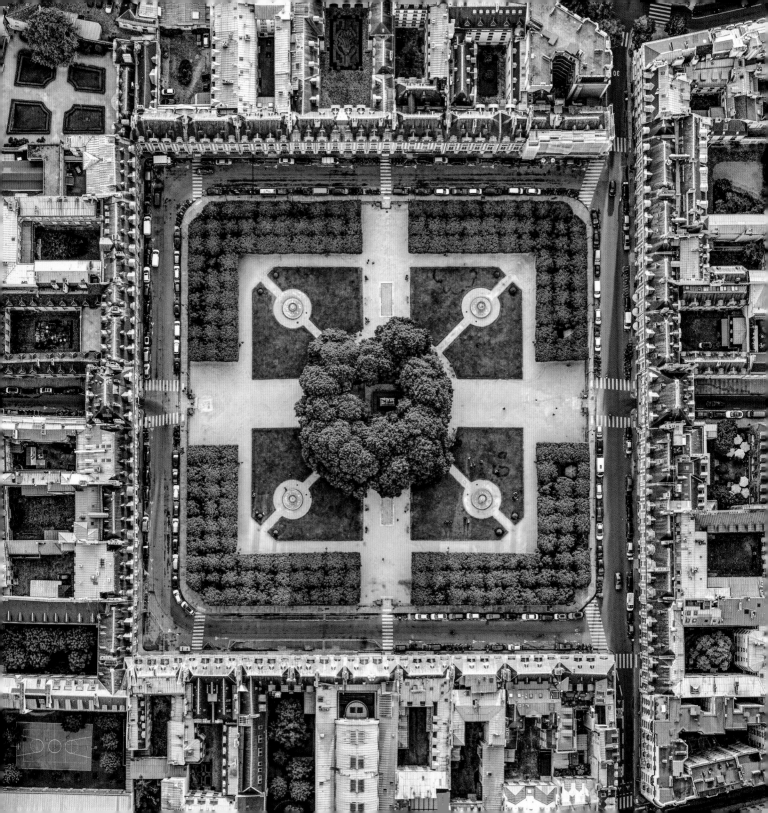

CONTENTS

Title: Place de la Madeleine and Place Vendôme
Opposite: Place des Vosges
6–7: Palais de Chaillot
8: 9th arrondissement
9: 8th arrondissement, with three grand boulevards—Avenue George V at top, Avenue Marceau in the middle, and Avenue d'Iéna at bottom

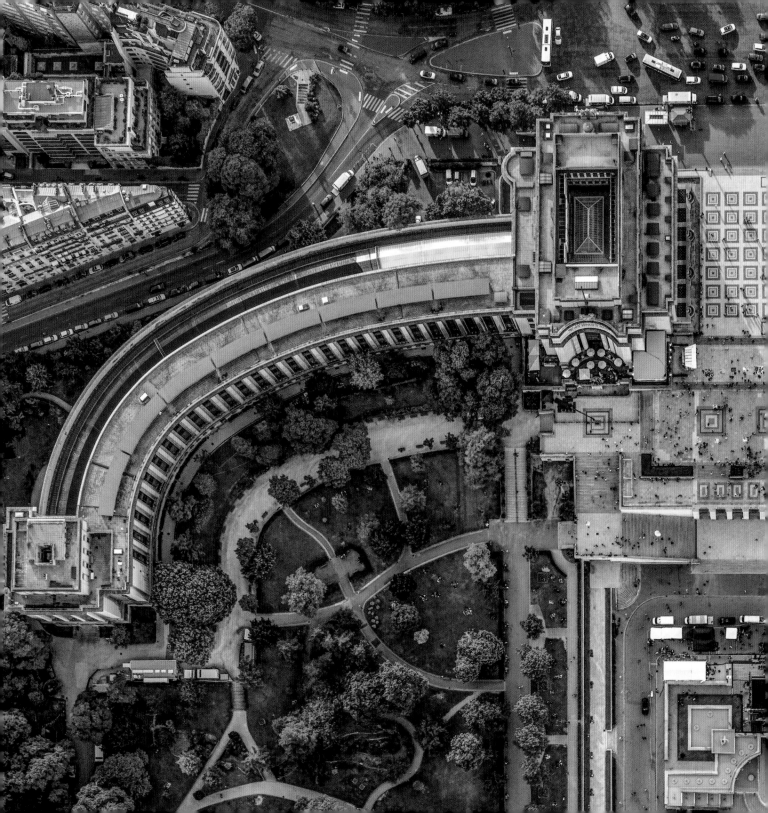

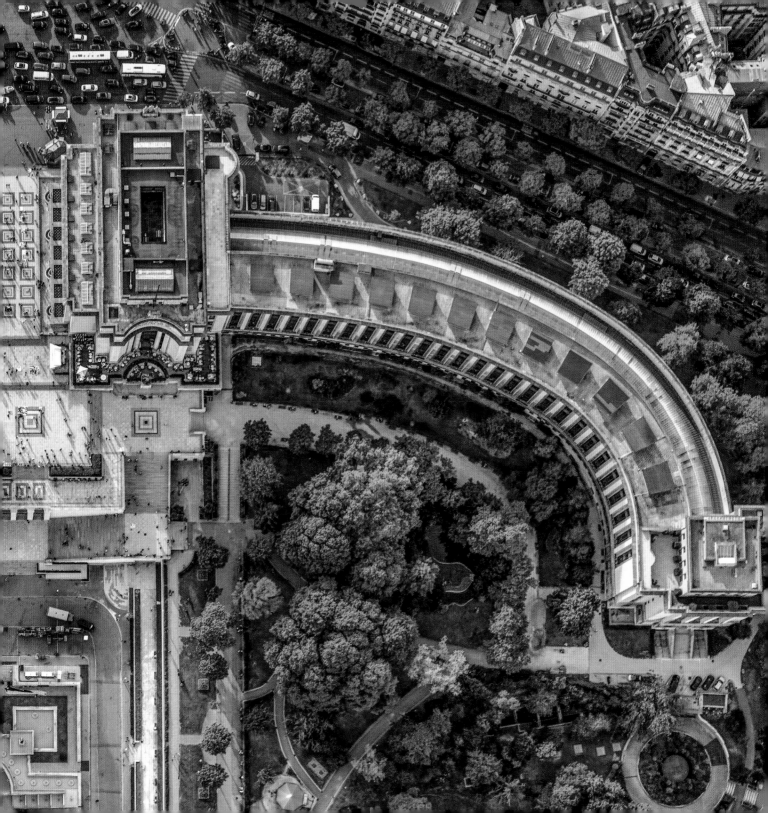

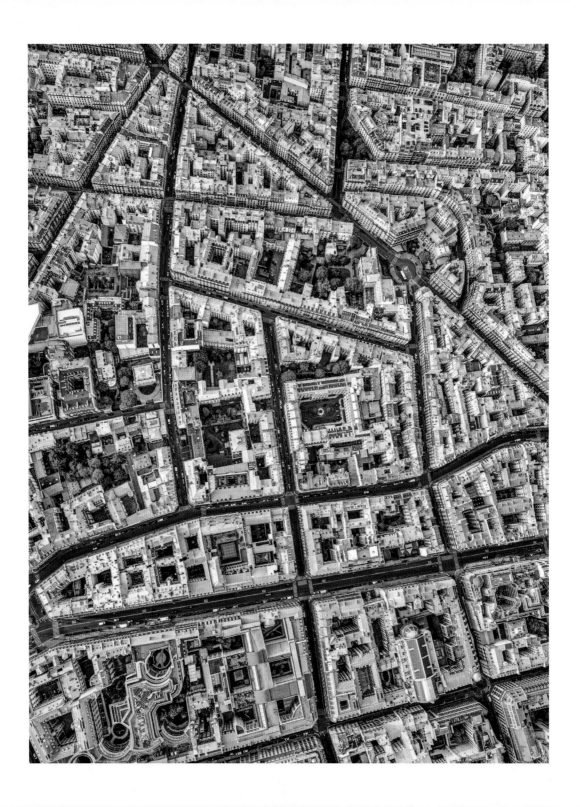

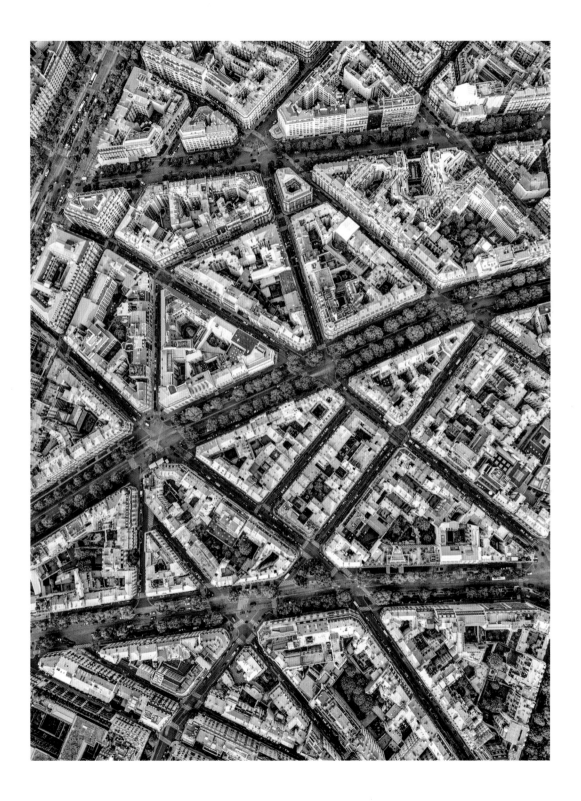

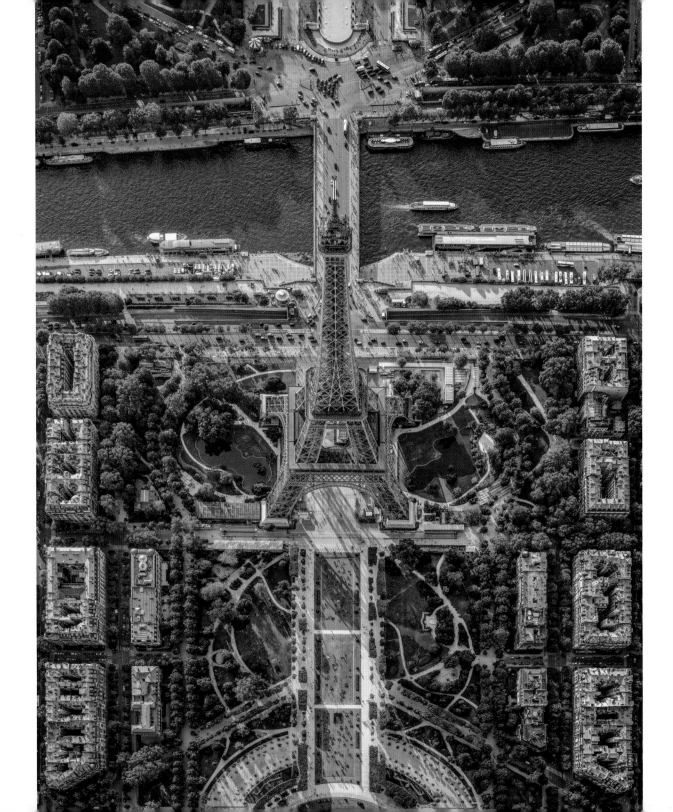

FOREWORD

James Crawford

Tour Eiffel

On October 18, 1909, just after half past four in the afternoon, a Frenchman called Charles de Lambert took off from the Juvisy Aerodrome on the outskirts of Paris in a flimsy Wright-Ariel biplane. De Lambert was Wilbur Wright's first pupil, and he had spent a year learning the rudiments of aviation before he embarked on this momentous flight. He traveled 15 miles northward, all the way to the Tour Eiffel, which he circled once, at a height of some 1,300 feet, before returning to the aerodrome. The whole journey, which lasted a little less than an hour, was described the following day by the *New York Times* as the "most remarkable cross-country flight ever accomplished in an aeroplane." It was also the very first time that an aircraft had ever flown over a city.

Watching from the window of a tiny, top-floor apartment on the Left Bank was another man: Charles-Édouard Jeanneret, a 19-year-old art student and son of a watchmaker. Jeanneret was entranced by de Lambert's flight and its vision of man and machine mastering the skies. Just over a decade later, he made his own journey

in an aircraft. He described the feeling as "ecstasy," an experience that offered a whole new way of seeing and understanding our world. "The airplane carries our hearts above mediocre things," he wrote, "enabling human beings to glance down like Gods upon the worlds they have made."

By this time, the young man in the window had a new name—Le Corbusier, one of the father figures of modern architecture. As he looked down at the urban landscapes below him, he delivered a damning verdict: "Cities in their misery must be torn down," he said. "They must be largely destroyed and fresh cities built." This included Paris. Le Corbusier called his vision for the future, dreamed up in an aircraft, the *Cité Radieuse* ("the Radiant City") and he built a scale model of the French capital that replaced its elegant boulevards with highways and huge, high-rise apartment blocks. Not unsurprisingly, he found few takers.

Nonetheless, the Paris that Jeffrey Milstein captures so beautifully in this book is still the product of radical change. Today's city of lights, love, and enlightenment was rebuilt—in some places *entirely*—in the middle of the 19th century. Before Le Corbusier, there was Georges-Eugène Haussmann, the public official who oversaw the demolition of the squalid medieval core of Paris. Out went overcrowded, ramshackle, and insanitary streets and dwellings, and in came long, interconnecting parks and avenues; row after row of brand-new buildings, all fashioned from the same cream-colored stone; and huge spaces carved out for the glittering, iron-and-glass cathedrals of the industrial age, the railway stations of Gare de Lyon, Gare de l'Est, and Gare du Nord. In less than two decades, the old city was gone and a new one stood in its place.

If Haussmann could have come along for the ride with Jeffrey in his helicopter in the summer of 2019, he would have recognized a great deal of the city that he created a century and a half earlier. His ordered *reordering* of the fabric of Paris—which is experienced by the pedestrian as an abundance of light and space, sight lines receding into the distance along pleasingly uniform boulevards punctuated by eye-catching

Looking west over the 1st arrondissement, with Jardin du Palais Royal at lower left, Les Halles above, and Musée du Louvre at right

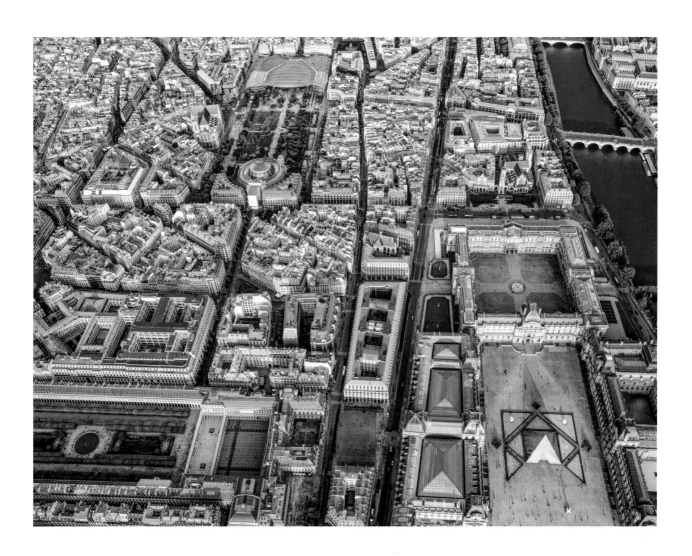

monuments—becomes even more remarkable when viewed from the sky.

In the images that follow, you will see this famous city as you have never seen it before. Very few photographers have ever been granted the privilege of capturing it from the air. In Jeffrey's skilled hands, the familiar is transformed. The Place des Vosges unfolds as a huge green butterfly in the midst of uniform lines of blue-gray rooftops. The Place Victor Hugo, a nexus point where 10 sun-caressed streets meet, looks out at you like a solitary, unblinking eye. The tip of the Tour Eiffel stretches up like the stigma of some delicate, iron flower. Very fittingly, Paris from above is one giant work of art.

So Haussmann's geometric Paris remains very much intact, but not unaltered. The law of every city is change. As Jeffrey's lens flits across the urban landscape, it seeks out the many new forms that have taken seed and flowered. The cerulean pipework on the roof of the Centre Pompidou becomes a coral reef in the heart of the city. The curved-glass roof of Les Halles glimmers like liquid metal. Jeffrey likes to take his photographs around sunset, in those moments just before dusk, when the light is low and warm, people flood the streets, and cities are at their most vital and vibrant. In what is perhaps my favorite image in the book, he captures the abstract form of the Louvre Pyramid from above. Its glass glows burnished gold, its shadow stretches out into a long, triangular point, reaching all the way across a flagstone plaza infused orange by the dipping sun. Tiny figures walk around the pyramid in small groups, their own shadows running far away from them like Pollockian splashes of paint. It is the perfect evocation of the joy—and power—of aerial photography. People and light are caught in perfect concert, wonderfully alive within the worlds we have made.

Opposite: Musée du Louvre, Pyramide entrance and Place du Carrousel
16–17: Looking south across the Seine, with Palais de Chaillot and Jardins du Trocadéro at right, Tour Eiffel and Champ de Mars at left

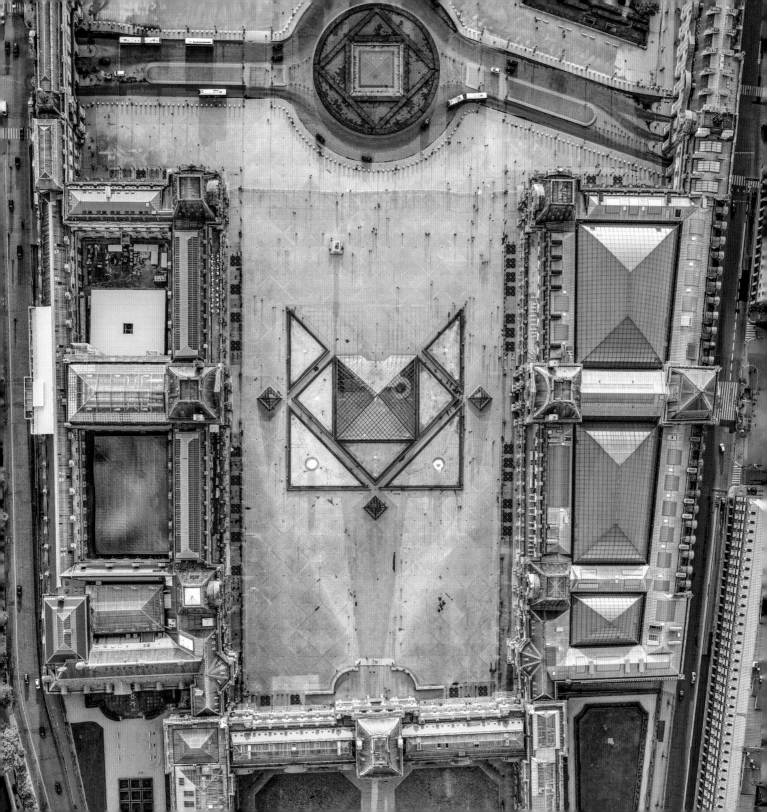

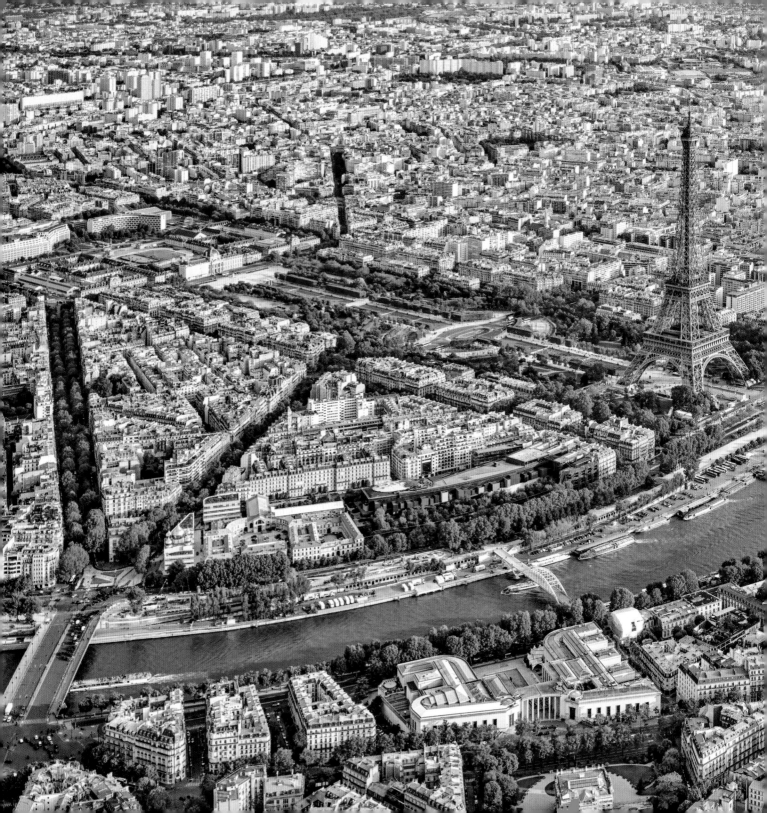

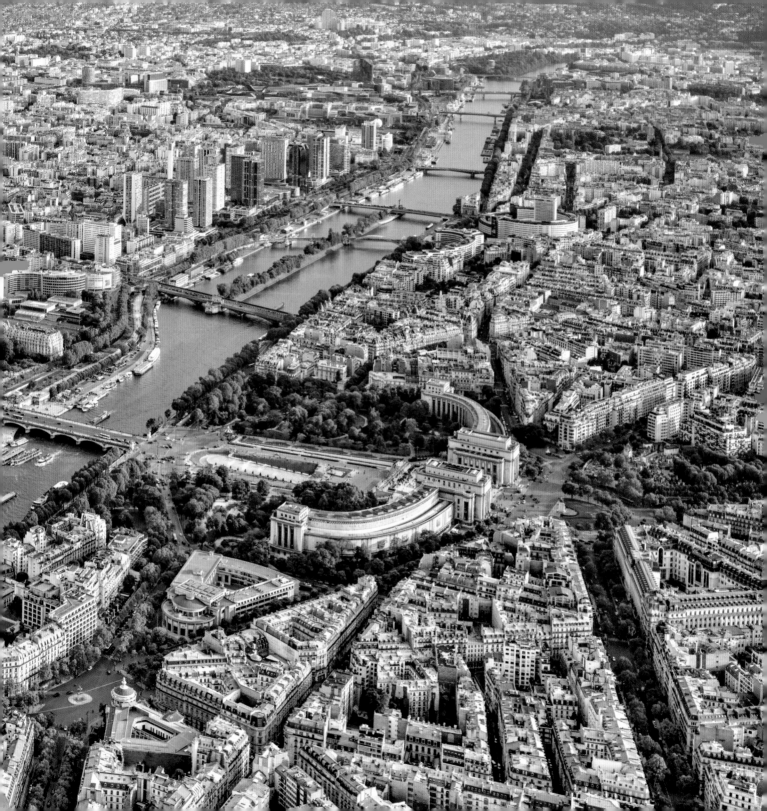

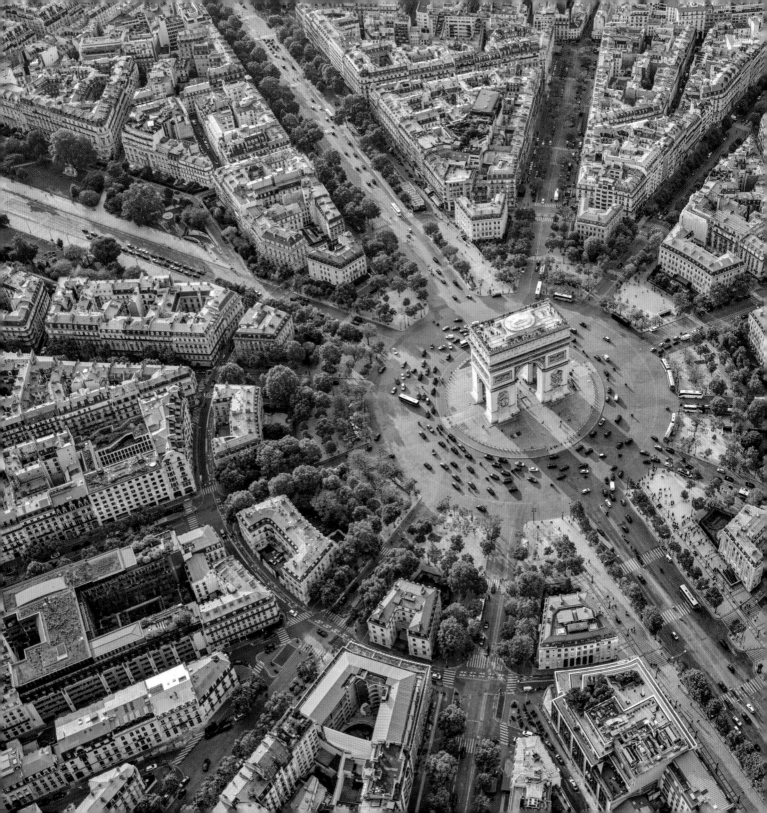

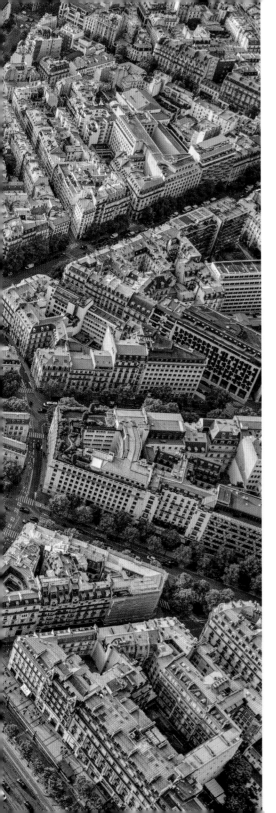

Opposite and 20–21: Place Charles de Gaulle and the Arc de Triomphe

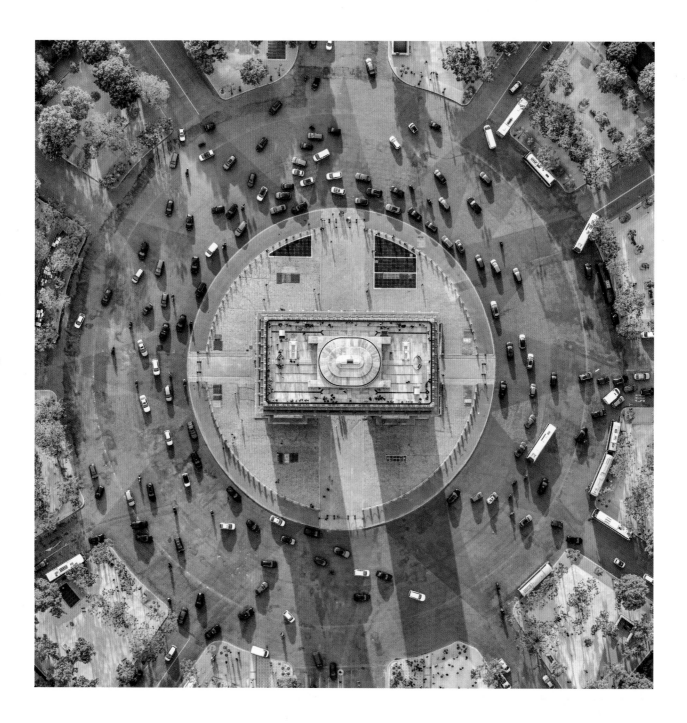

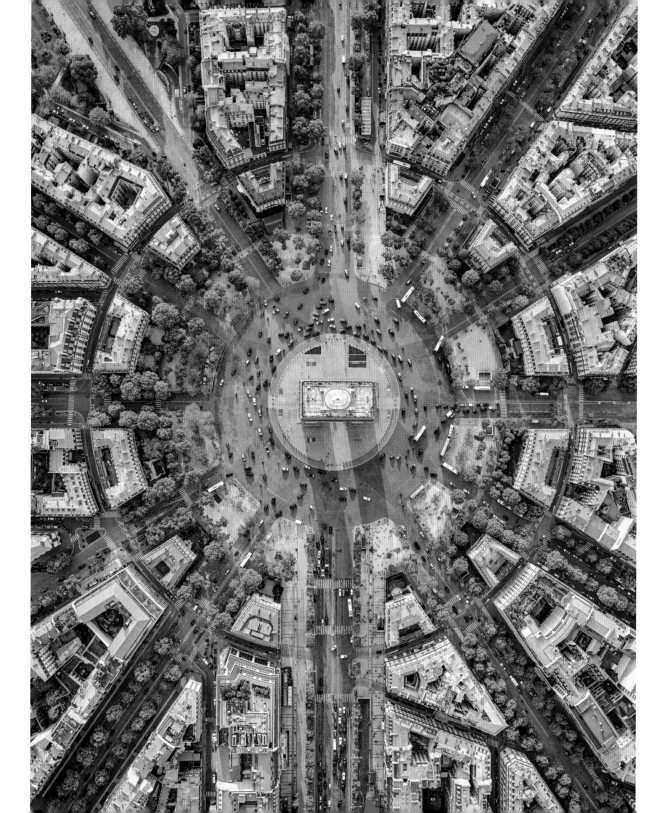

22 Arc de Triomphe

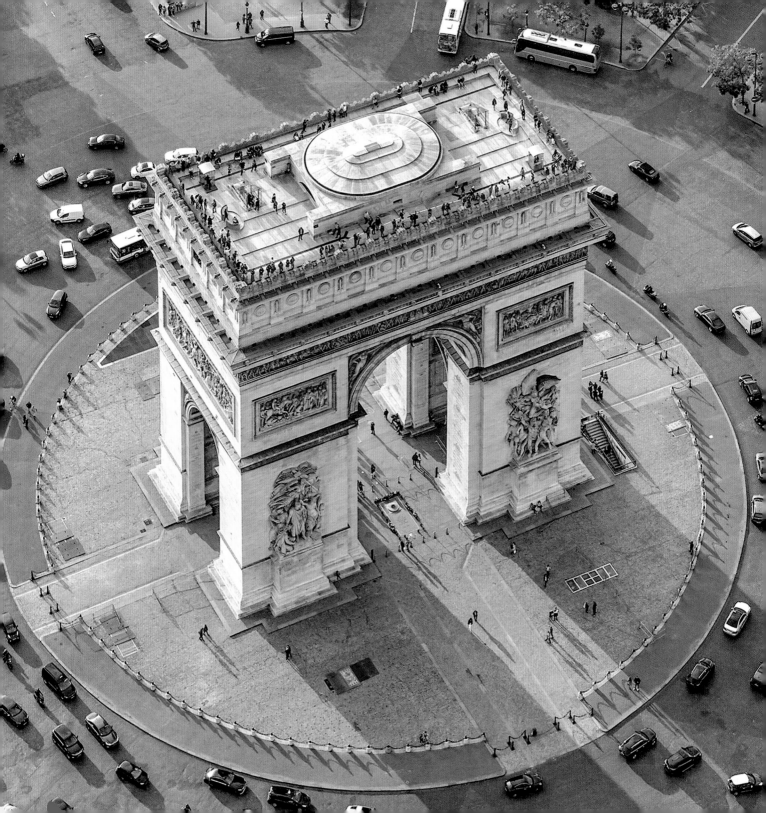

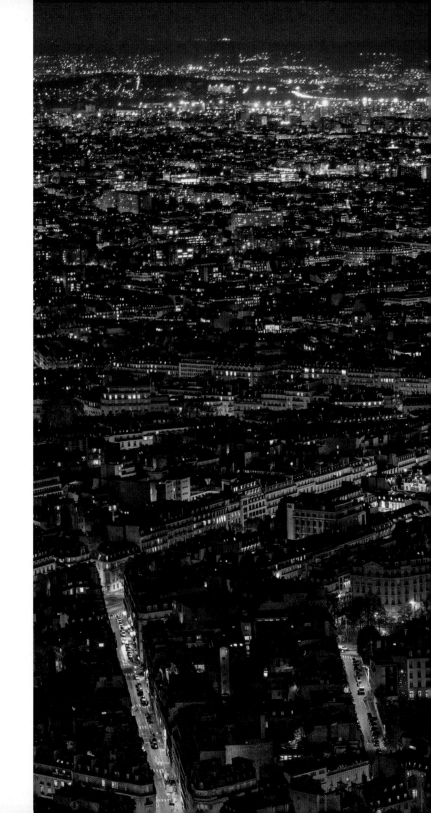

24 Place Charles de Gaulle at night

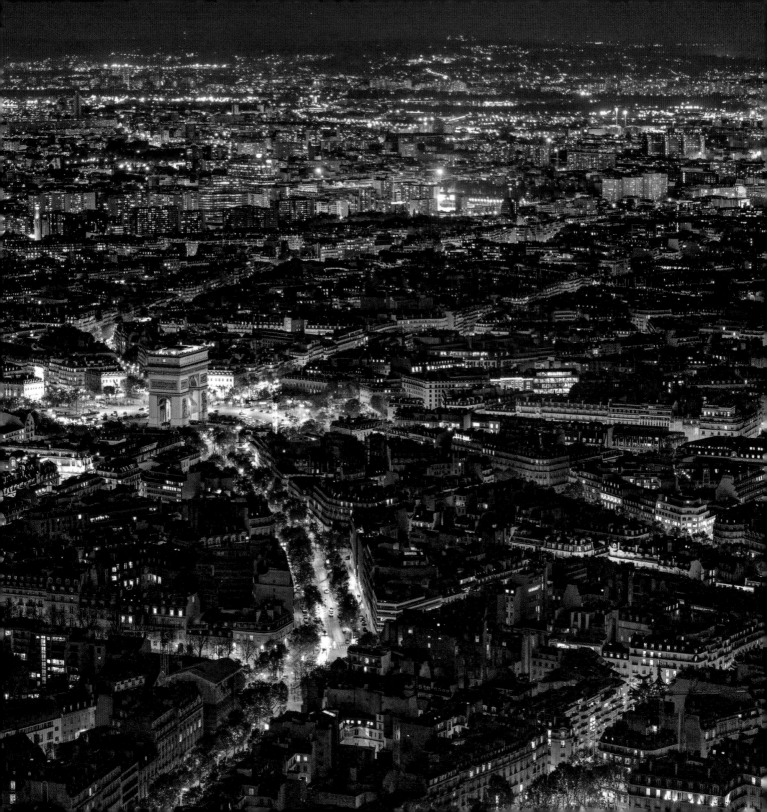

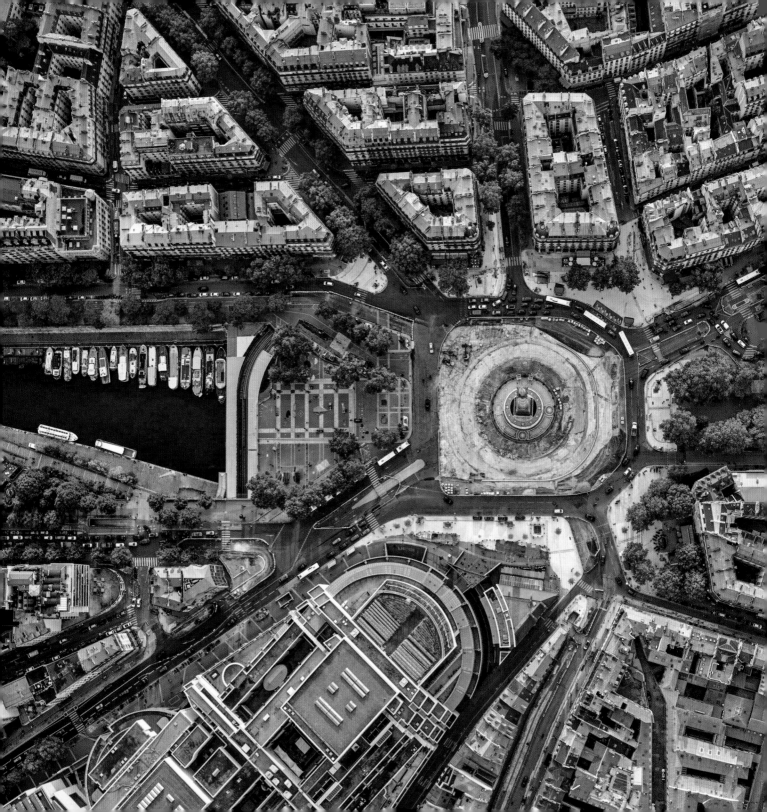

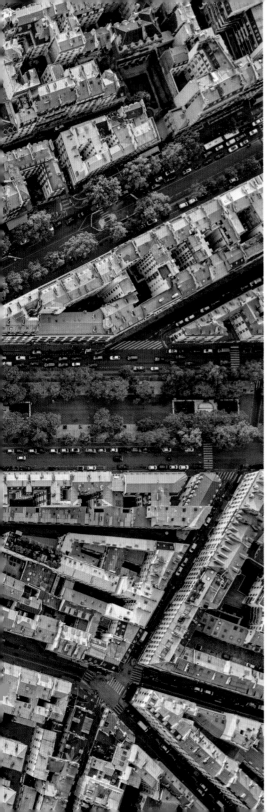

Opposite: Place de la Bastille | **28–29:** Looking southeast across 27
Place des Vosges toward Place de la Bastille and Canal Saint-Martin

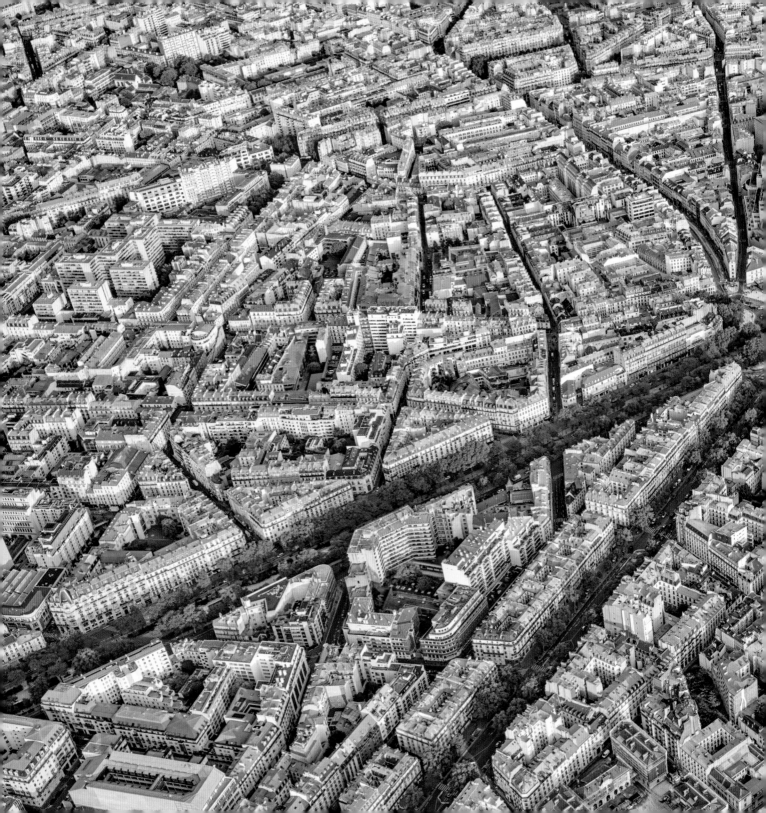

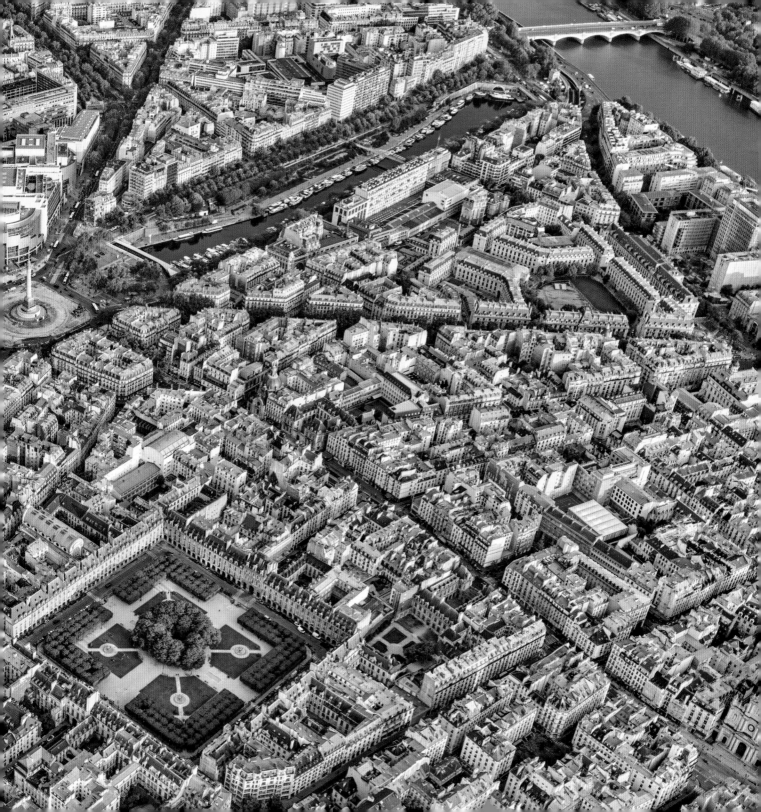

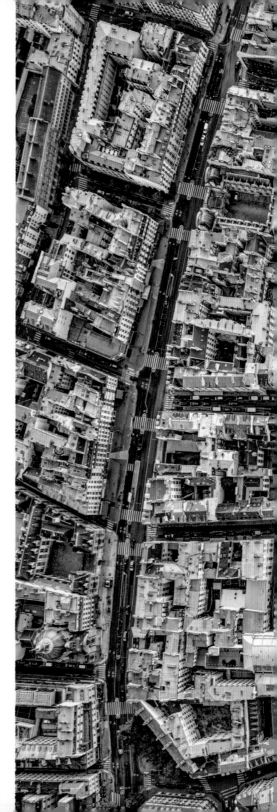

30 Place des Vosges and surrounding neighborhood of the 4th arrondissement

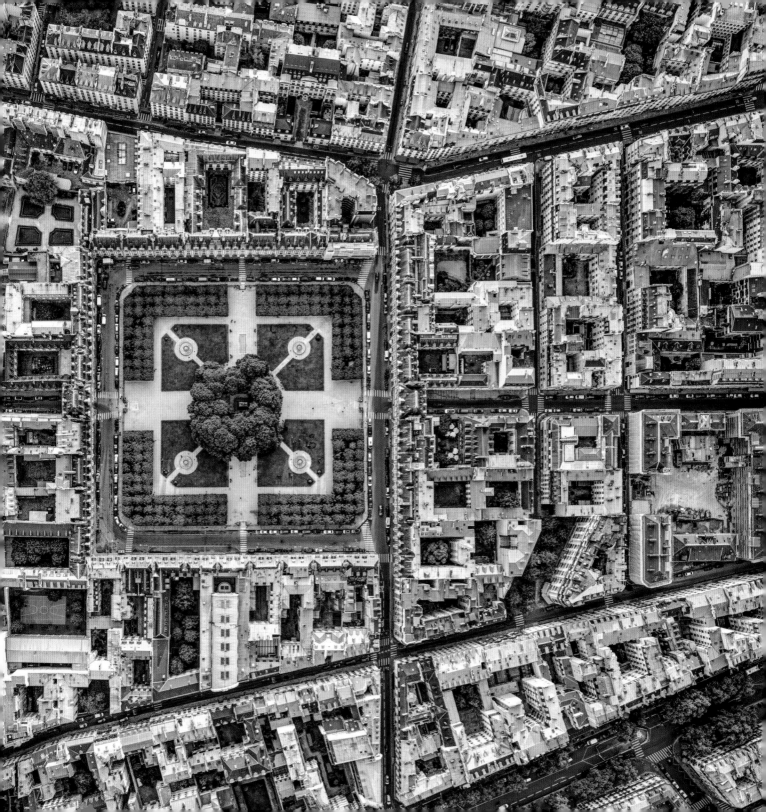

32 **Opposite:** Western end of the Jardin des Tuileries with the Musée de l'Orangerie at top and Jeu de Paume at bottom, facing Place de la Concorde
34–35: Jardin des Tuileries

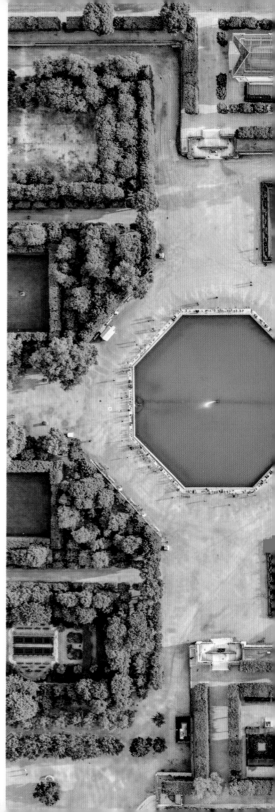

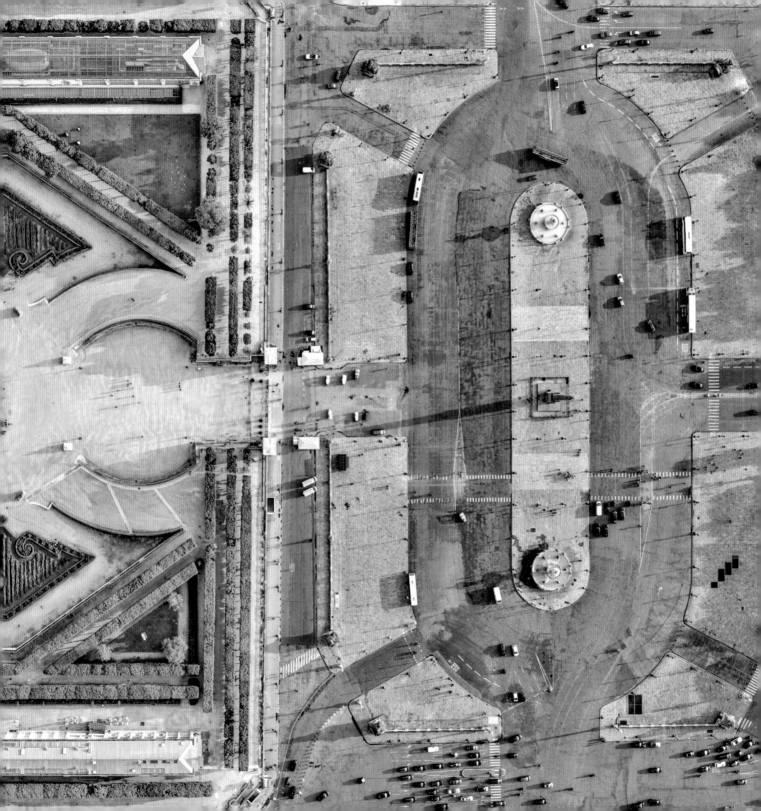

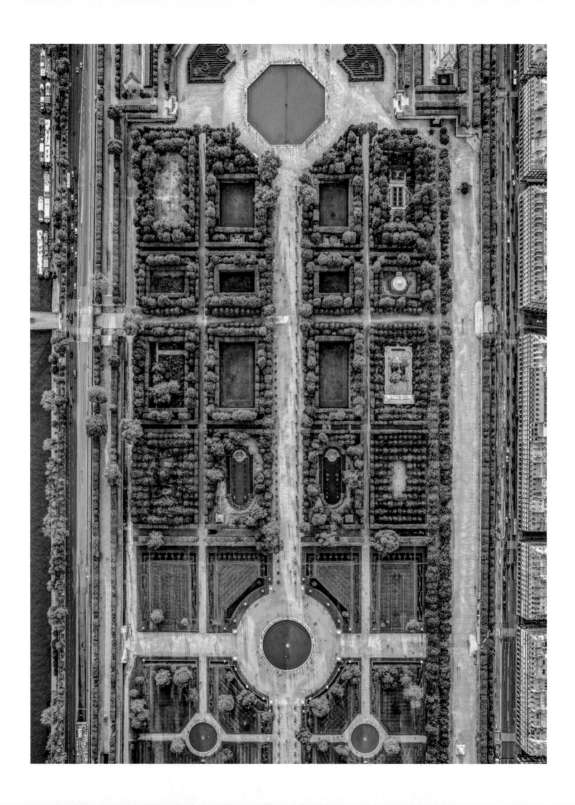

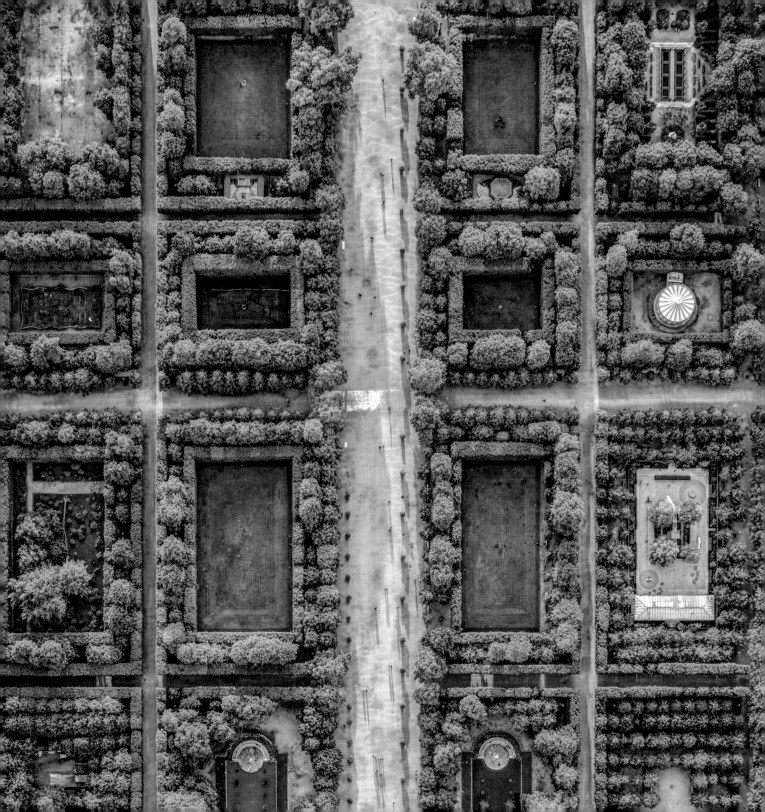

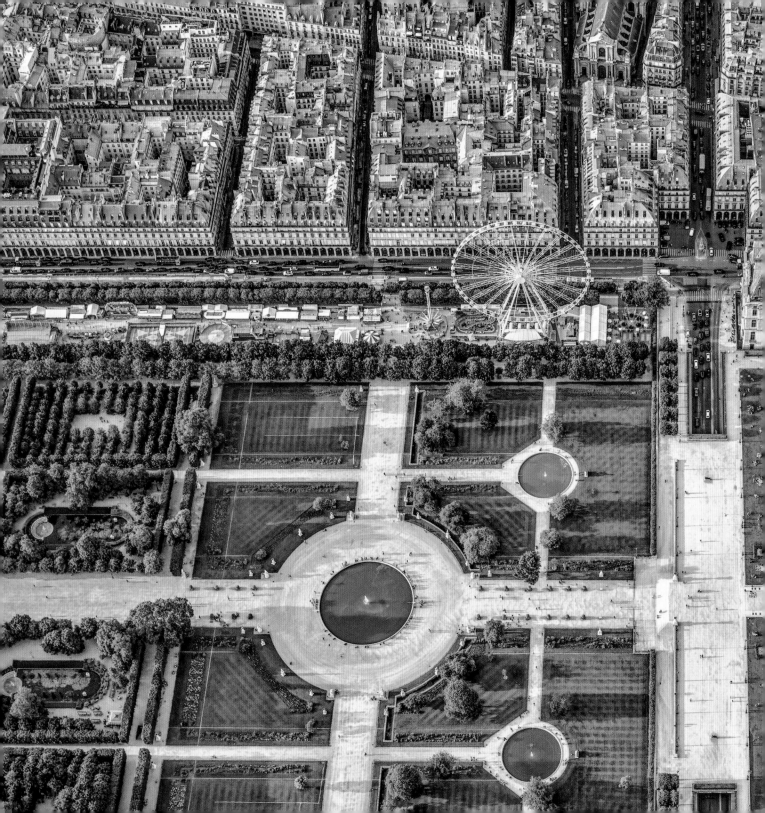

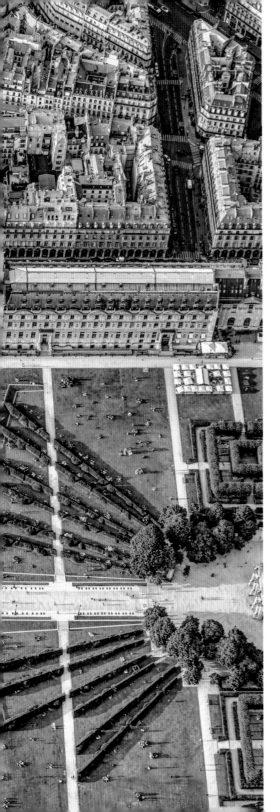

Jardin des Tuileries, with the Fête des Tuileries funfair


37

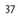

38 Forecourt of Musée du Louvre with the Pyramide entrance,
Place du Carrousel inverted pyramid, and Jardin des Tuileries

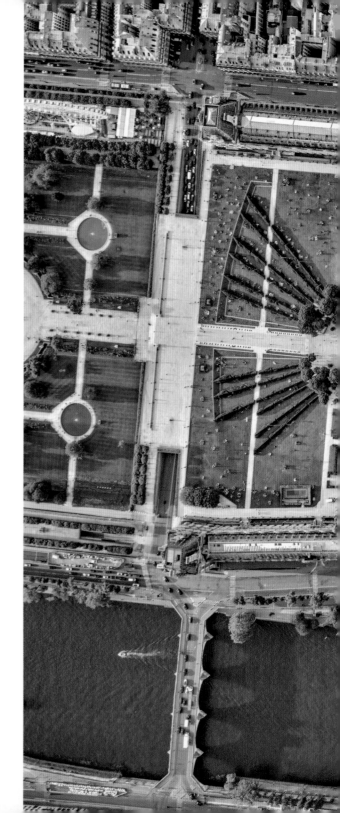

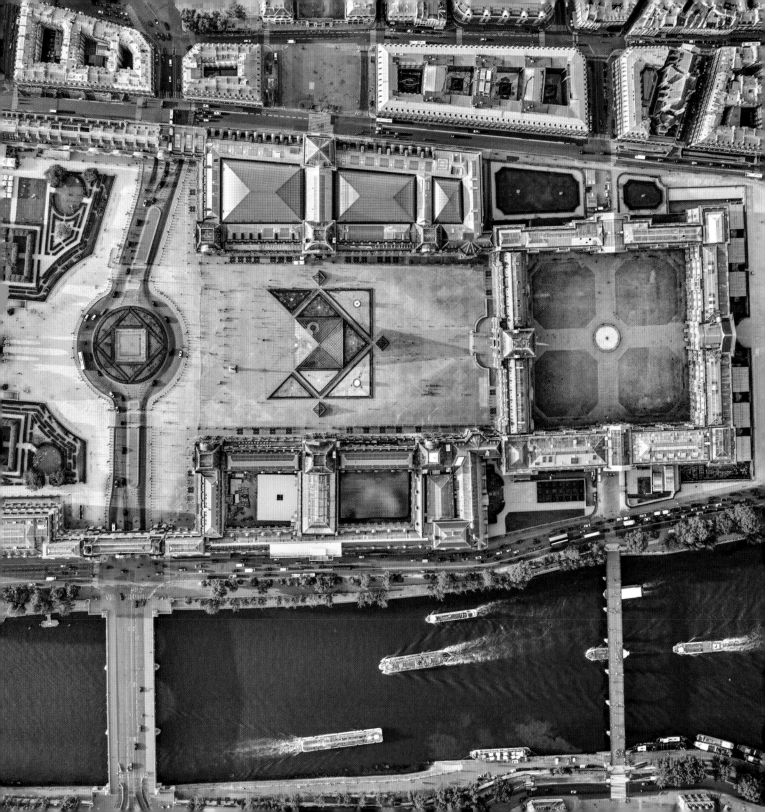

40 Pyramide du Louvre

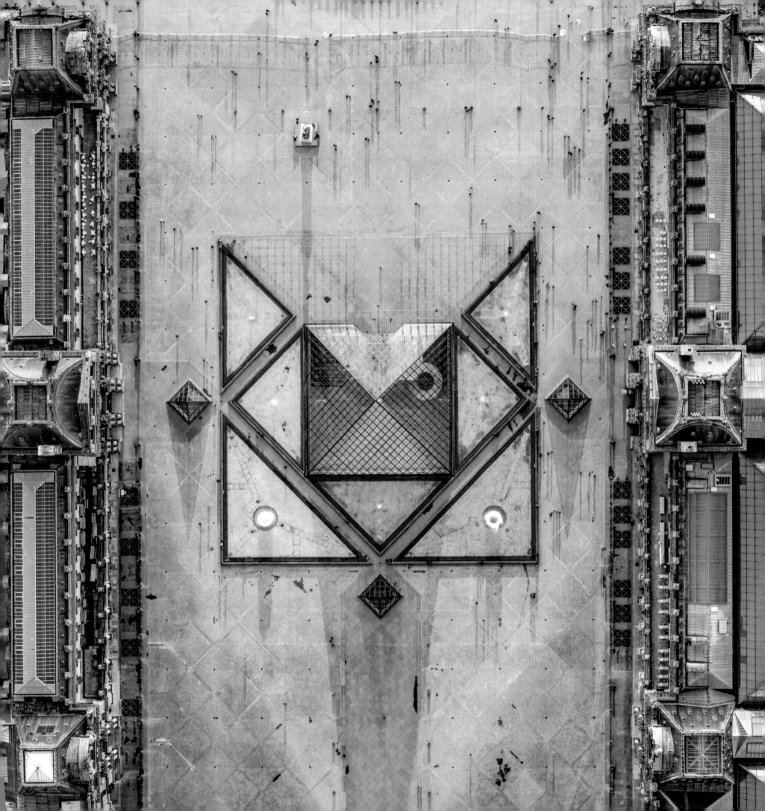

42 Musée du Louvre at night

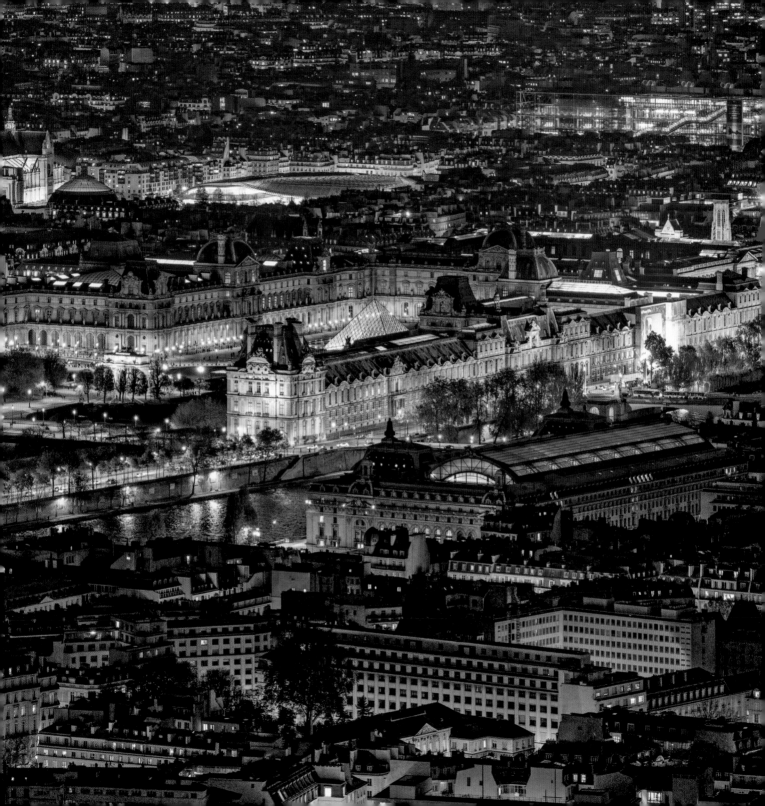

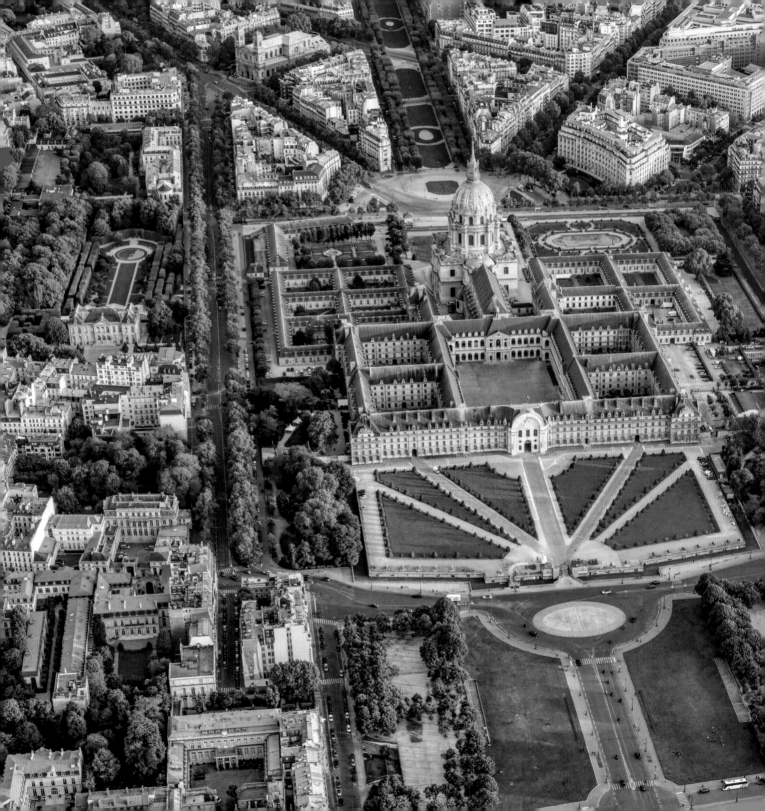

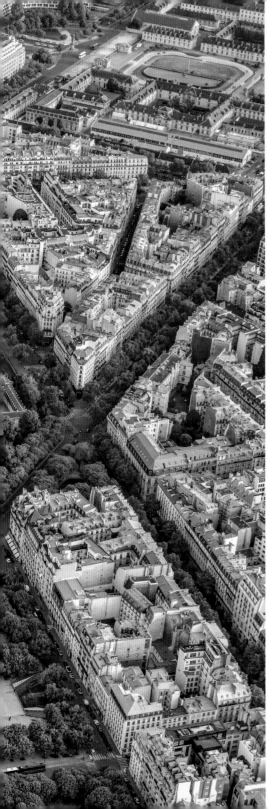

Opposite: Hôtel des Invalides 45

46–47: Hôtel des Invalides and Napoleon's Tomb

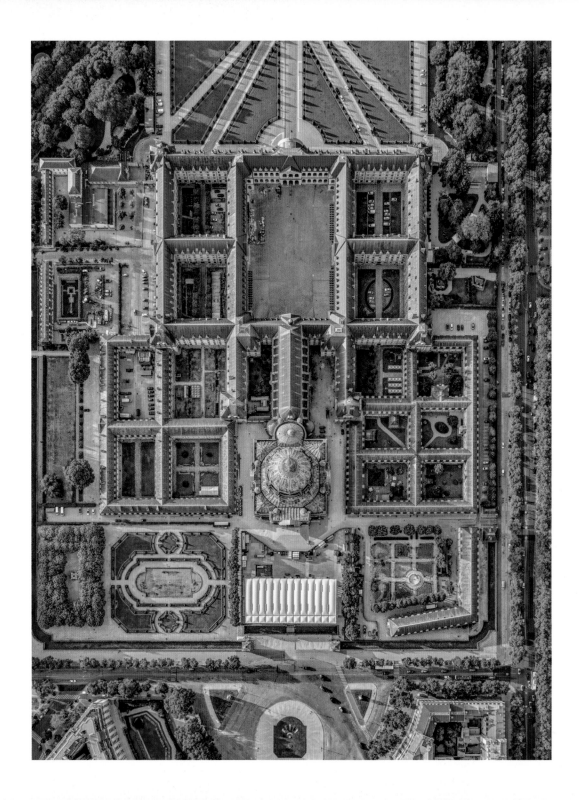

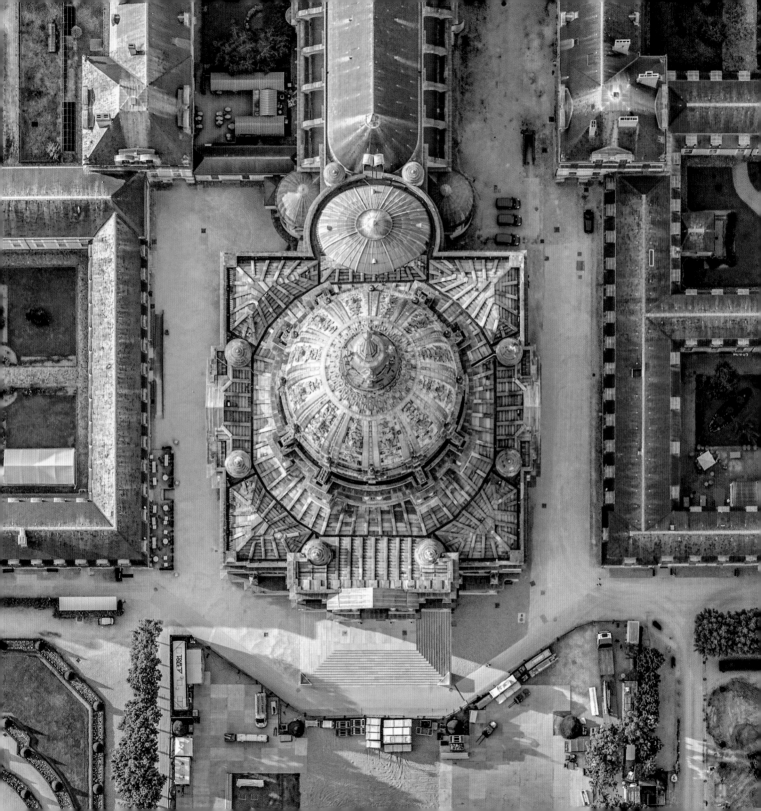

48 Looking south past Hôtel des Invalides toward Tour Montparnasse

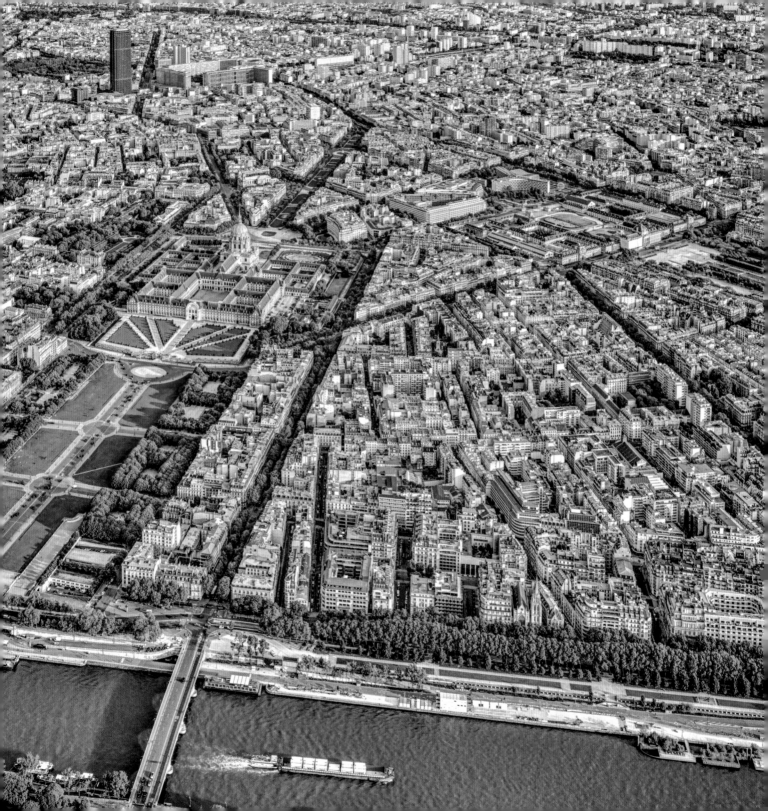

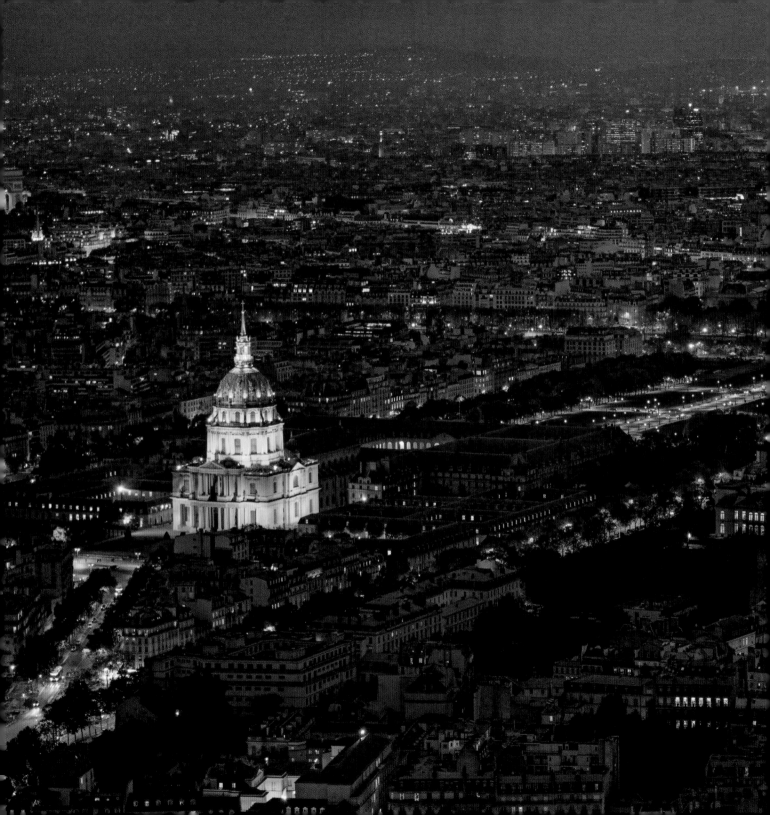

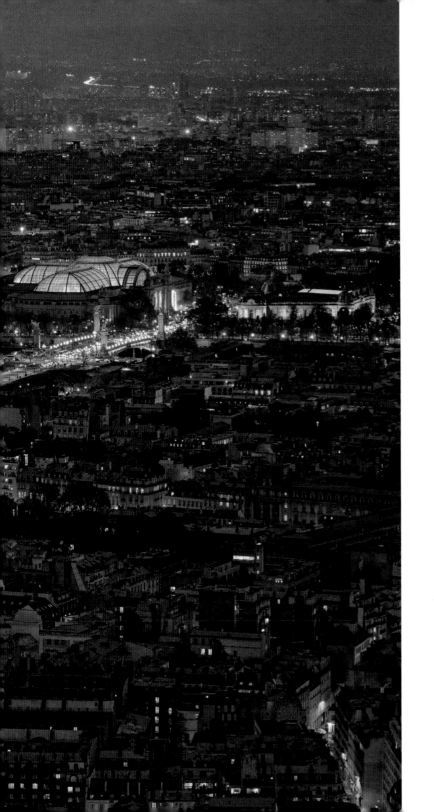

Looking north past Hôtel des Invalides 51
toward the Grand Palais

52 **Opposite:** Grand Palais and Petit Palais | **54:** Petit Palais | **55:** Grand Palais, detail

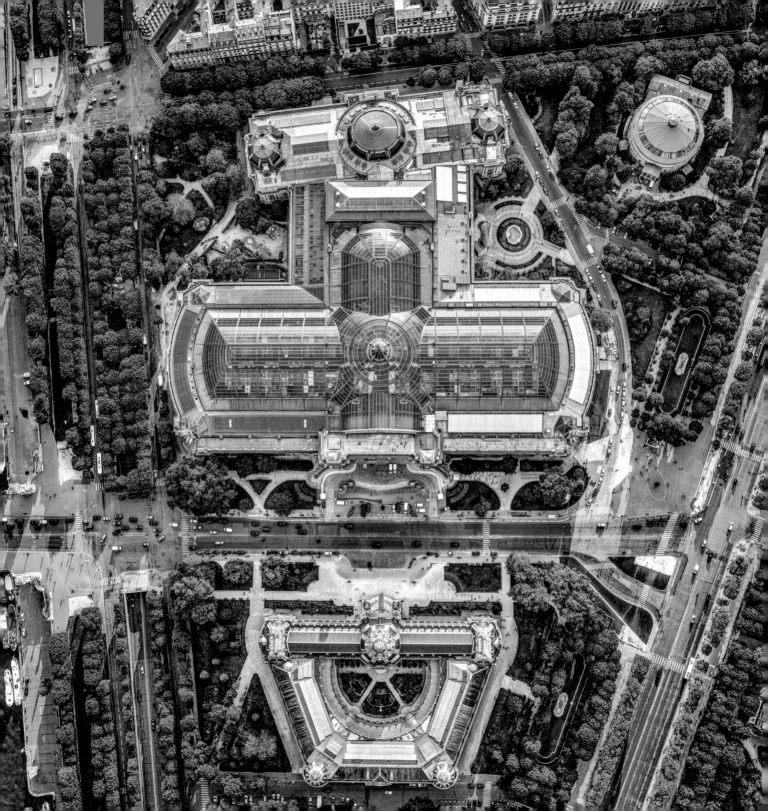

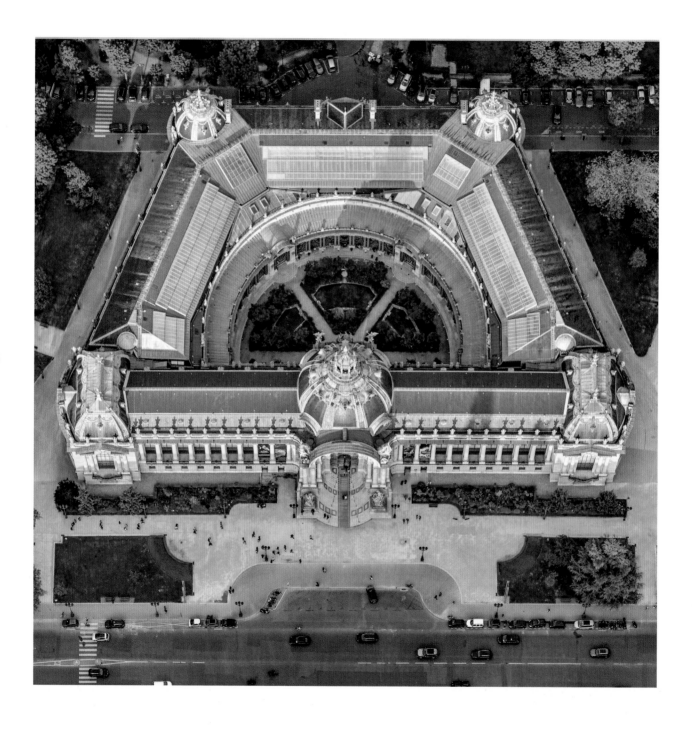

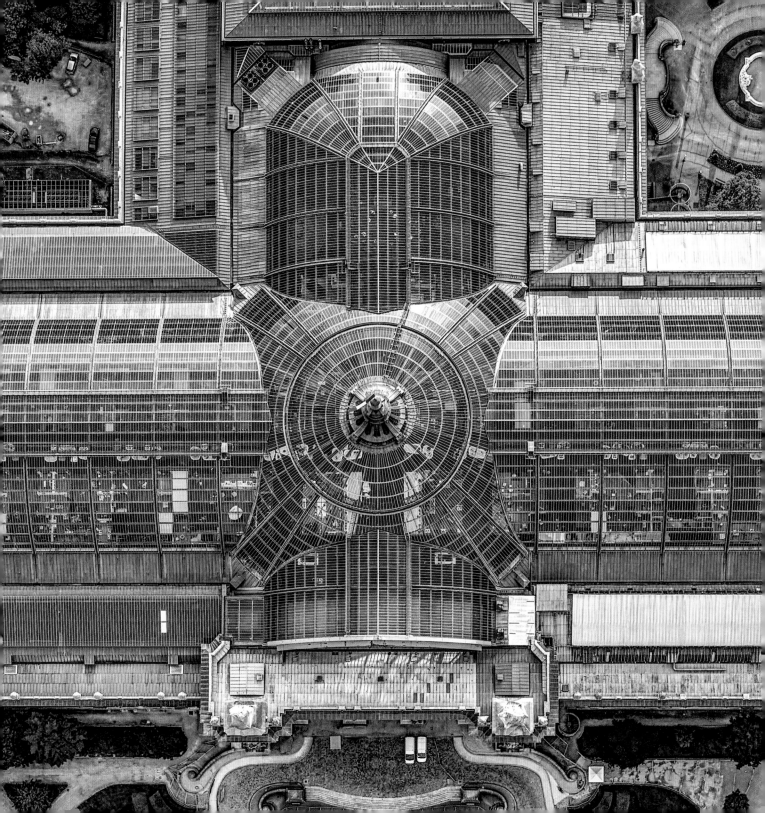

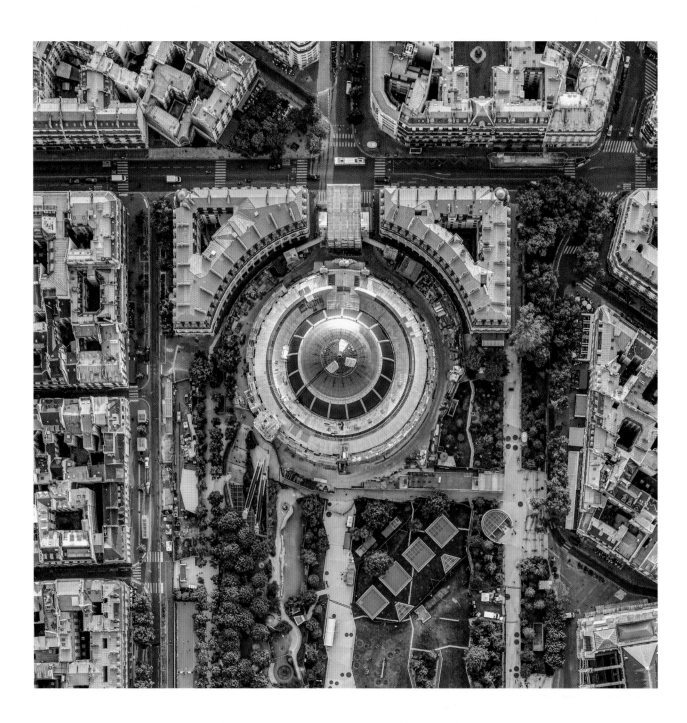

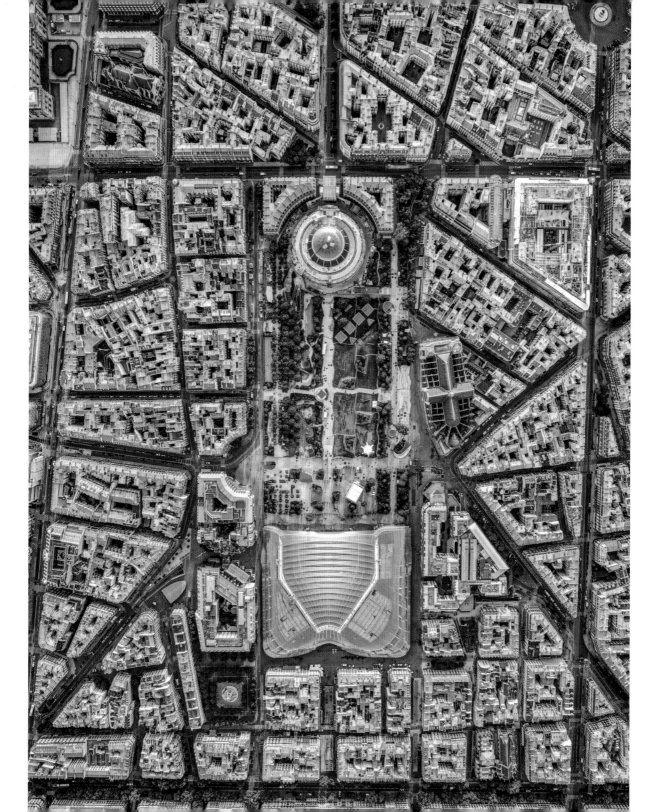

58 **56:** Bourse de Commerce at Les Halles | **57:** Les Halles, with the Forum des Halles shopping mall at bottom | **Opposite:** Place des Victoires, with Jardin du Palais Royal at top right

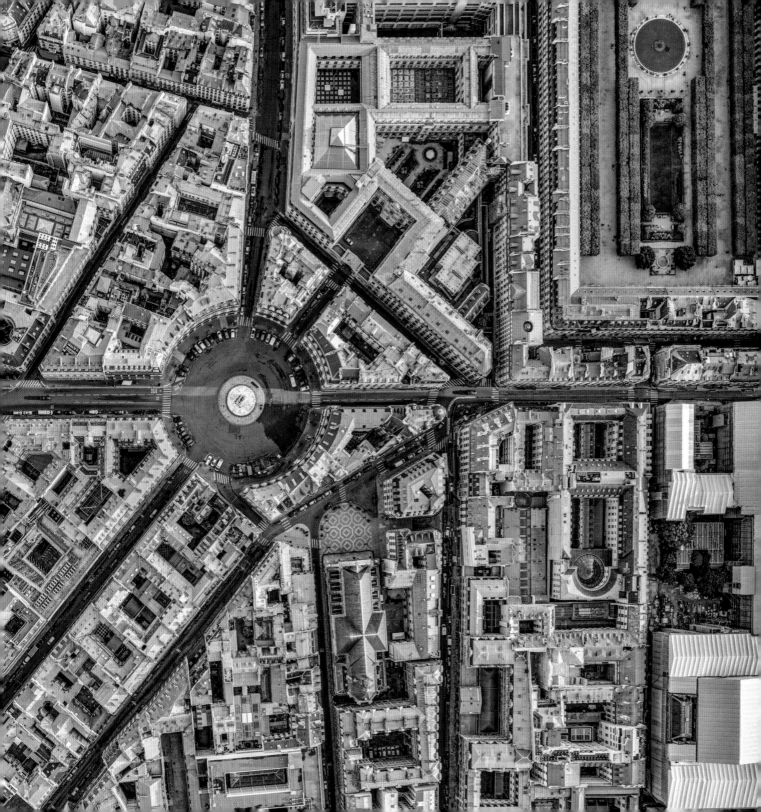

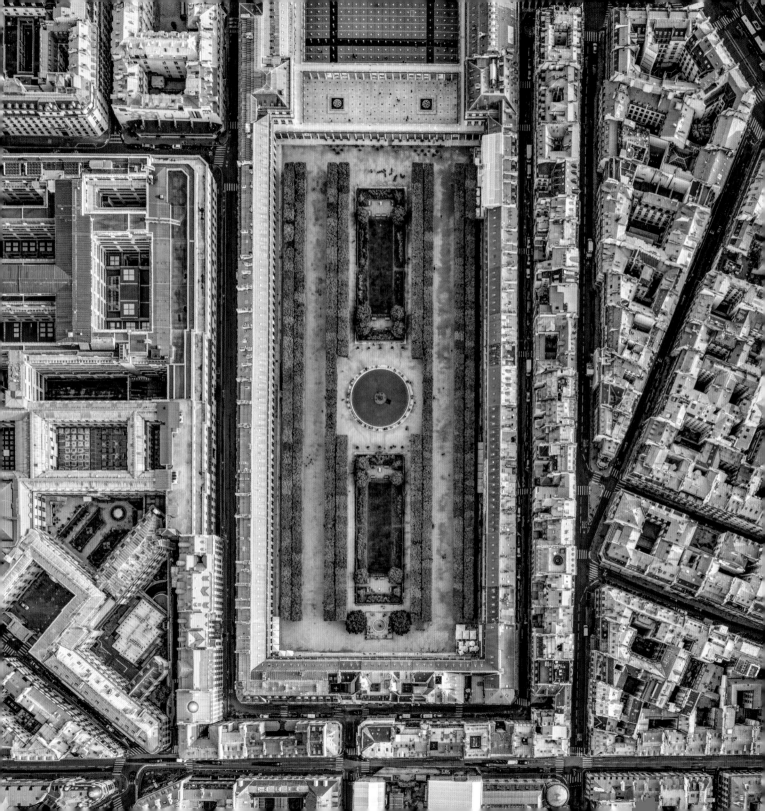

60–61: Jardin du Palais Royal | **Opposite:** Place de la Madeleine | 64–65: Place de l'Opéra

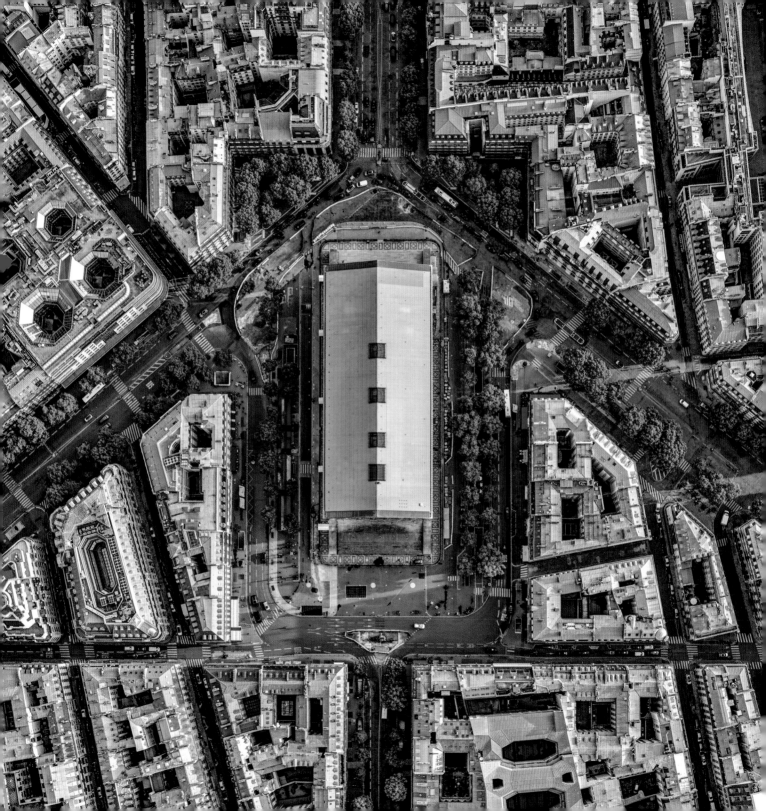

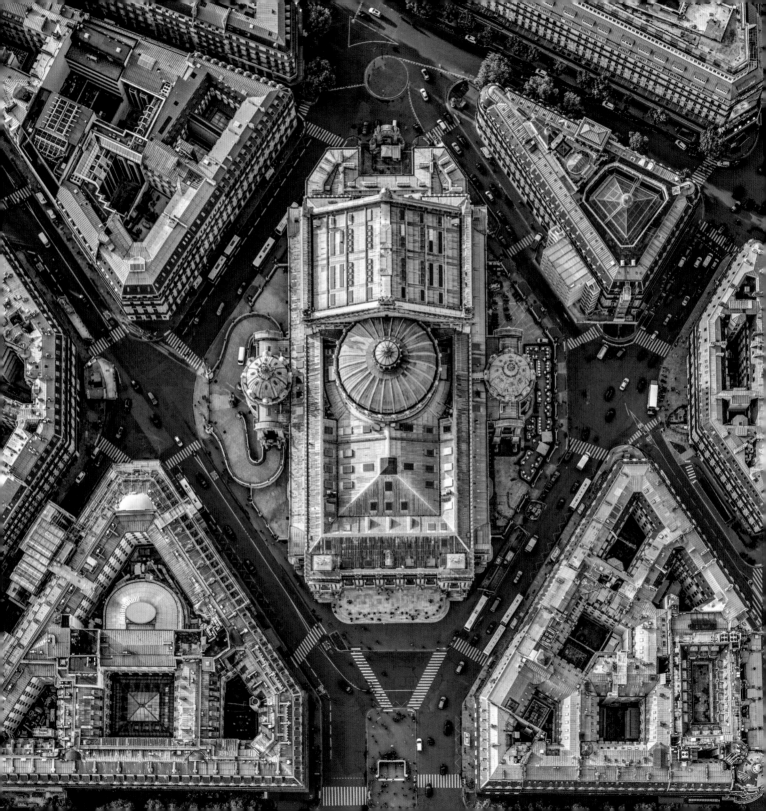

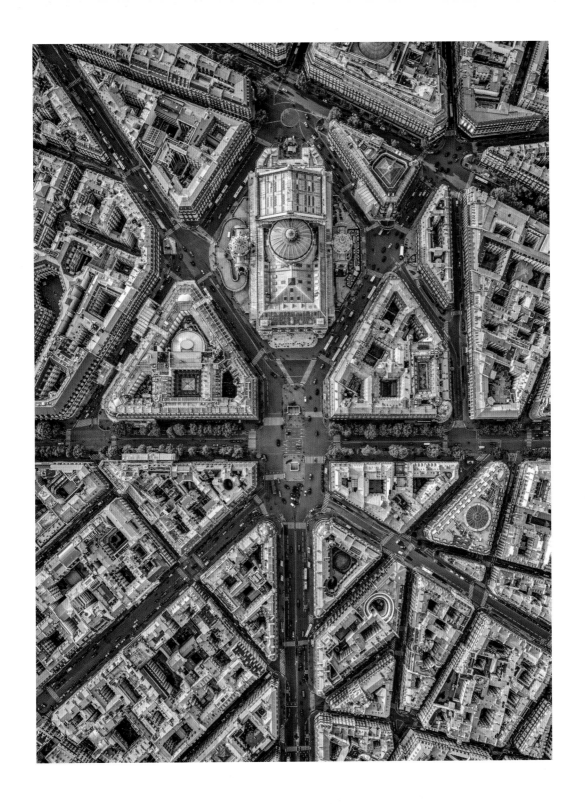

66 **Opposite:** Place de la Madeleine and Place de l'Opéra
68–69: Place Vendôme, with Rue de la Paix at top

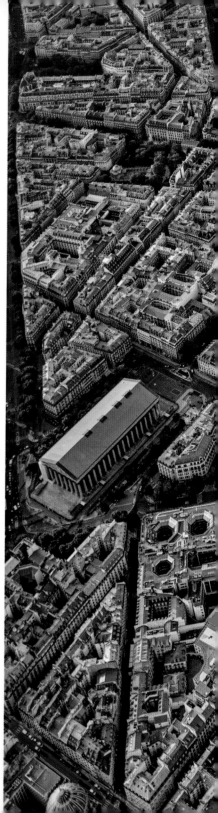

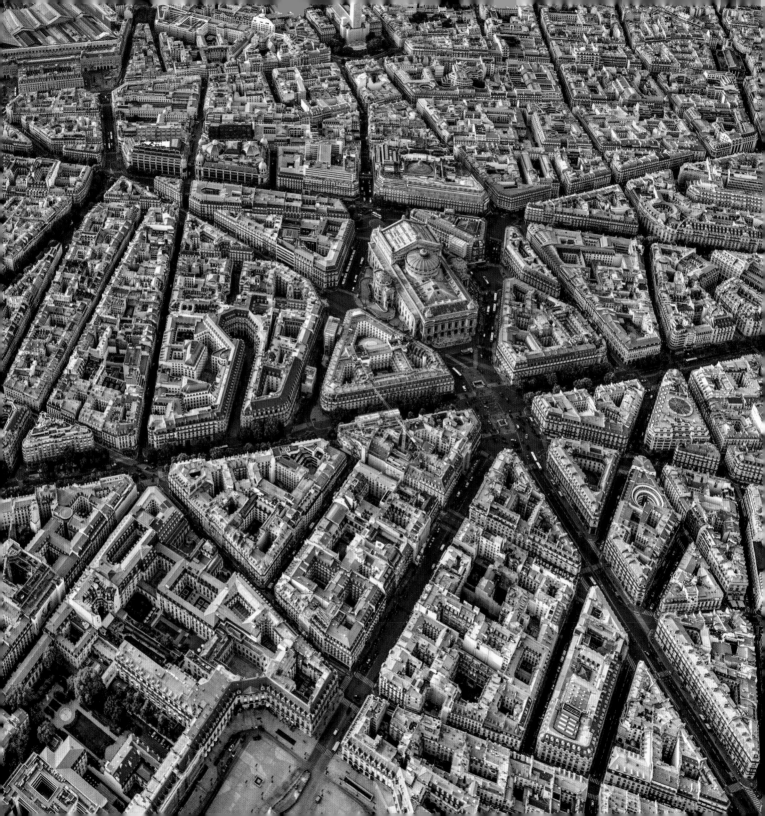

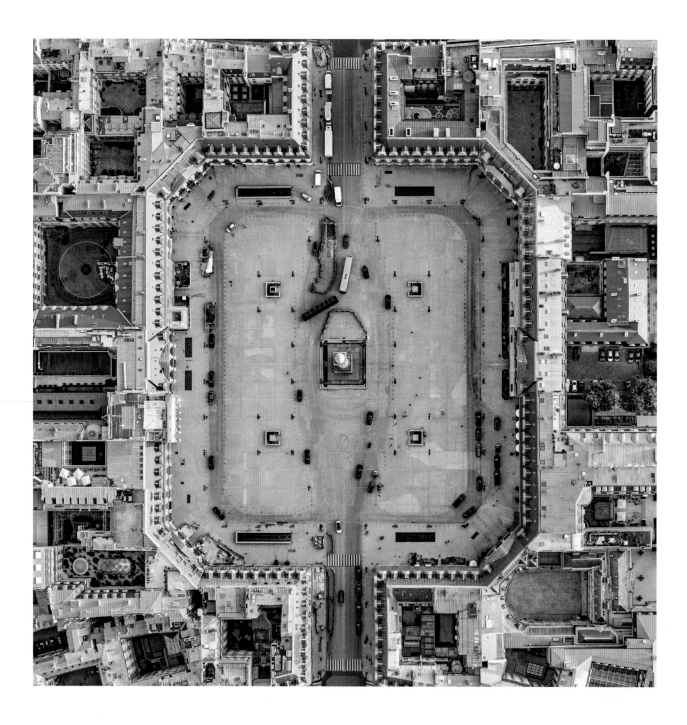

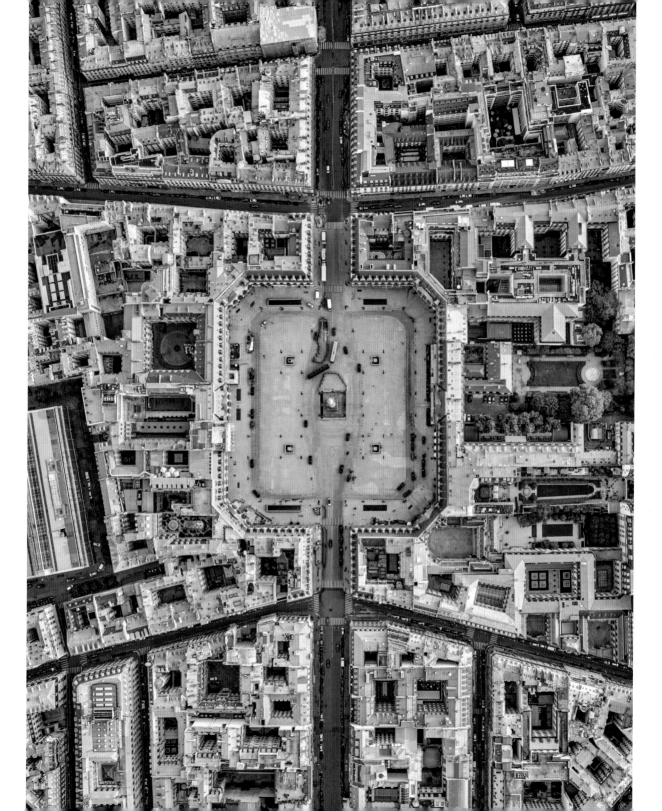

70 **Opposite:** Place Vendôme | **72–73:** Place Victor Hugo

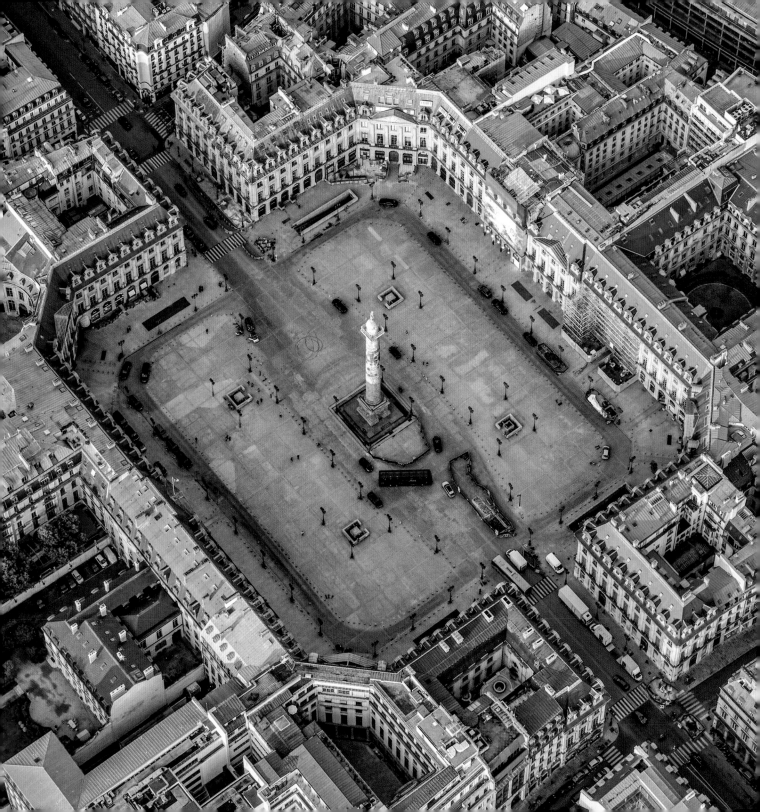

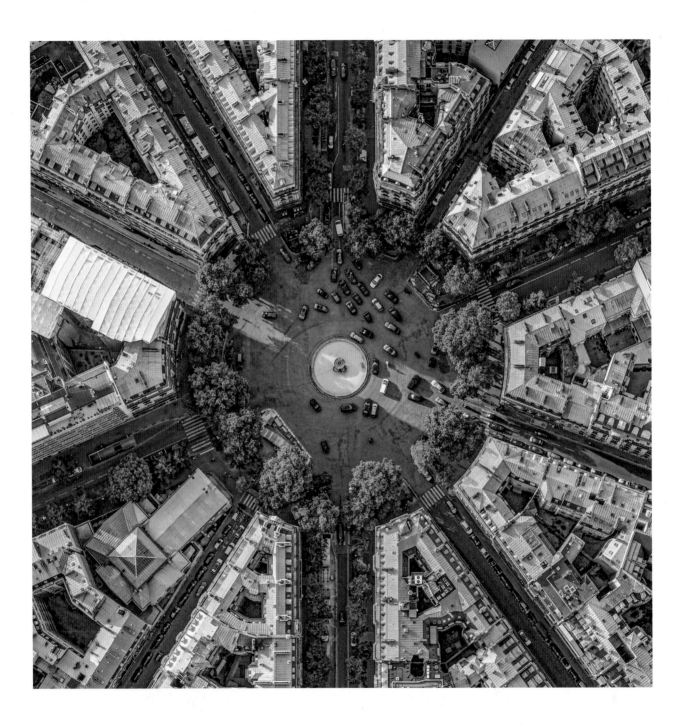

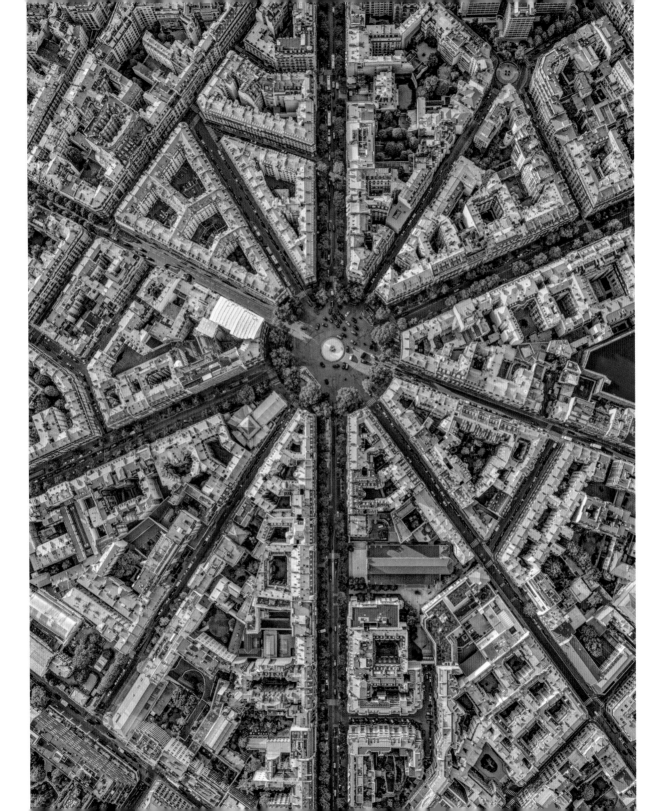

74 Tracks entering Gare du Nord

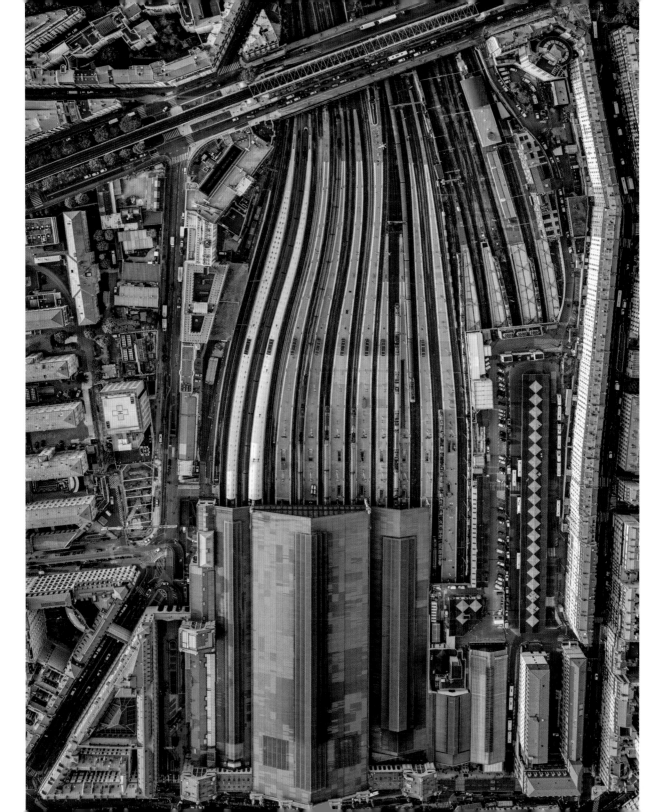

76 Tracks entering Gare Montparnasse beneath the Jardin Atlantique

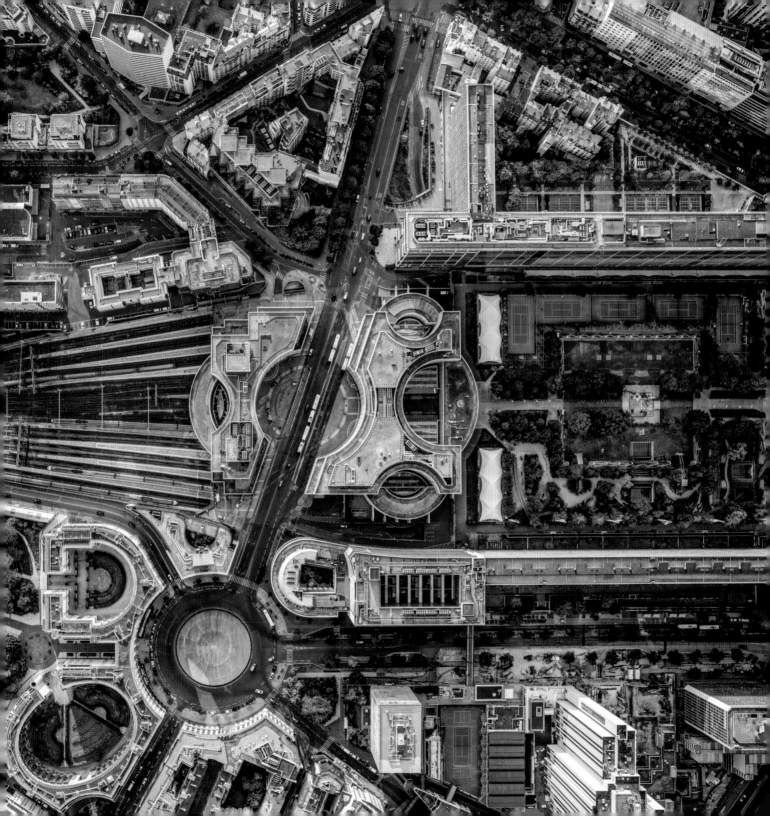

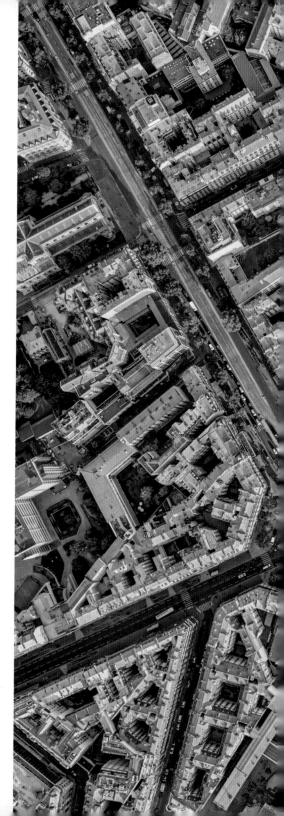

78 Looking straight down on Tour Montparnasse
and the entrance to Gare Montparnasse

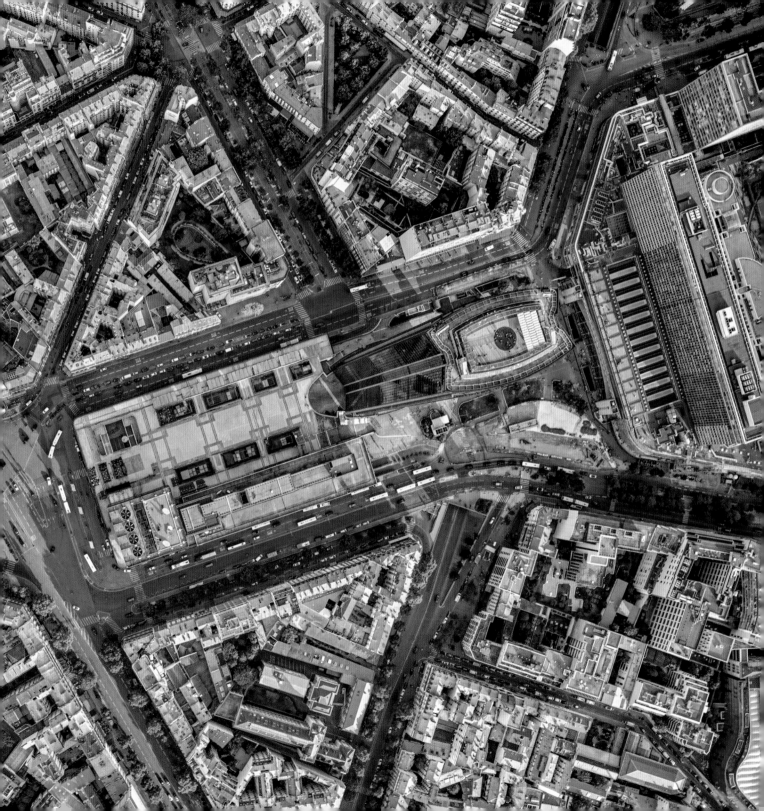

80 Cimetière du Montparnasse

82 Centre Pompidou, also known as the Beaubourg

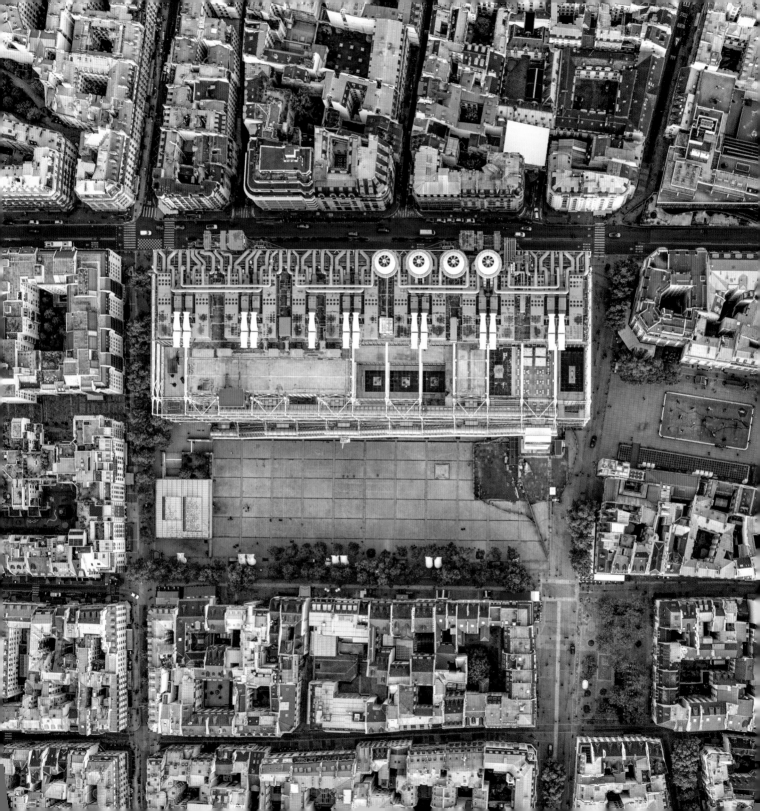

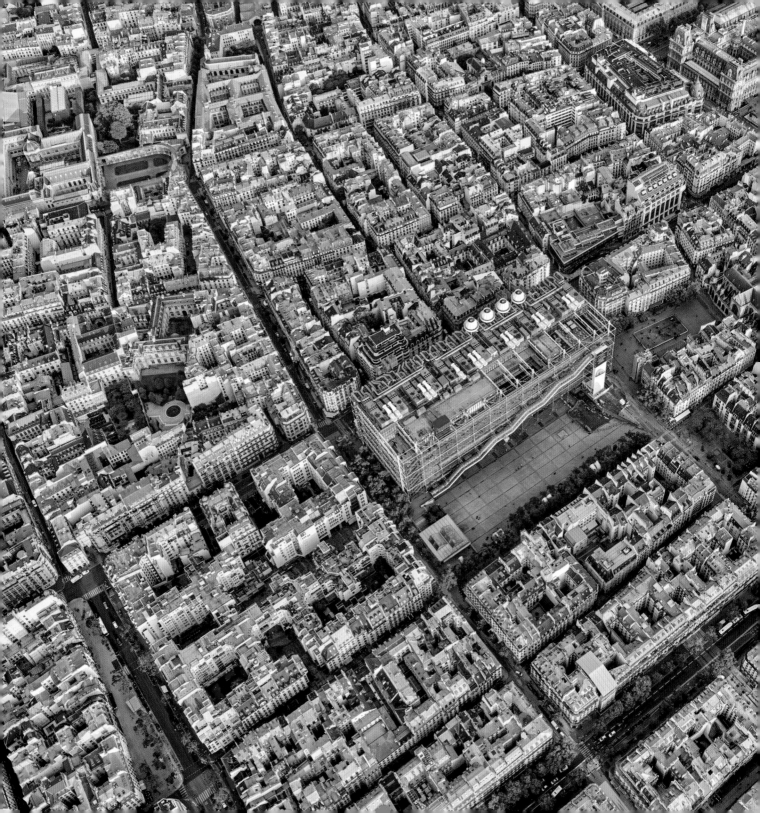

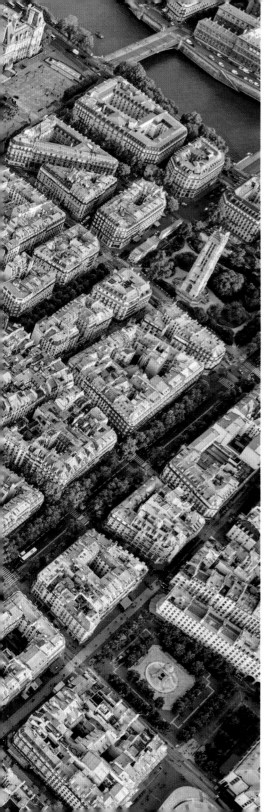

Centre Pompidou and the 4th arrondissement 85

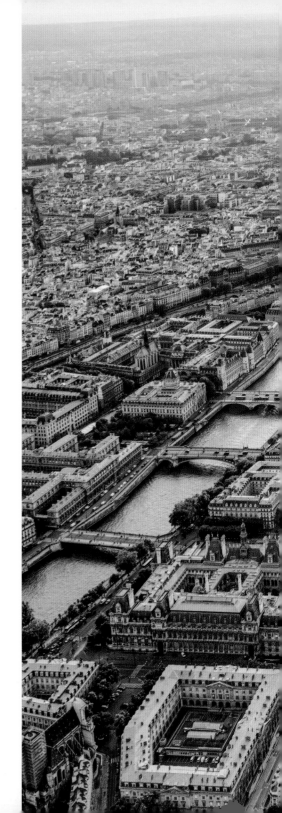

86 Looking west over the Hôtel de Ville at left foreground, Centre Pompidou, Les Halles, and the Louvre, with La Défense in the distance

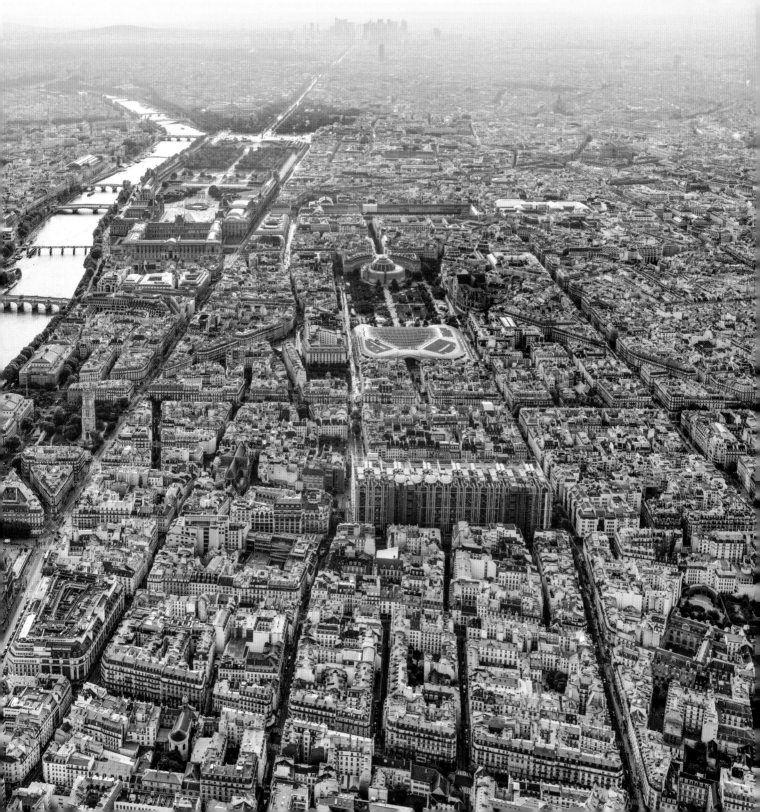

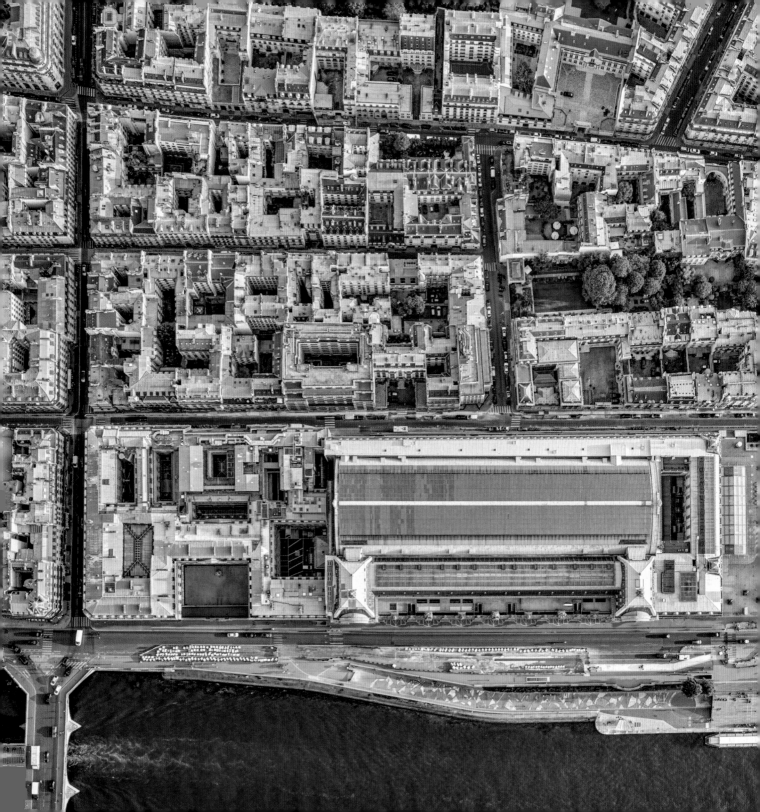

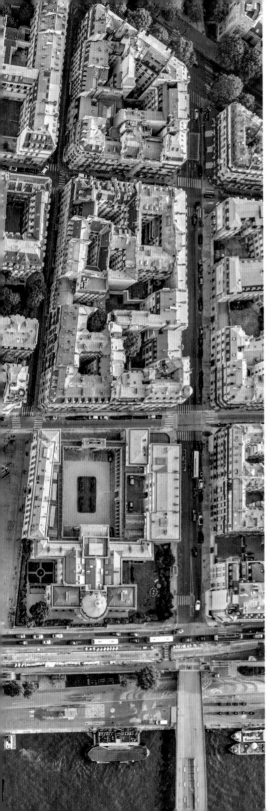

 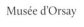

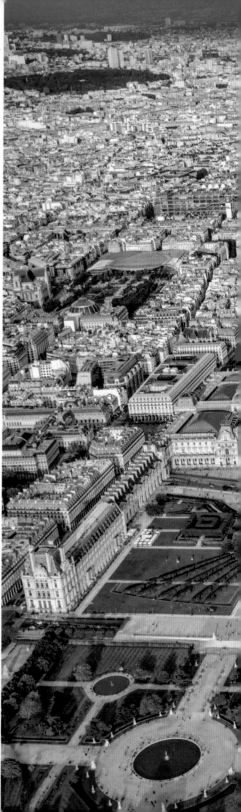

90 Looking east along the Seine, past the Louvre toward
Île de la Cité and Île Saint-Louis

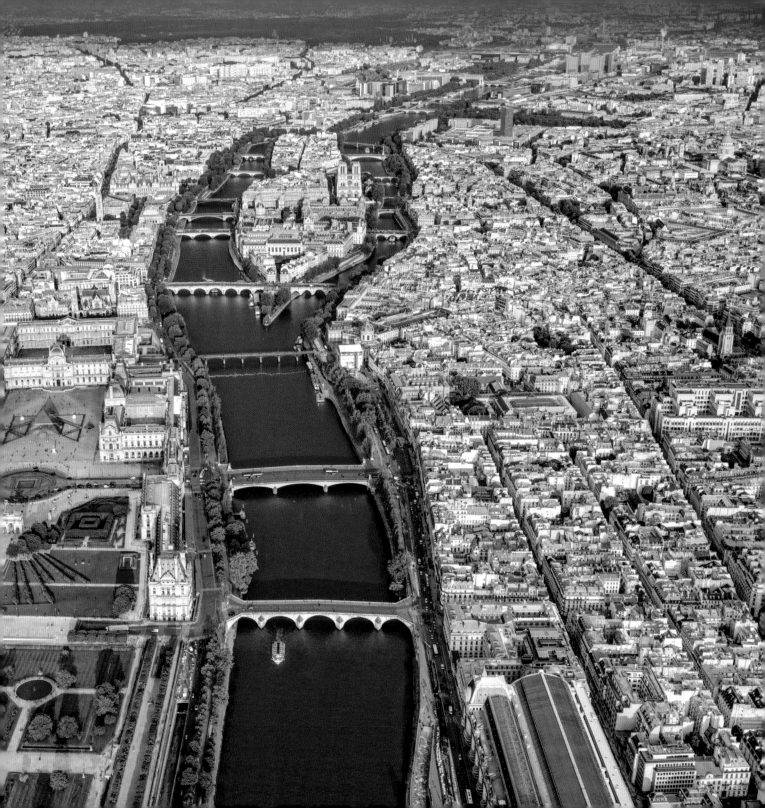

Opposite: Sorbonne Université, Jussieu Campus | **94–95:** Jussieu Campus, detail

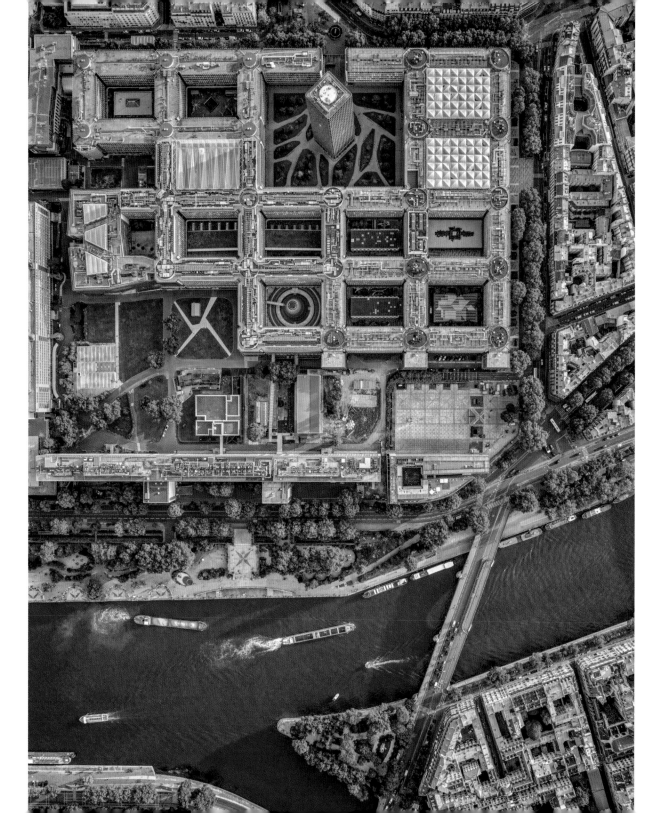

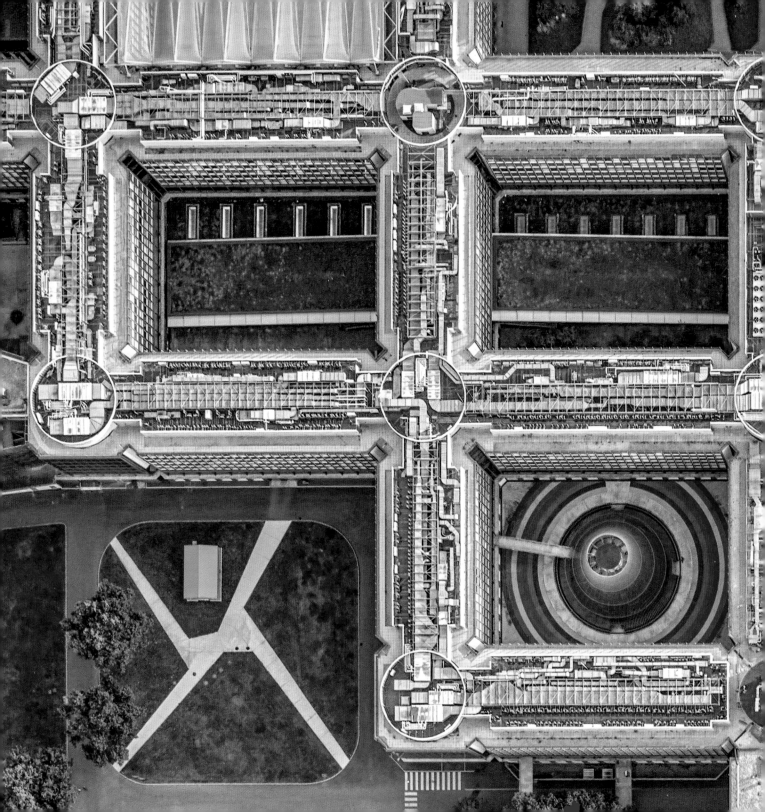

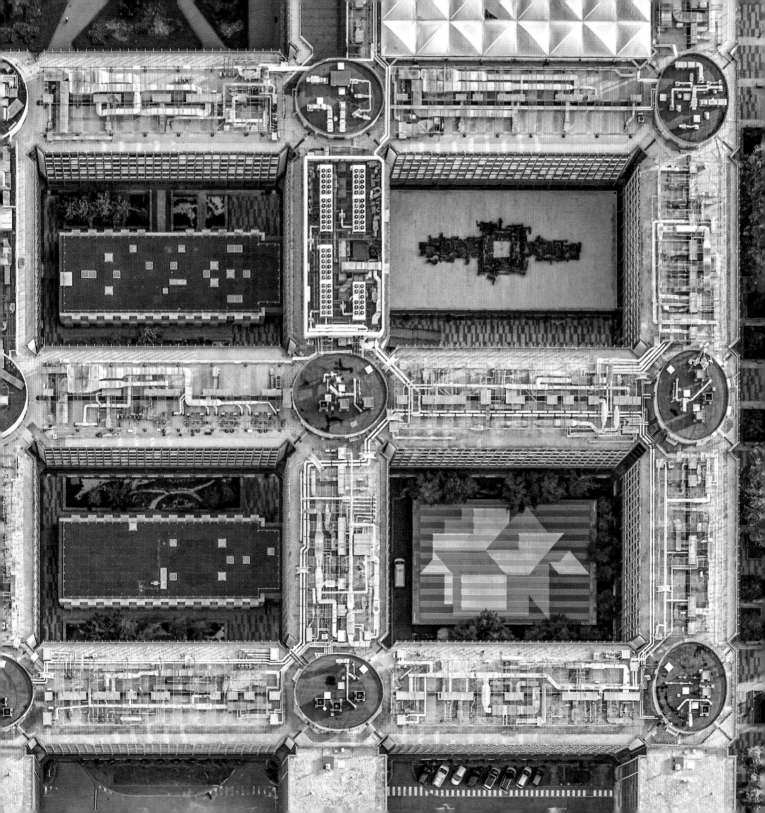

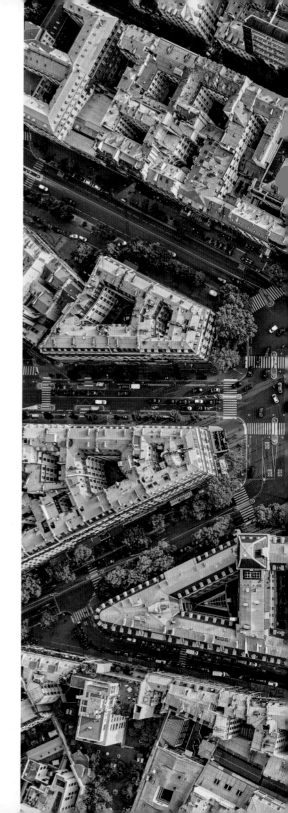

96 Place de la République

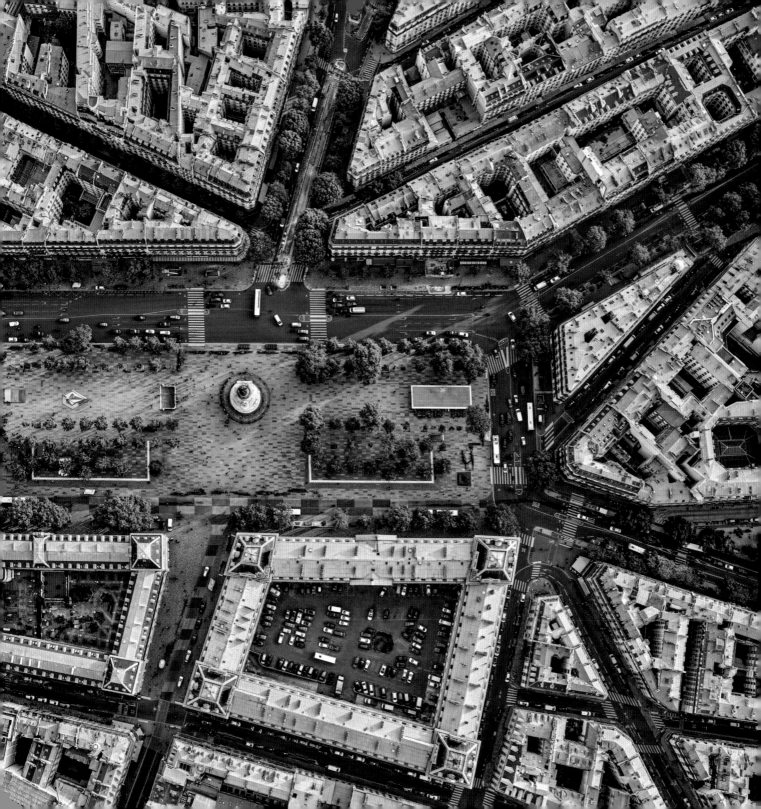

98　　　**Opposite and 100–101:** Palais et Jardin du Luxembourg

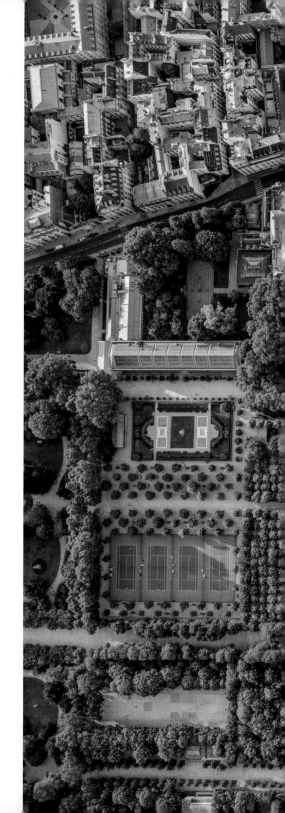

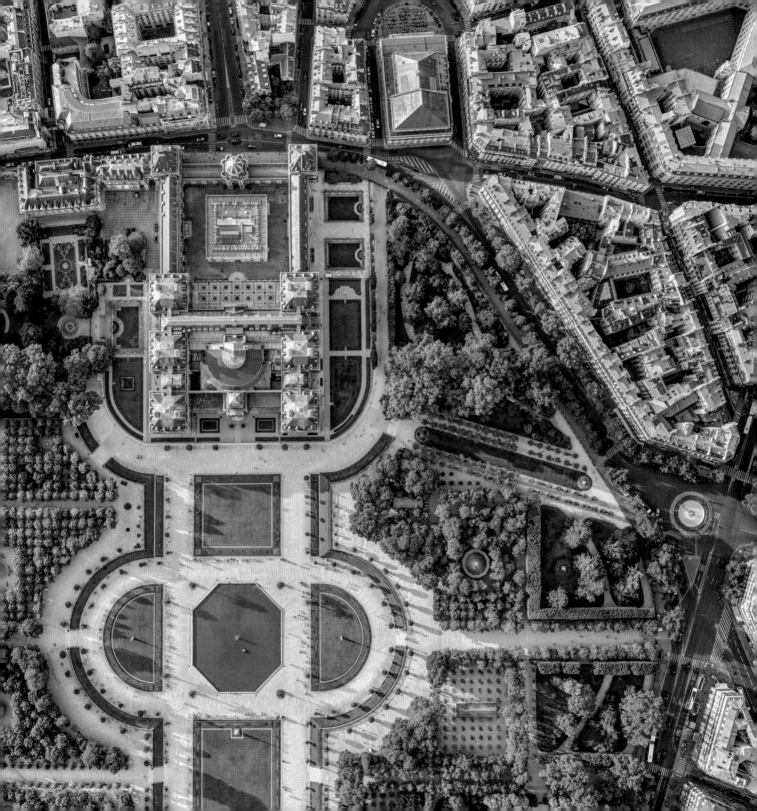

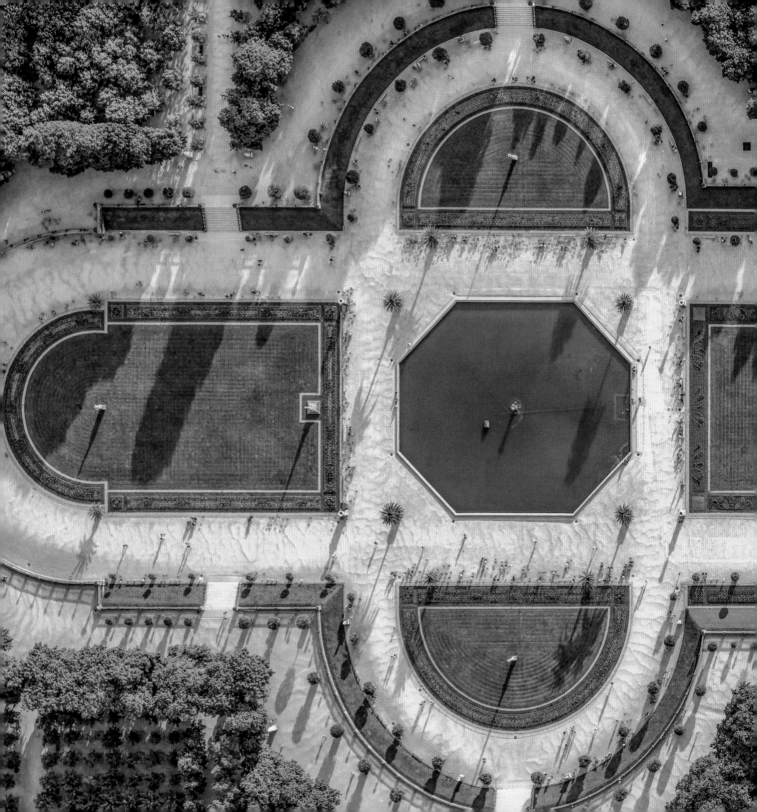

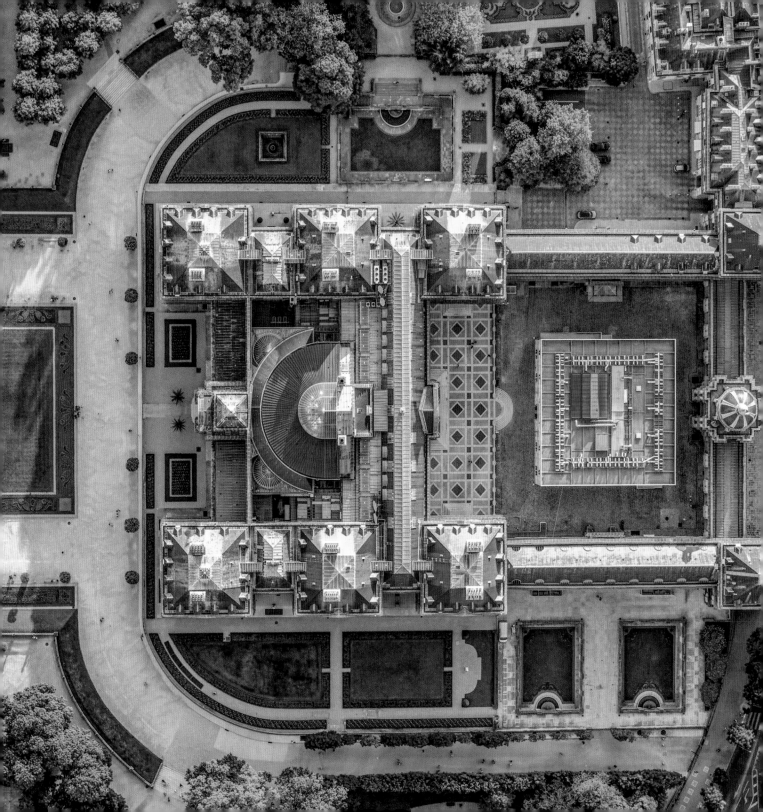

102 **Opposite:** Parc de Saint-Cloud | **104–105:** Basilique du Sacré-Coeur

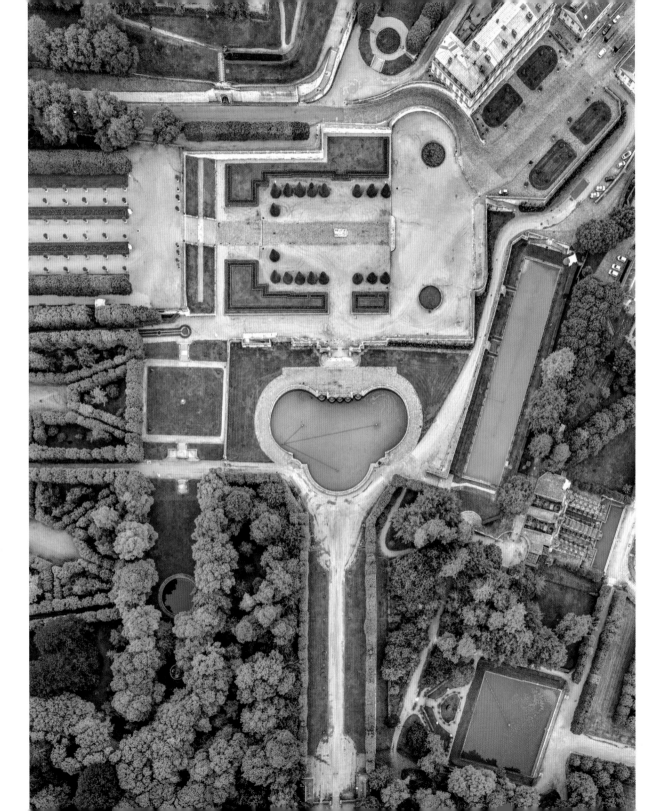

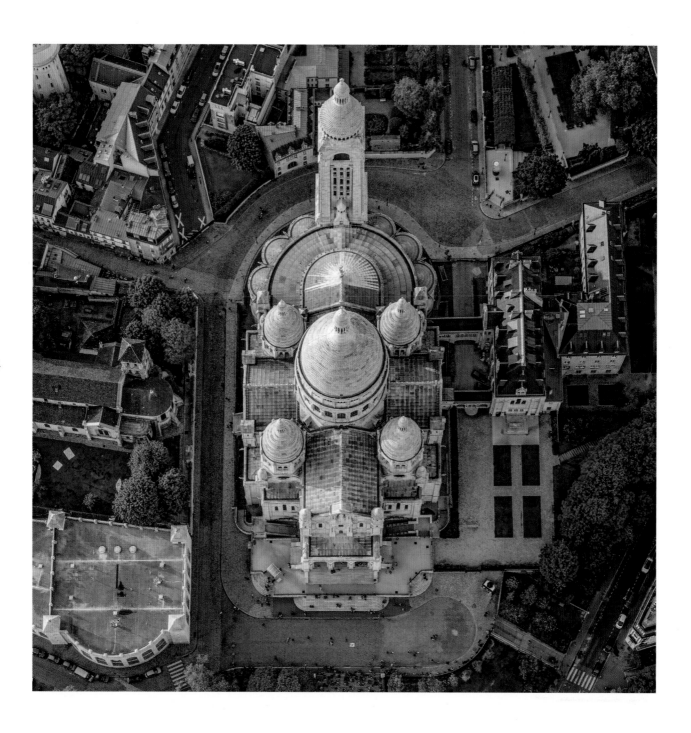

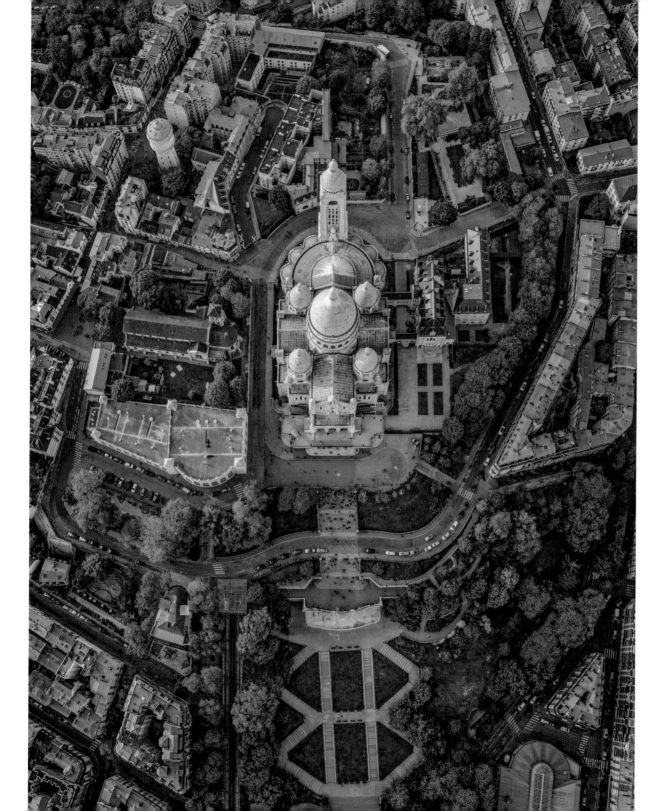

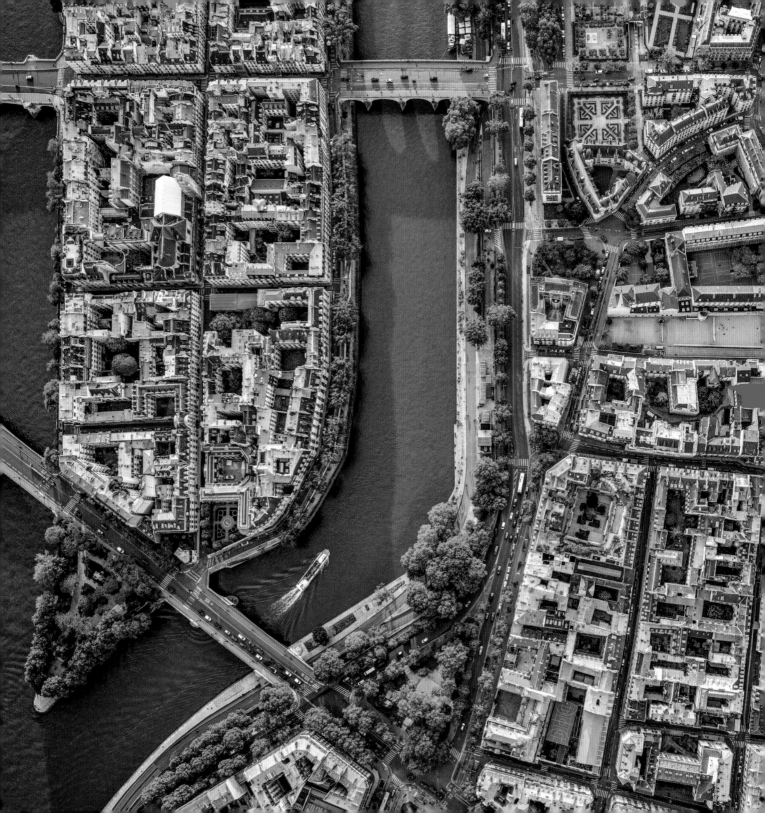

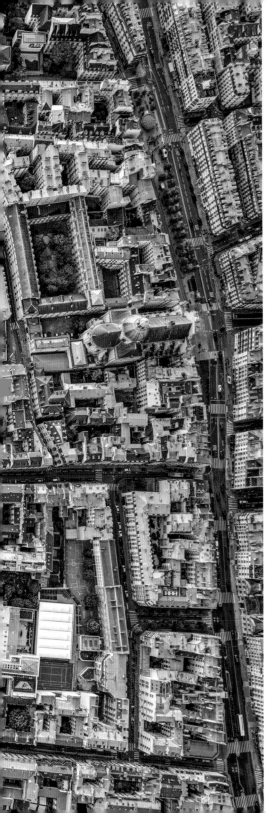

Opposite: Île Saint-Louis and part of the 4th arrondissement 107
108–109: Île Saint-Louis (left) and detail (right)

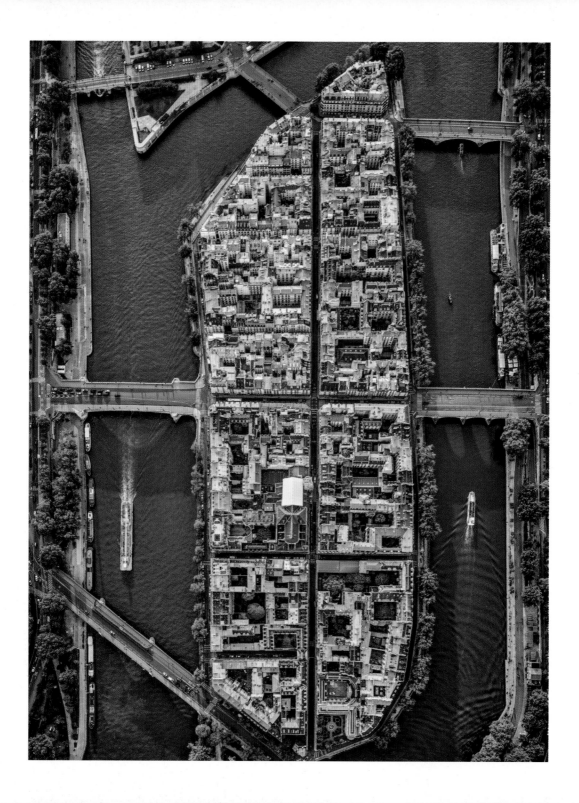

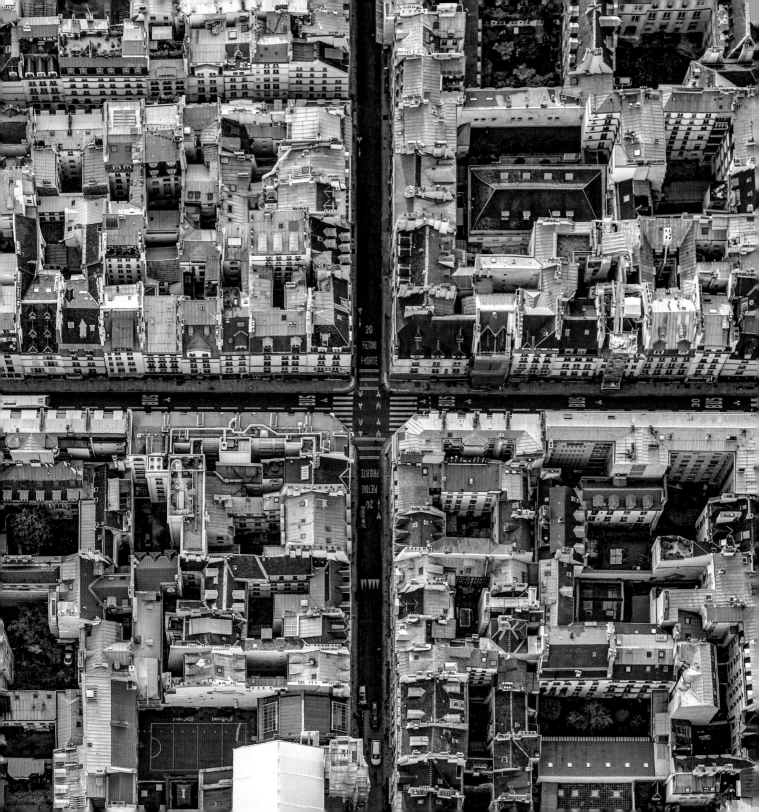

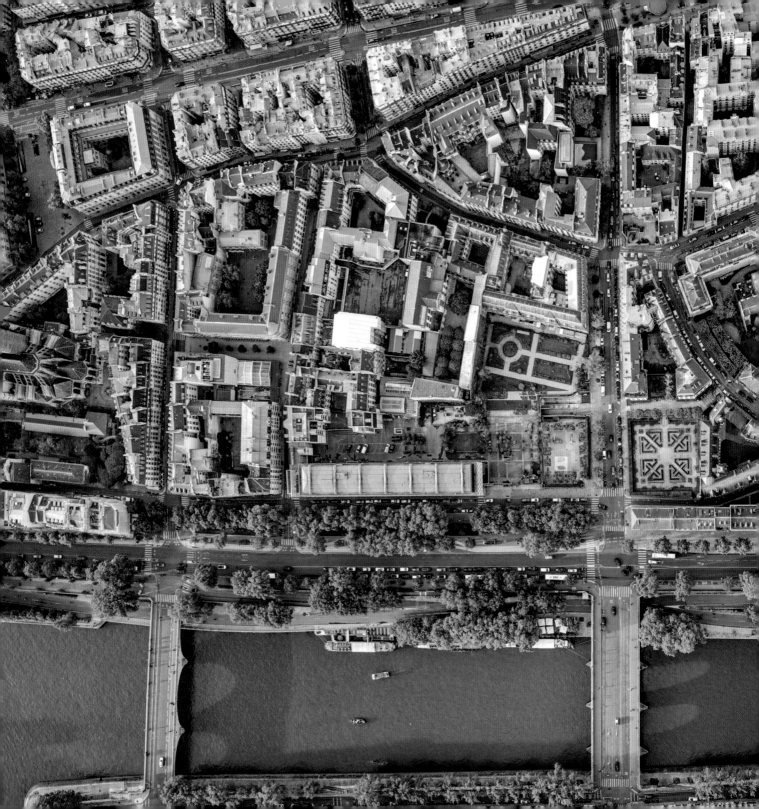

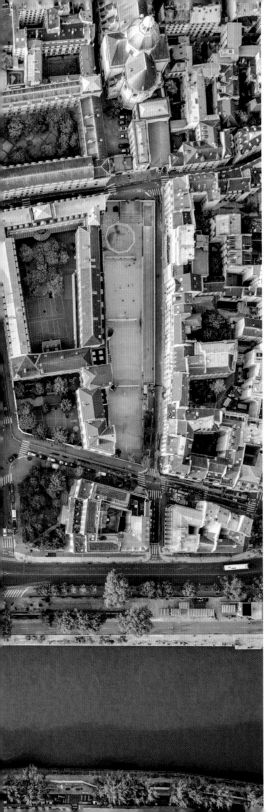

Opposite: Le Marais, 4th arrondissement | **112:** Le Marais, detail **111**
113: Les Archives Nationales, bottom

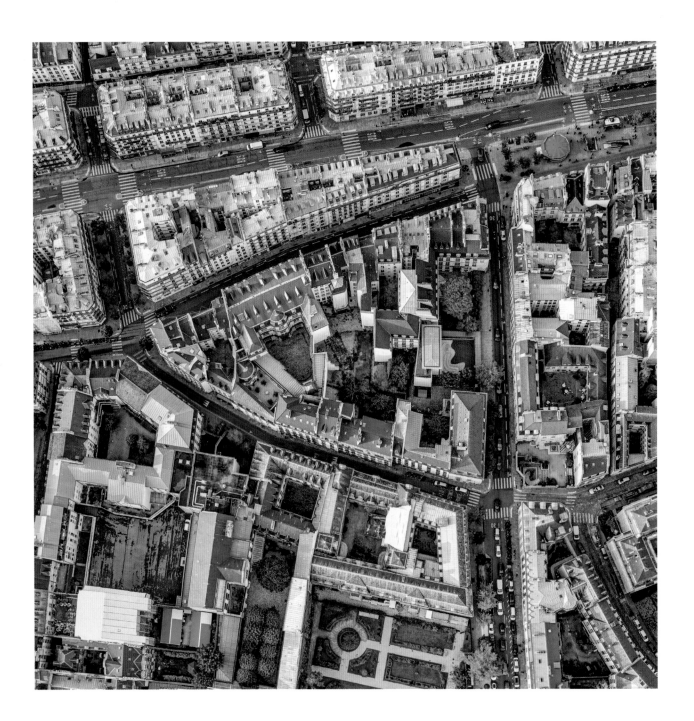

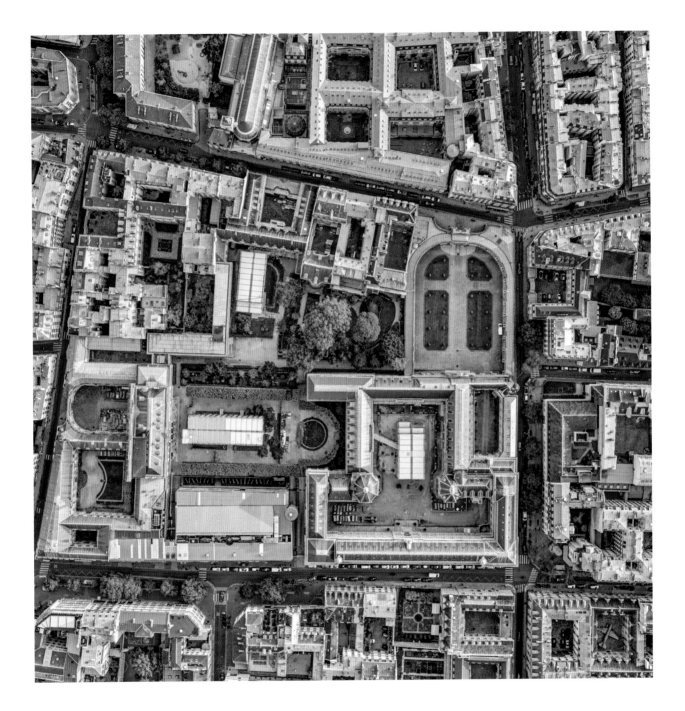

114 Le Marais, 3rd arrondissement

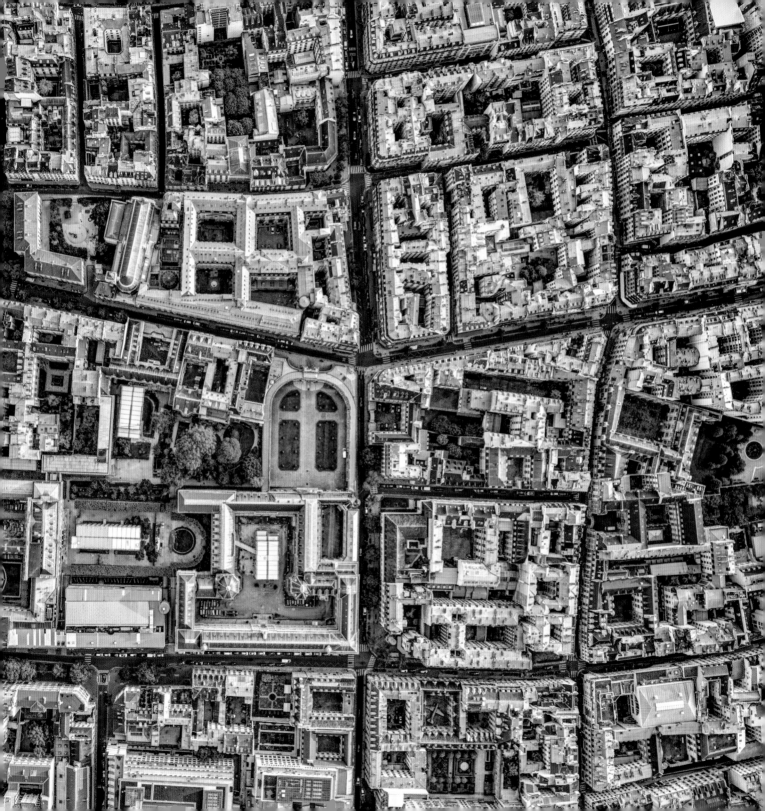

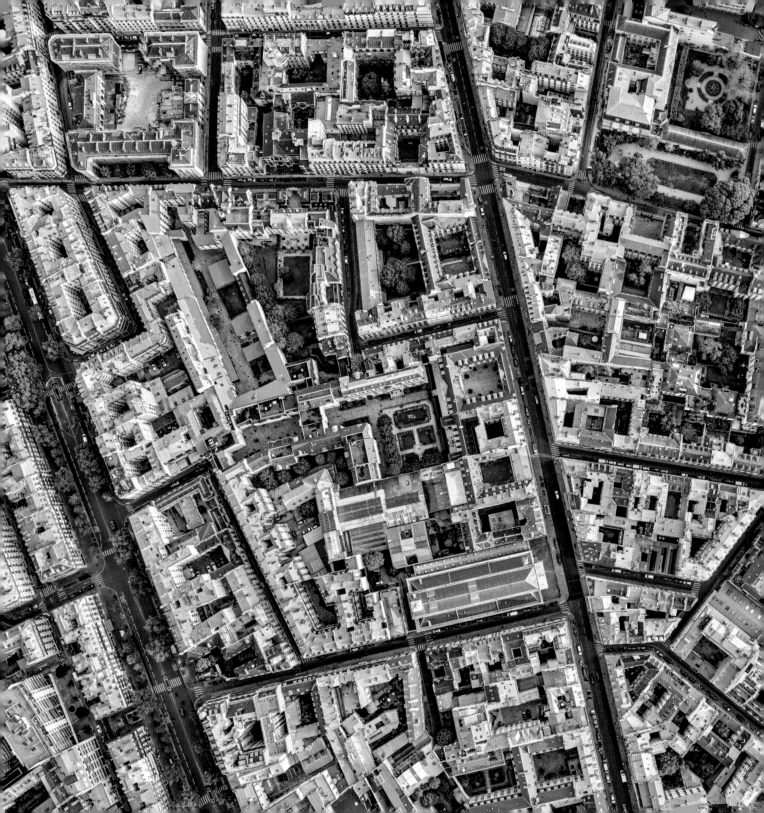

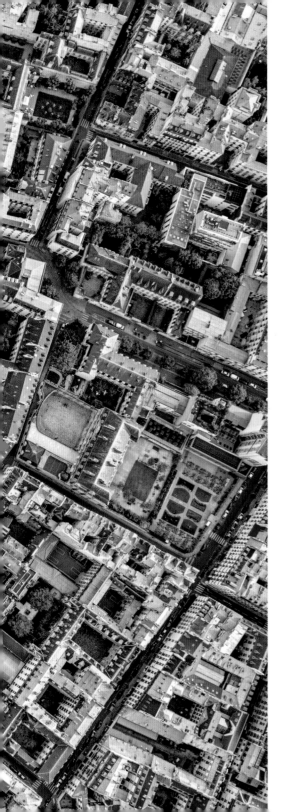

Opposite: 3rd arrondissement, with Boulevard Beaumarchais at left
118: Quartier de Chaillot, close-up of Hotel Peninsula with replica of L'Oiseau
Blanc airplane hanging in the courtyard | 119: Avenue Kléber at left

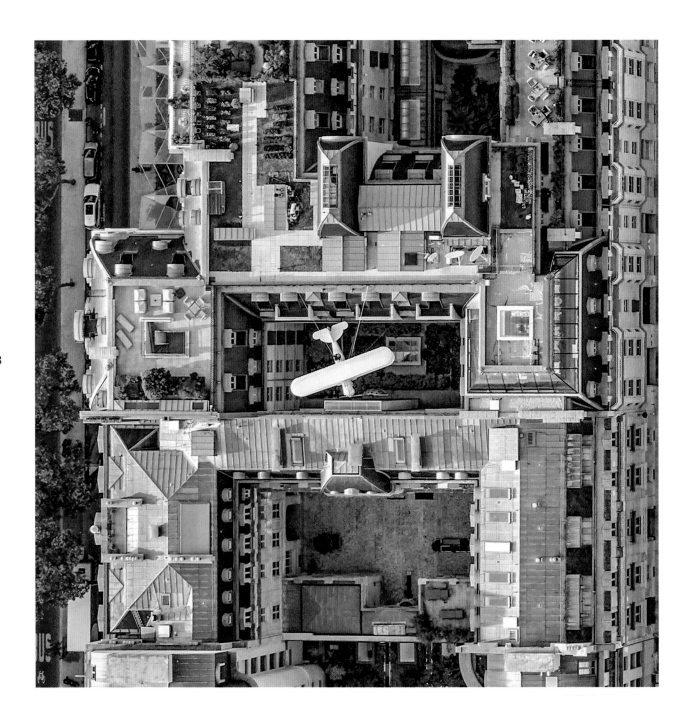

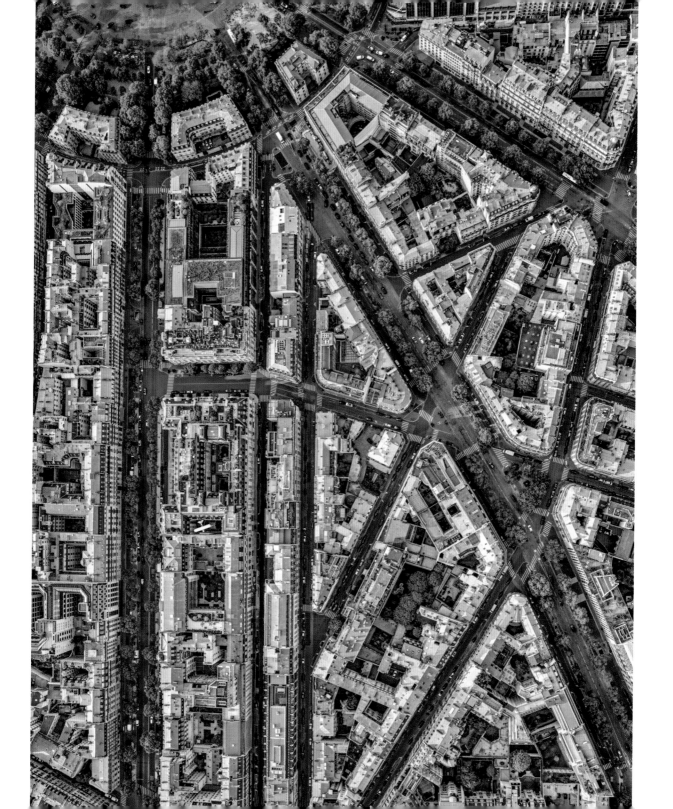

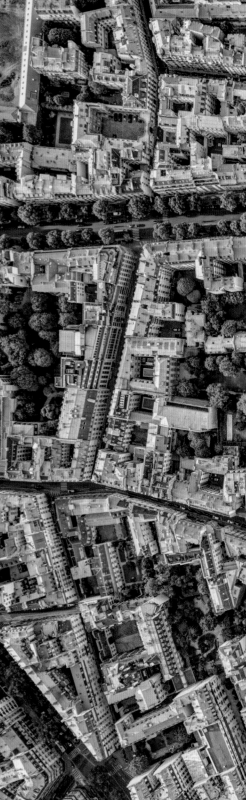

120 6th arrondissement, Saint-Germain-des-Prés, with Rue de Rennes intersecting Boulevard Saint-Germain at top

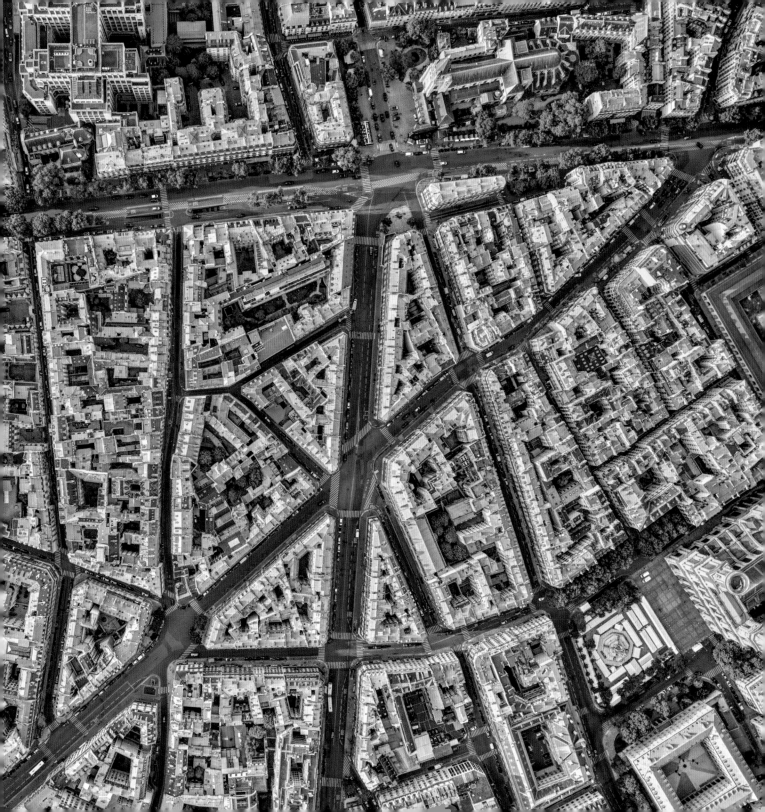

122 Le Panthéon, with Bibliothèques Sainte-Geneviève and Sainte-Barbe opposite

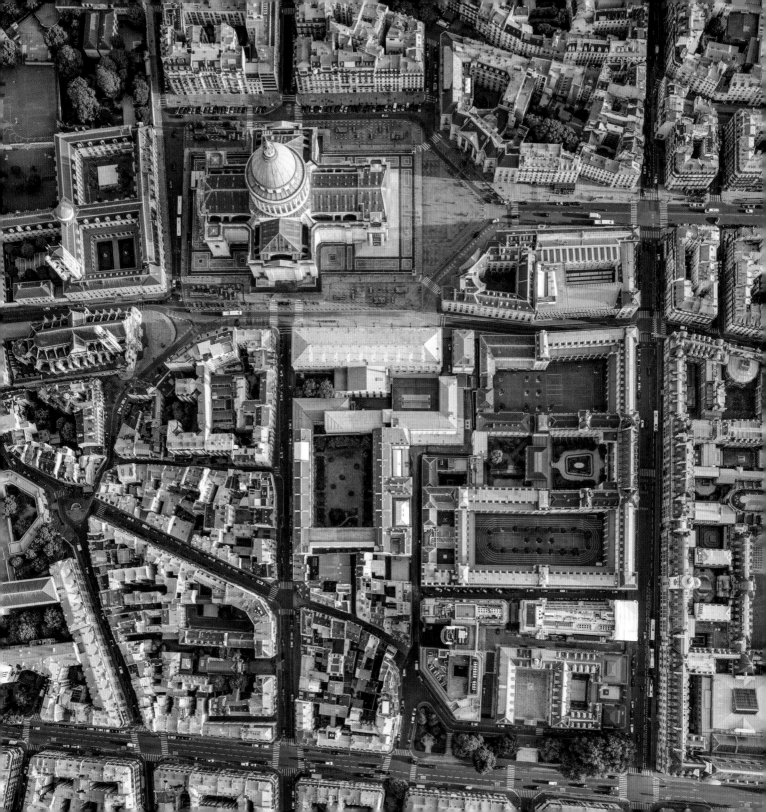

124 **Opposite:** La Défense, looking southeast through the Grande Arche toward central Paris | **126:** Skyscraper Tour D2 at La Défense
127: Grande Arche at La Défense

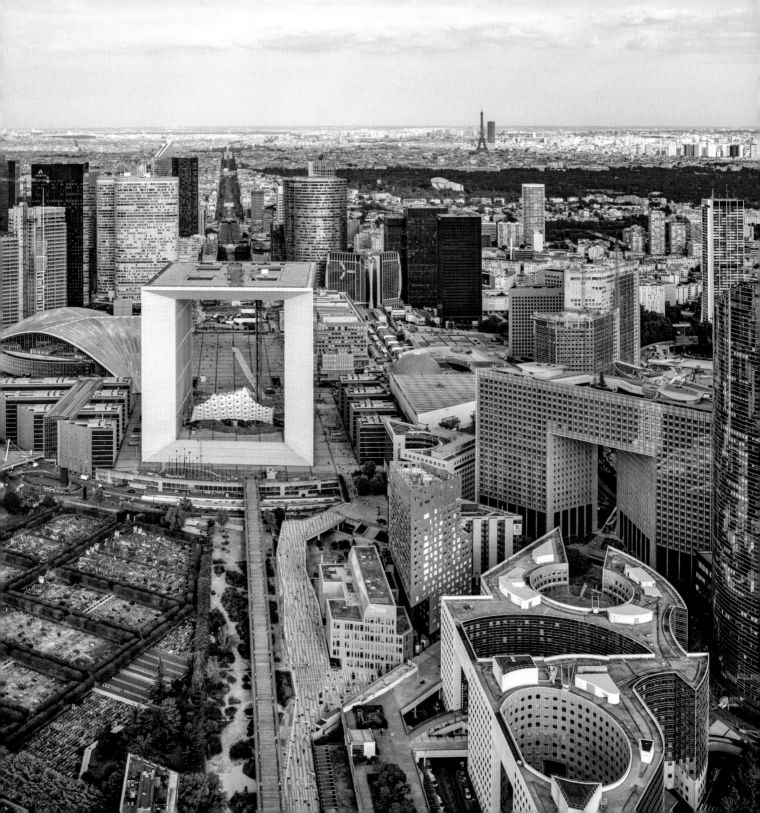

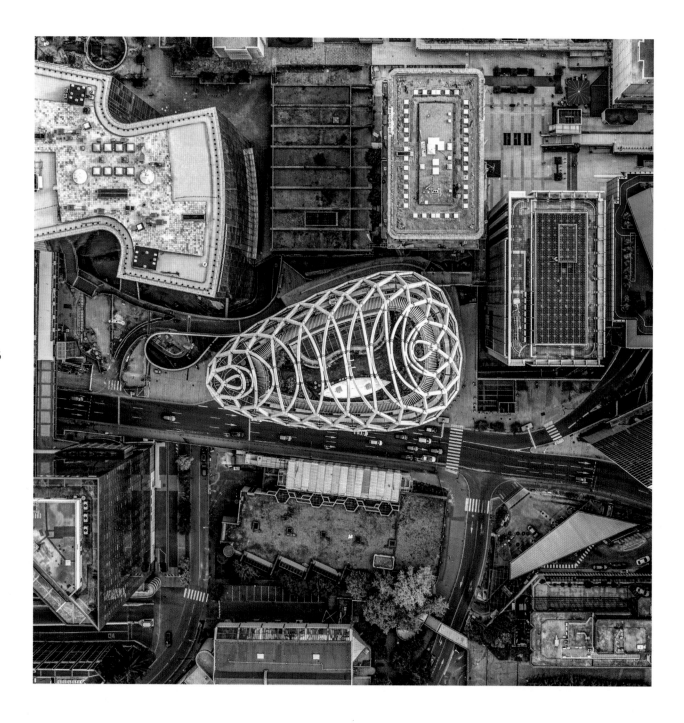

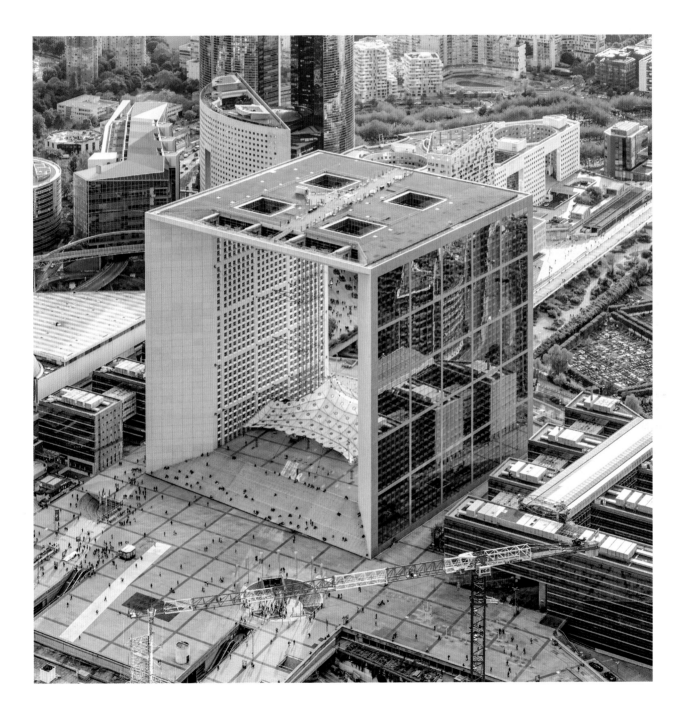

128 Skyscrapers of La Défense

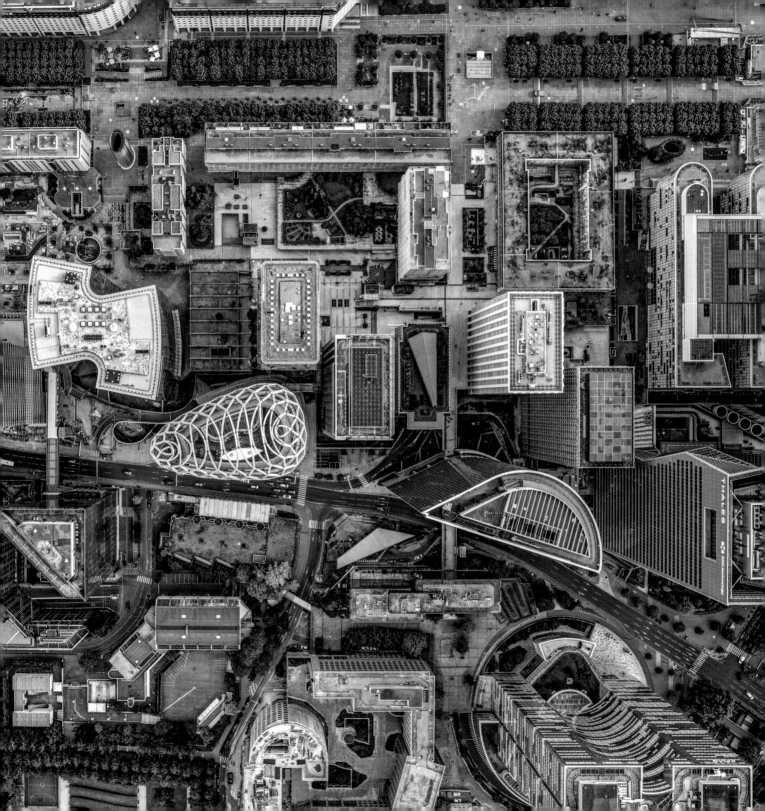

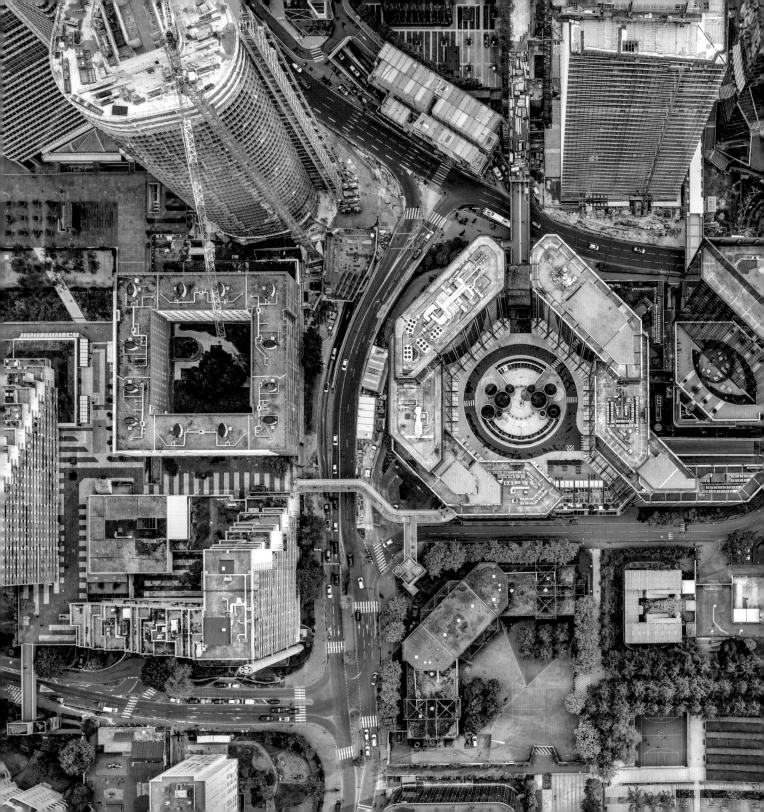

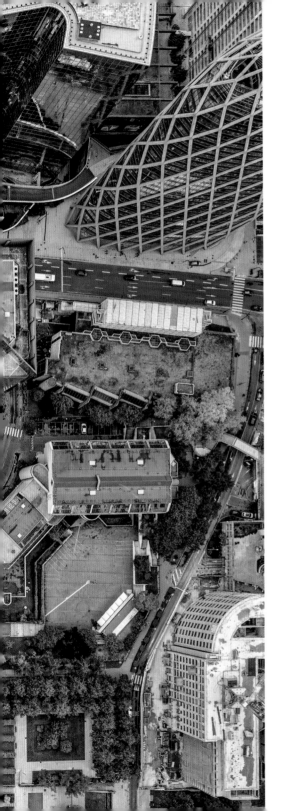

Opposite: Skyscrapers of La Défense | **132:** Cimetière de Puteaux at La Défense
133: Pont de Sèvres, with GE Renewable Energy headquarters

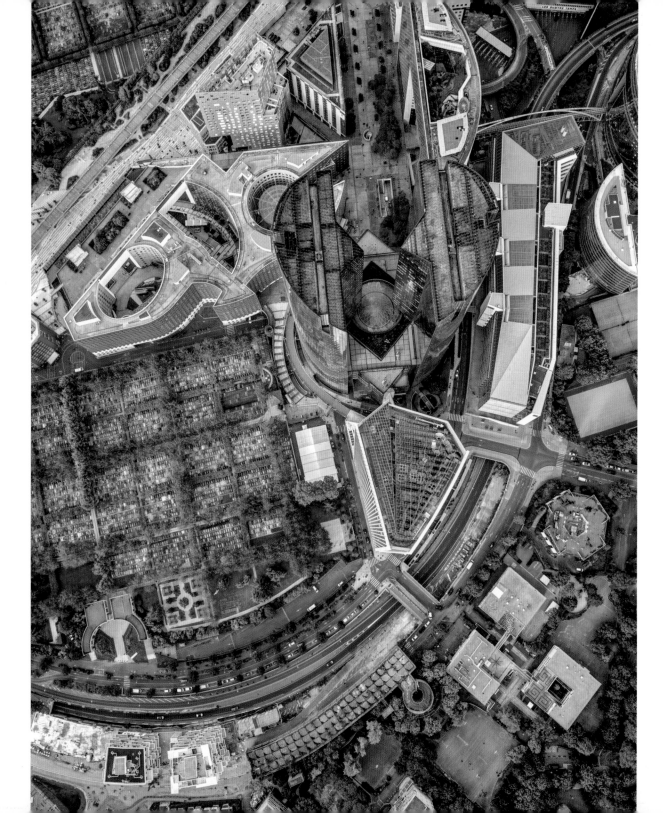

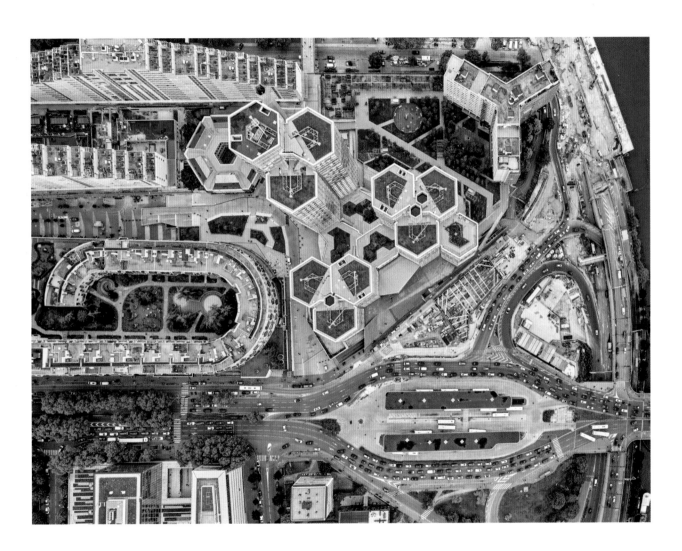

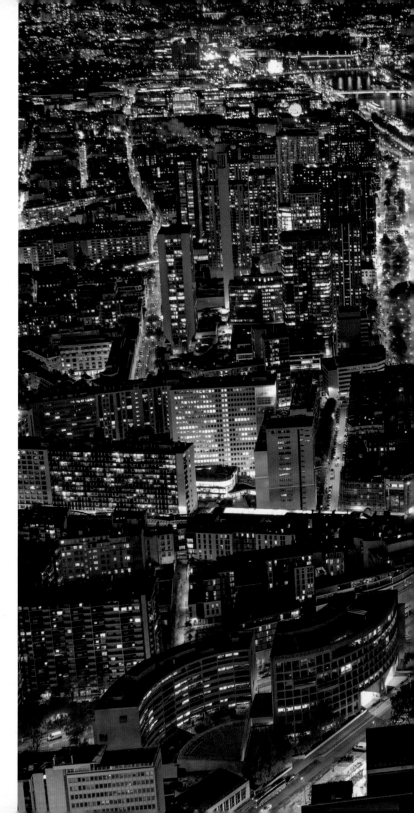

134 Looking southwest over the Seine at night
from above the Tour Eiffel

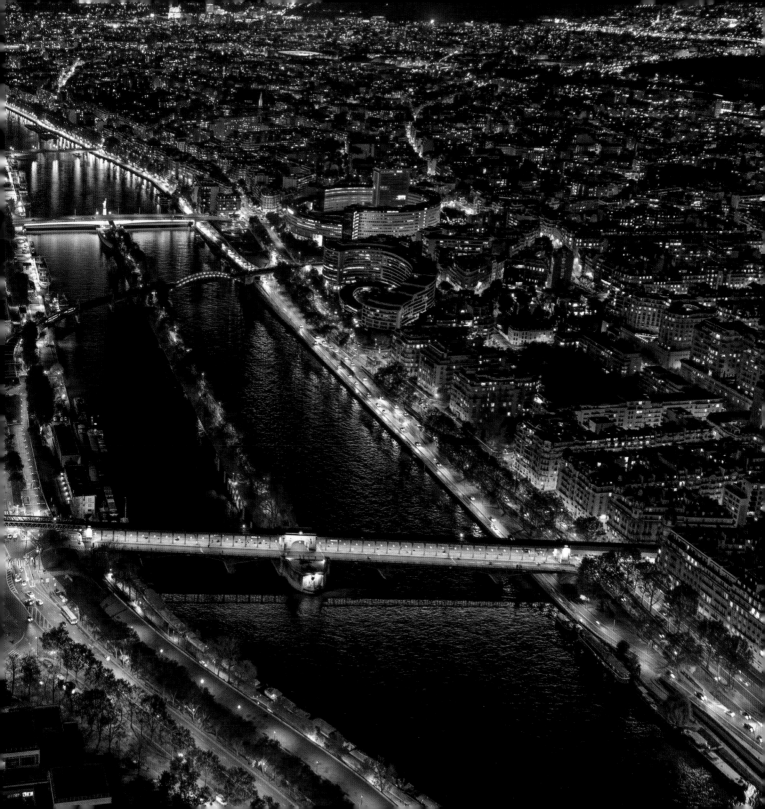

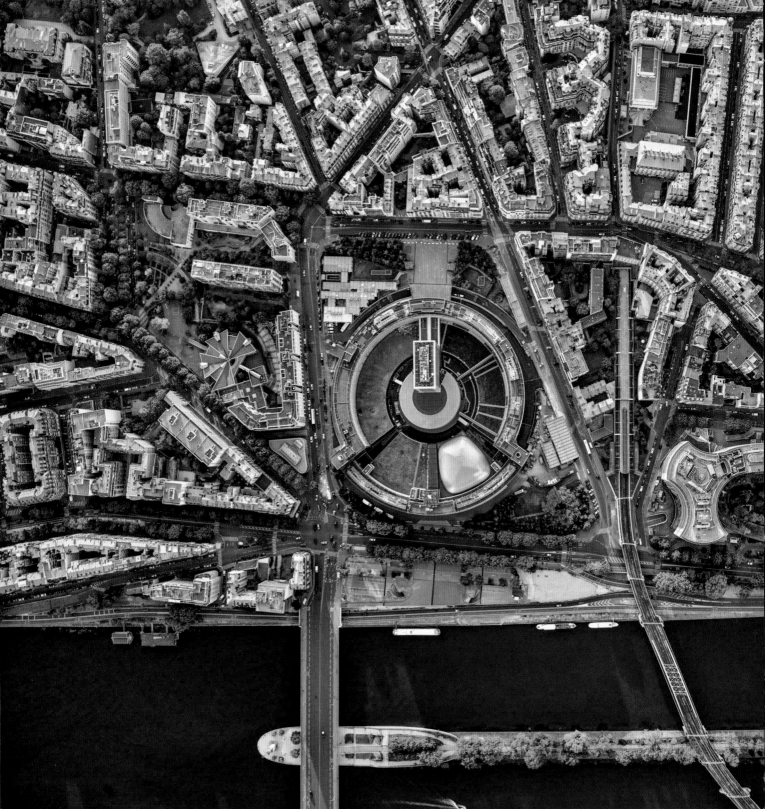

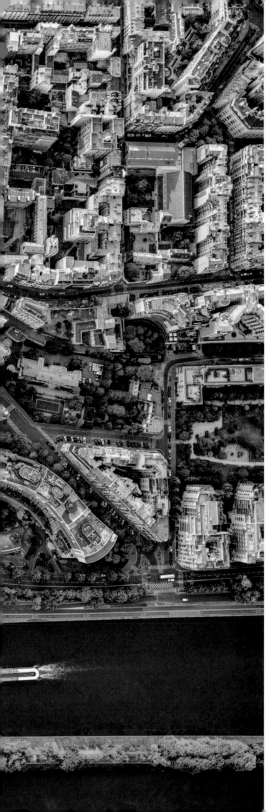

16th arrondissement, Maison de la Radio (Radio France headquarters) 137

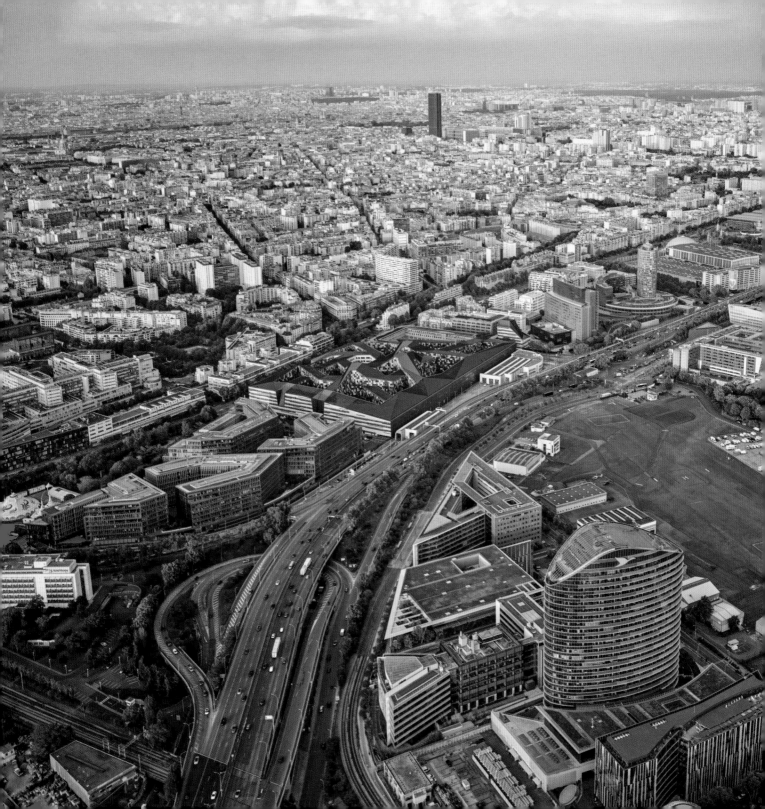

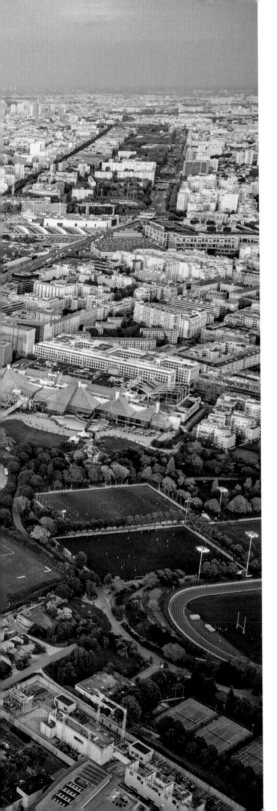

Looking east over Issy-les-Moulineaux Héliport toward Tour Montparnasse 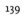 139

140 **Opposite:** Aquaboulevard water park | **142–143:** Foire du Trône funfair

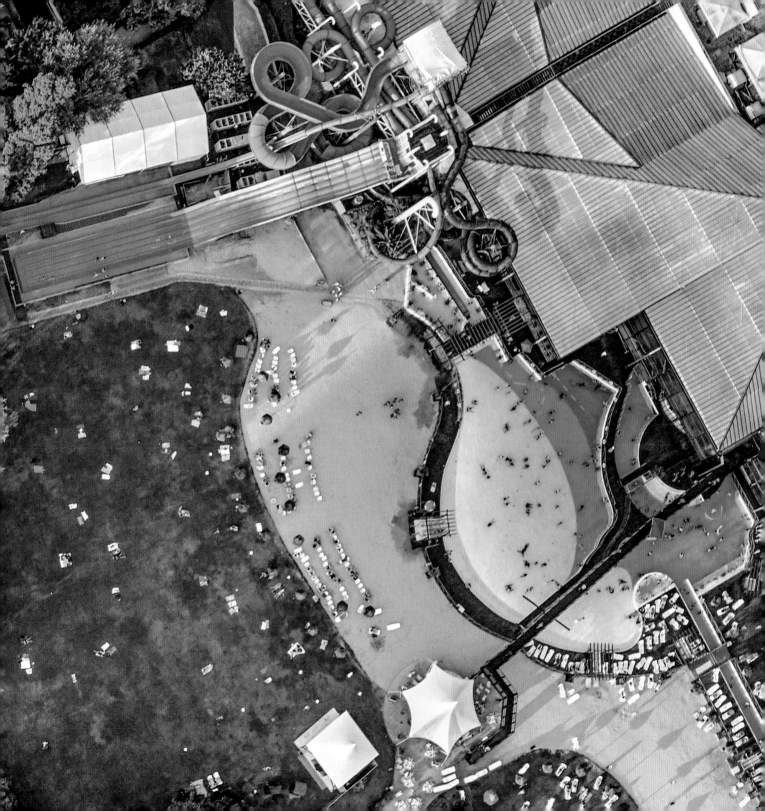

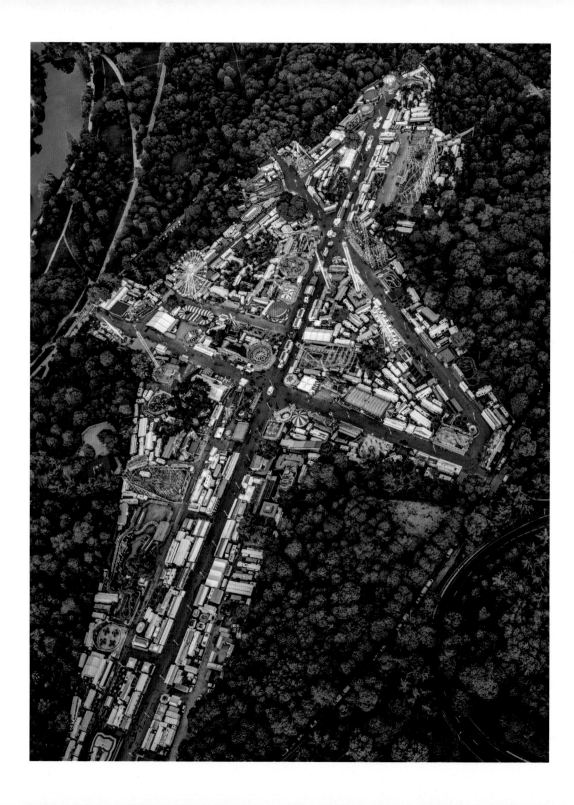

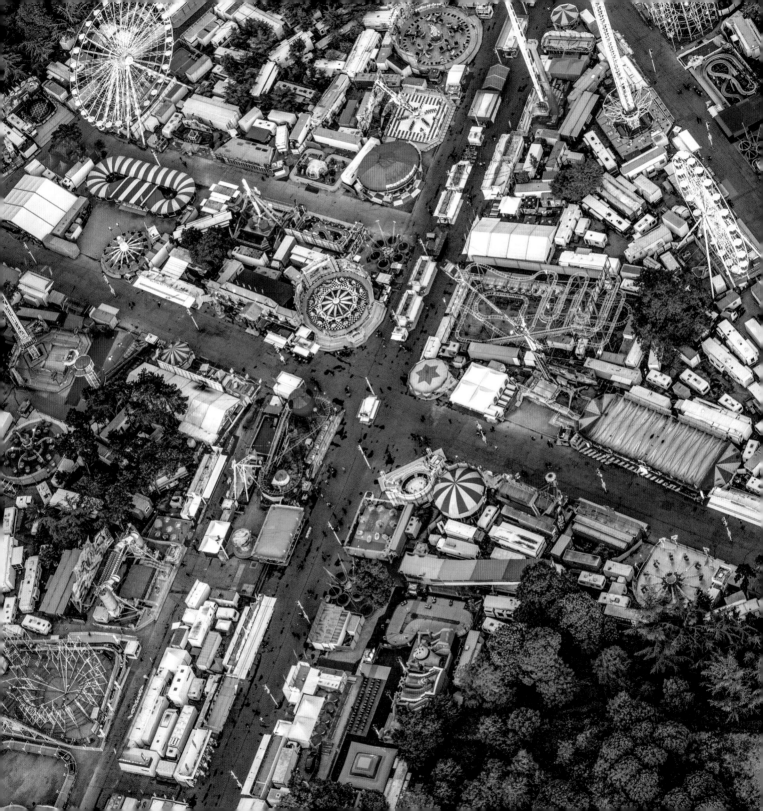

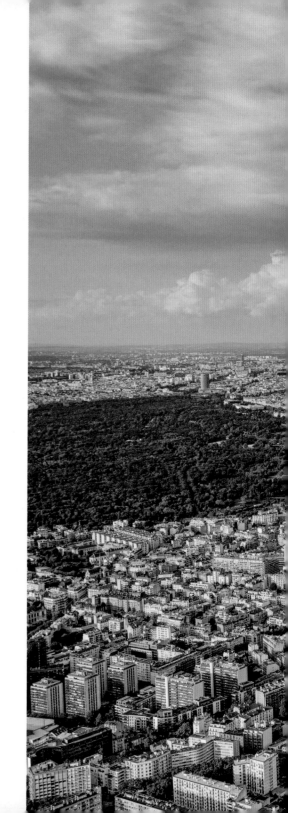

144 A corner of the Bois de Boulogne

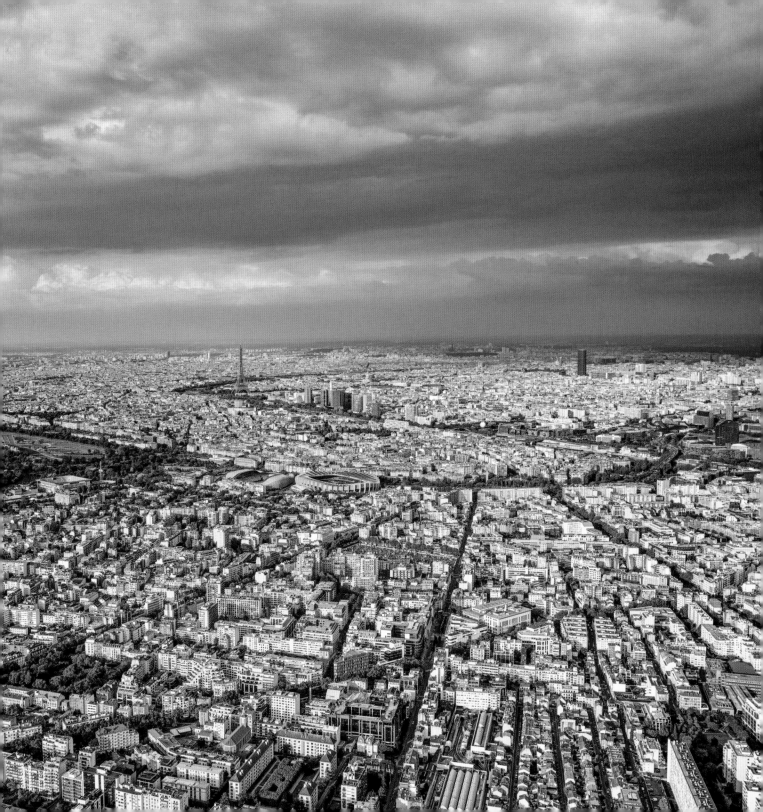

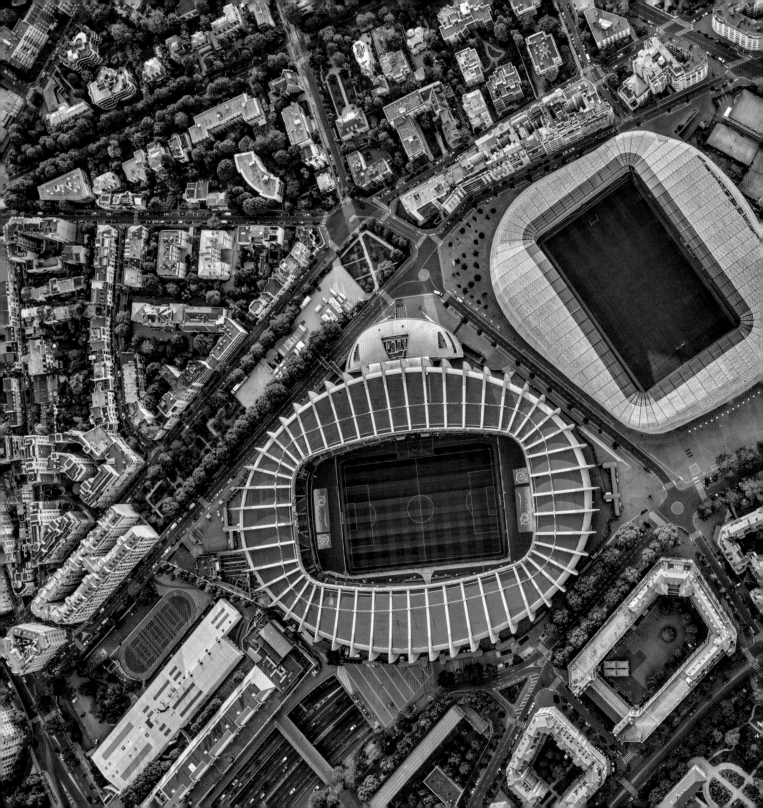

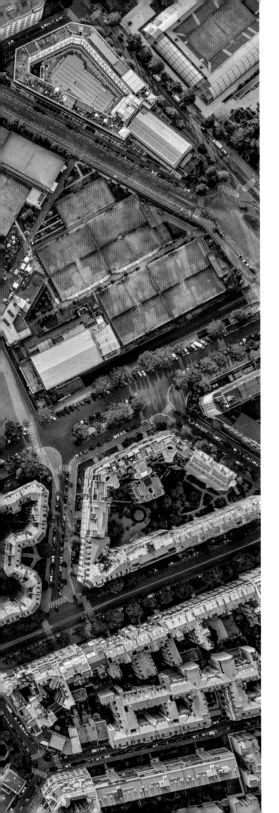

Le Parc des Princes soccer stadium at left and Stade Jean-Bouin at right　　**147**

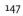

148 Place du Trocadéro and Palais de Chaillot

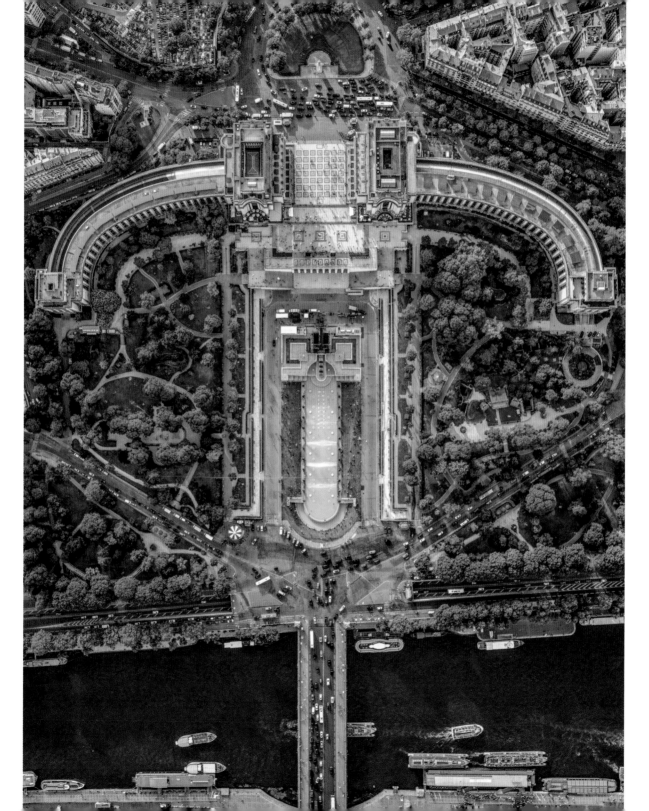

150 Palais de Chaillot at night

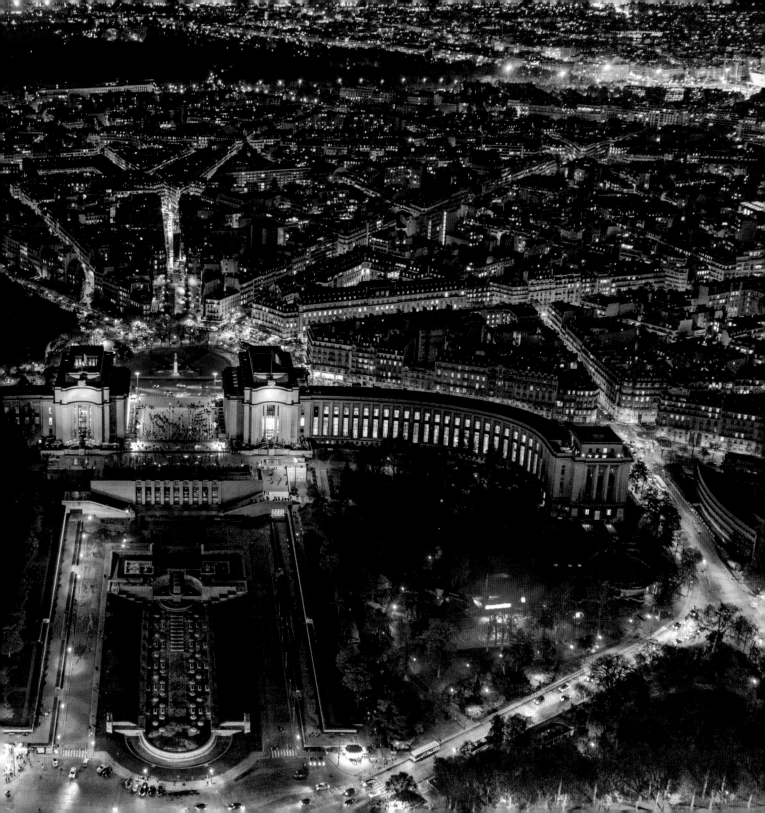

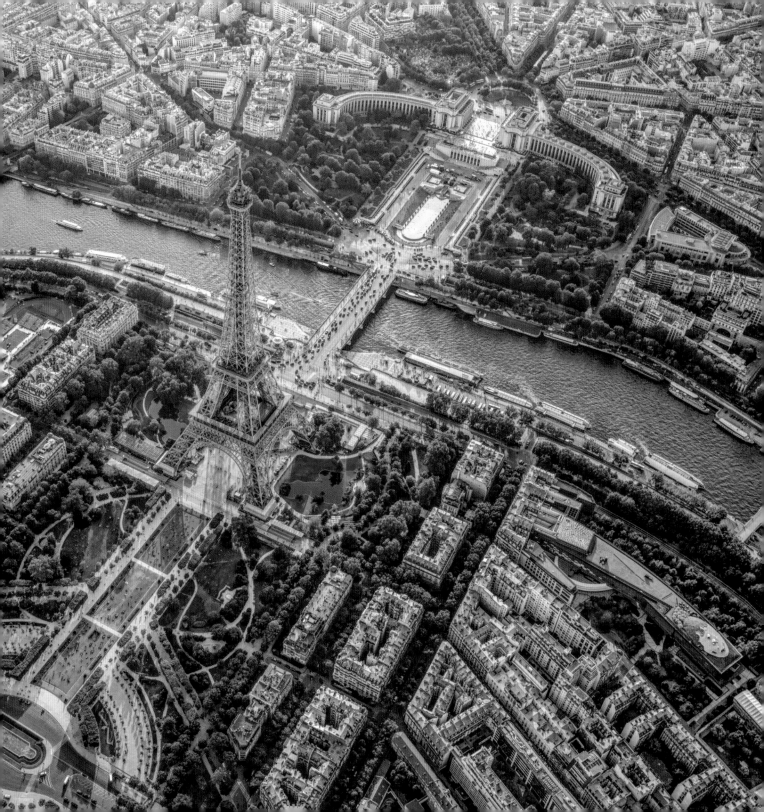

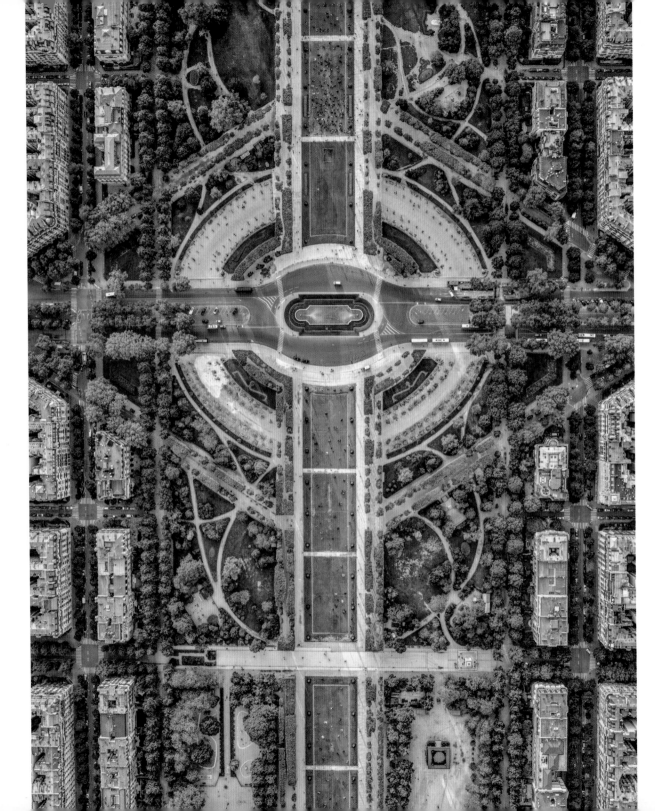

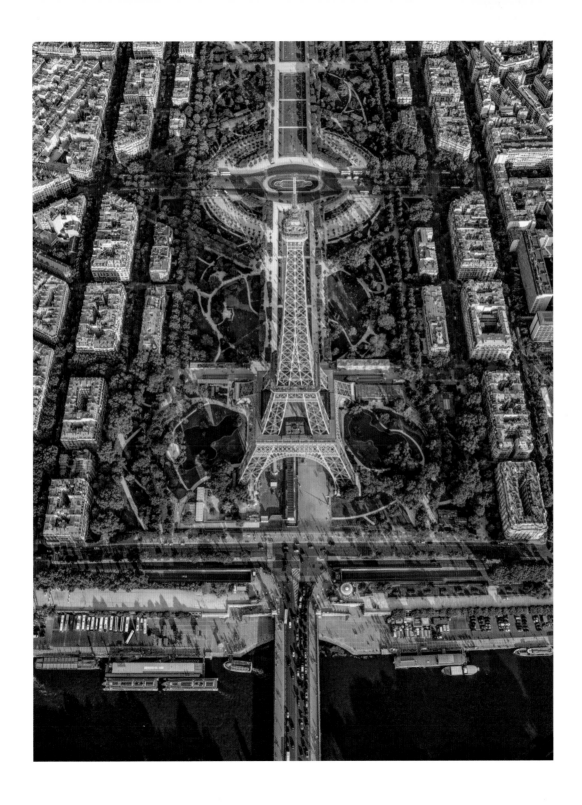

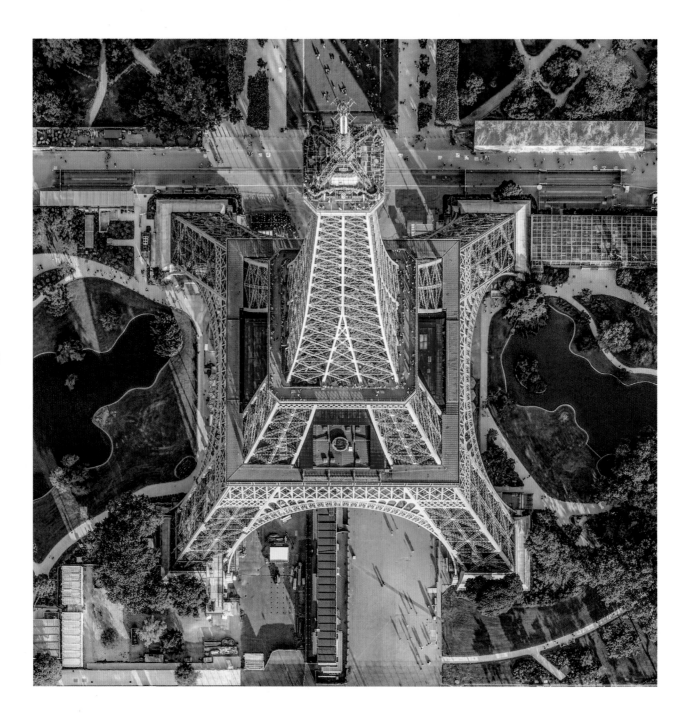

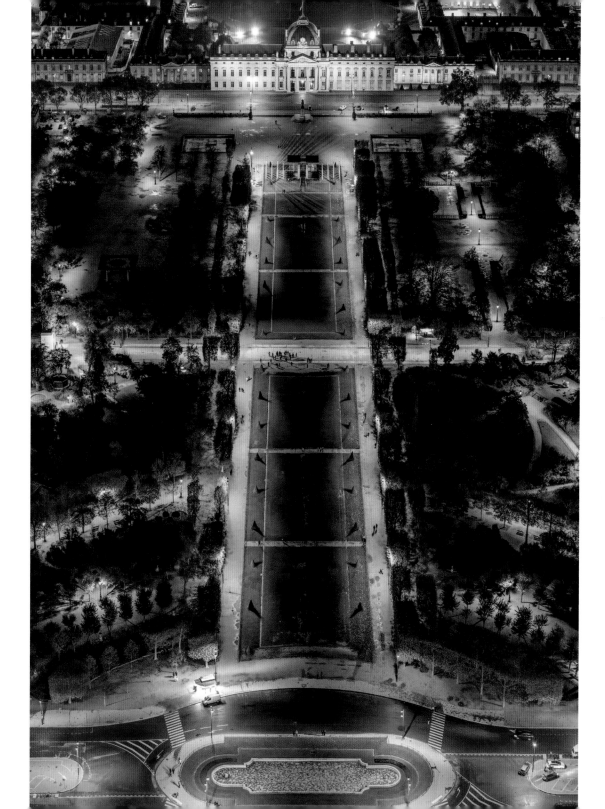

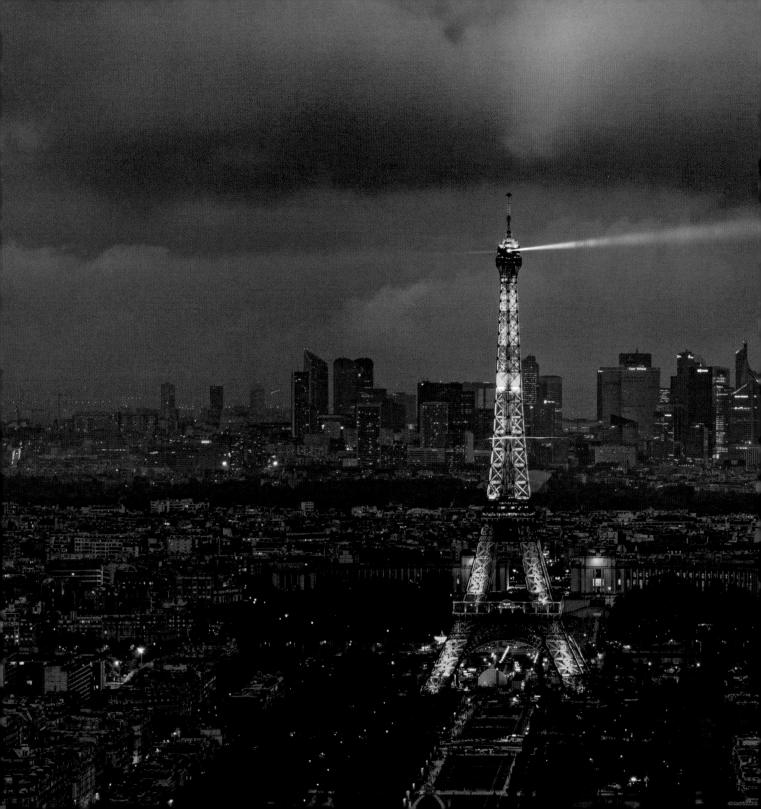

156: Tour Eiffel | **157:** École Militaire 159
Opposite: Looking northwest toward La Défense

PARIS-CHARLES DE GAULLE AIRPORT

The French have no fear of flying. Indeed, the first human ascents above the earth's surface were by a series of Parisian adventurers in hot air balloons, beginning in 1783. Later, paralleling the efforts of the Wright brothers in the United States, aviators in France were experimenting with fixed-wing, powered aircraft, and in 1909 the first flight across the English Channel was made by Louis Blériot. By the 1920s, French aircraft designers and pilots were ready to attempt a transatlantic crossing, but they were scooped by Charles Lindbergh, who flew solo from New York and landed at Le Bourget Airport some seven miles northeast of the city on May 21, 1927. Le Bourget, Paris's first airport, was opened in 1919 and succeeded in 1932 by Orly Airport, about eight miles south of the city.

French commercial aviation developed somewhat slowly, but in 1933, the government created Air France, which merged with the Dutch airline KLM and is based at France's largest airport, Charles de Gaulle (CDG). Opened in 1974 and still being enlarged, CDG served more than 76 million passengers in 2019.

Boarding gates of Terminal 2, Paris-Charles de Gaulle Airport

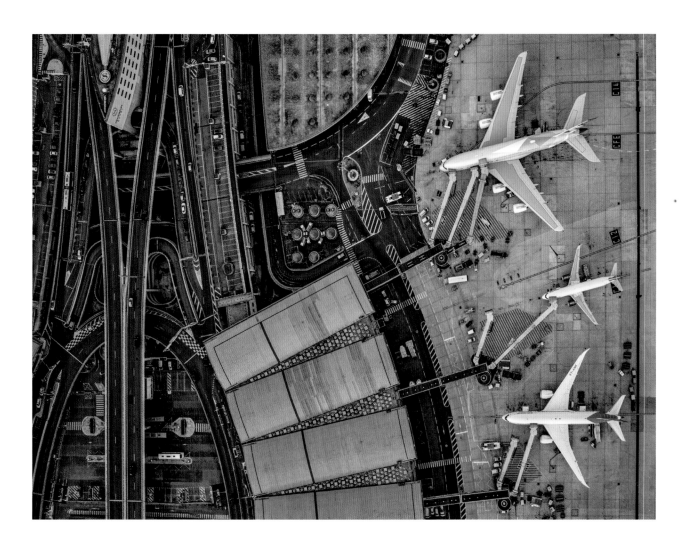

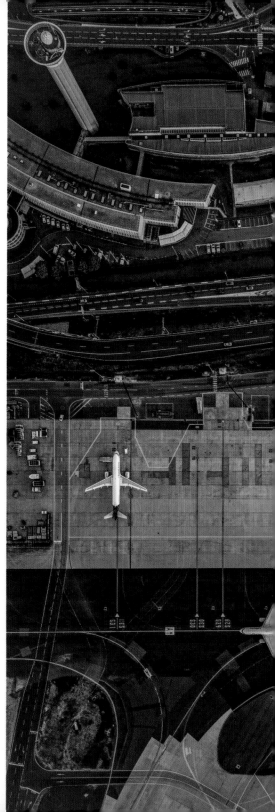

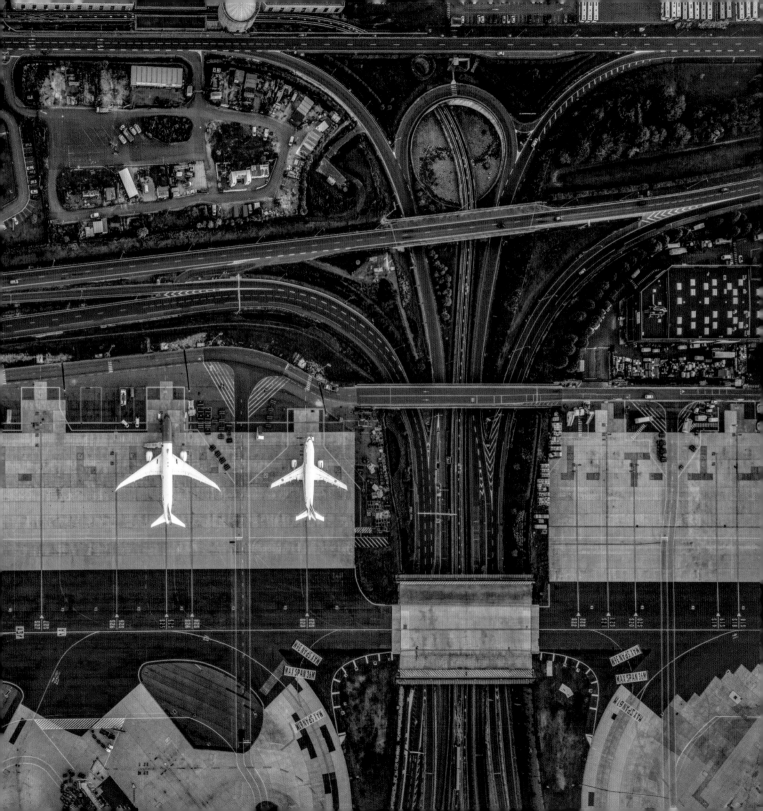

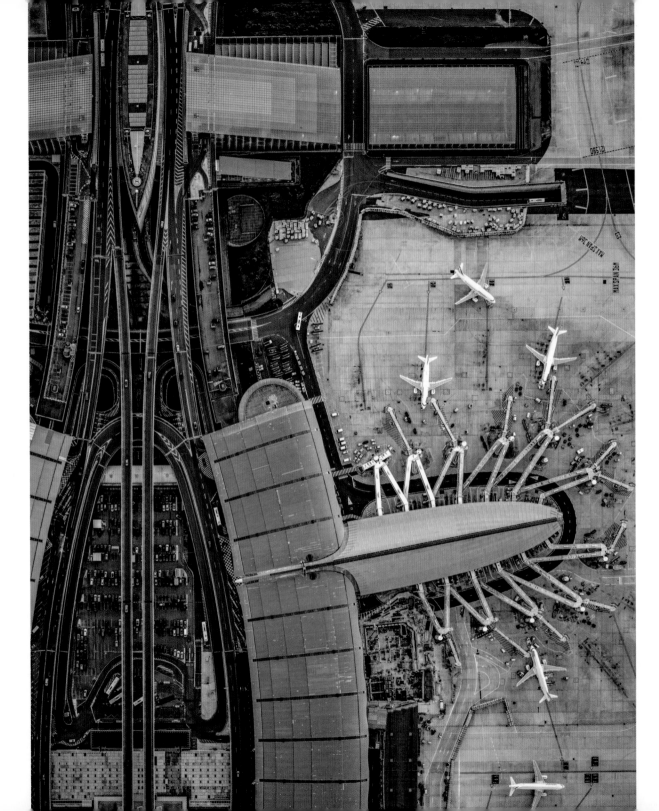

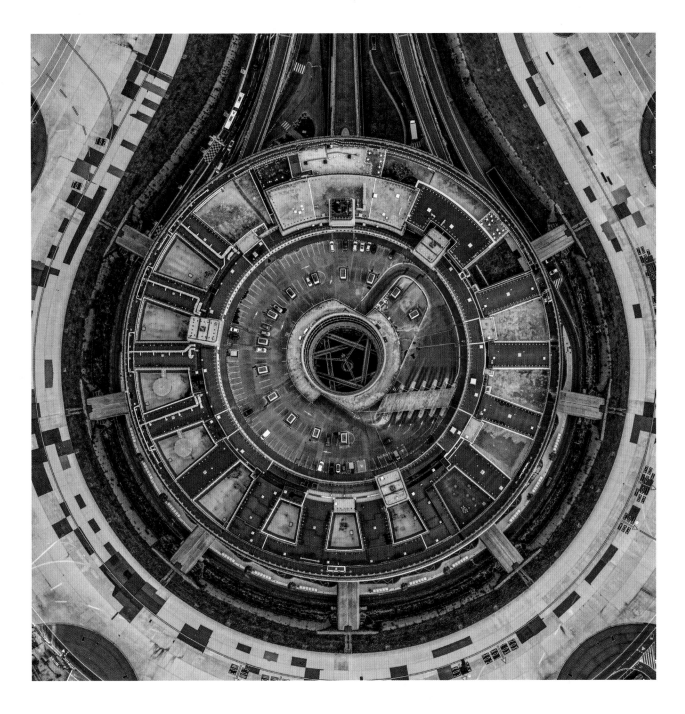

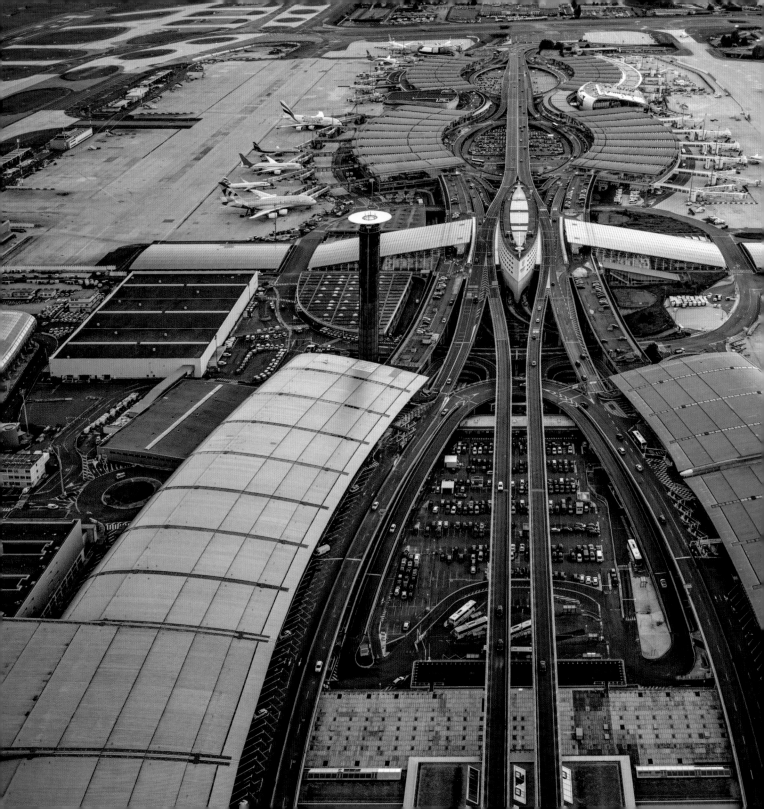

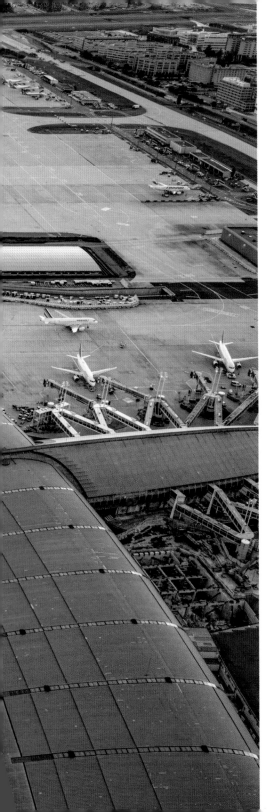

Terminal 2, Paris-Charles de Gaulle Airport

VERSAILLES

Louis XIV became king of France before he was five years old, but he was mostly neglected or ill as a child, shuffled from palace to palace in the crowded, dirty heart of Paris. He grew to hate the city and often longed for the wooded 10,000-acre property out at Versailles, where his father had converted a hunting lodge into a modest château. Soon after he took over the reins of government in 1661 at age 23, Louis demolished the town of Versailles and began to build a splendid palace with extensive gardens, fountains, and groves. In 1682, he moved the royal household—more than 5,000 people—to Versailles. Enlarged and embellished several times by Louis and his heirs, with a large chapel and an opera house, the palace grew to contain 2,300 rooms. After the Revolution in 1789, the royal family abandoned Versailles as a residence. In 1830 it was slated to become a museum of the history of France, but that idea failed, and in 1892 work began to restore it to its original splendor as the residence of the Sun King and his court, efforts that are largely complete.

Château de Versailles at dusk

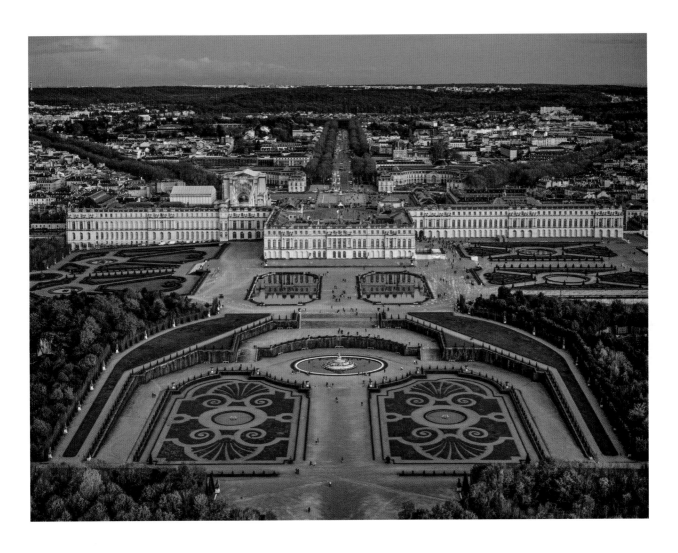

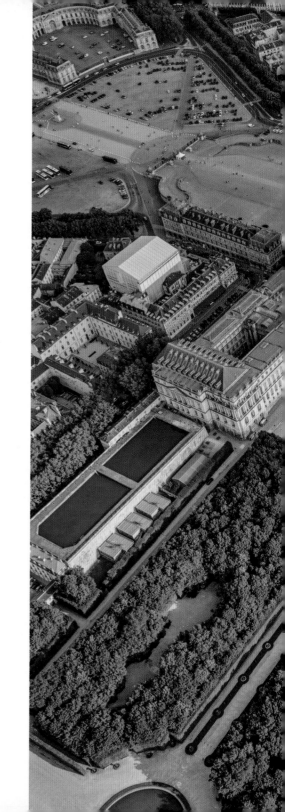

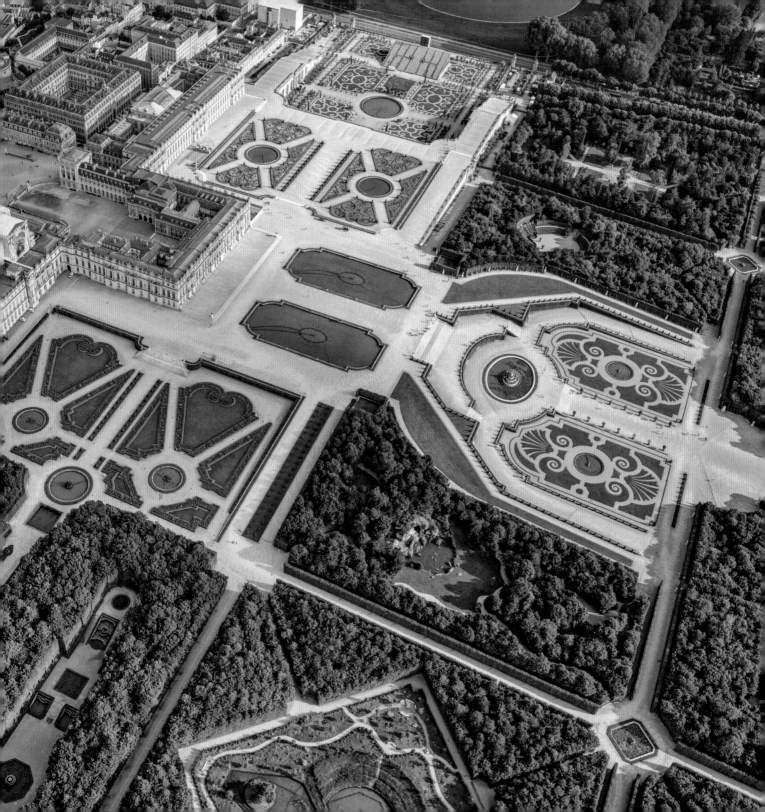

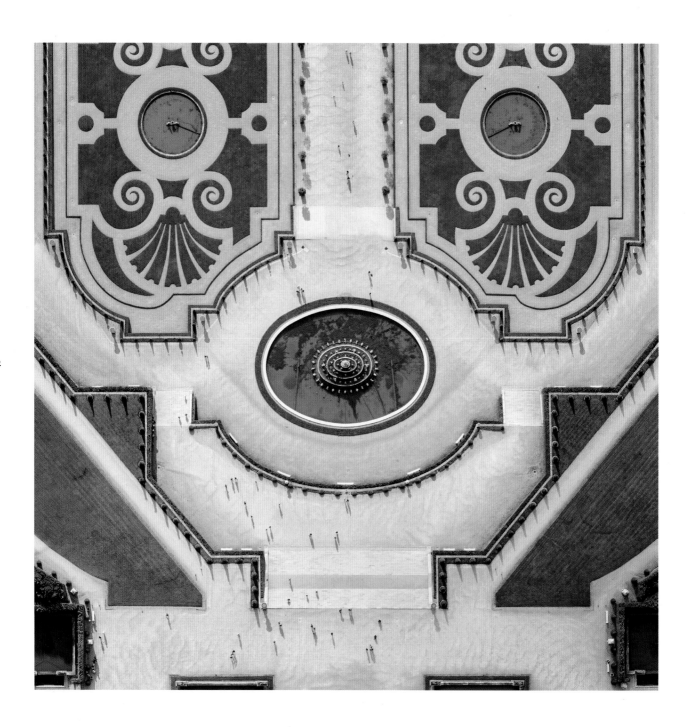

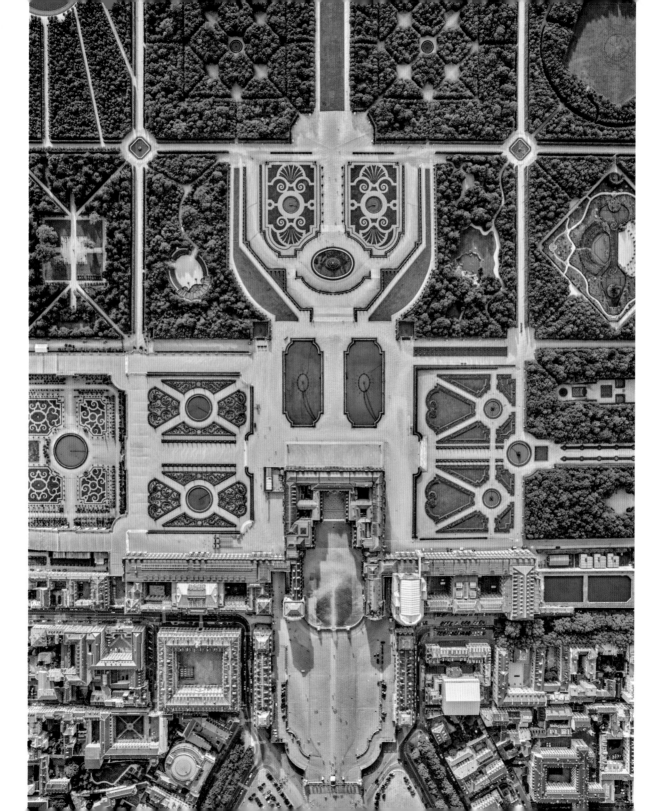

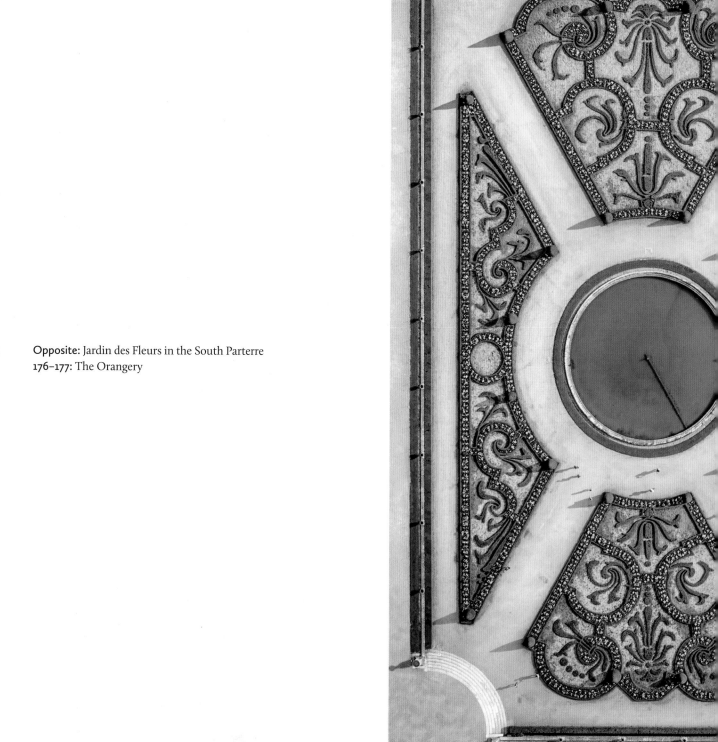

174 **Opposite:** Jardin des Fleurs in the South Parterre
 176–177: The Orangery

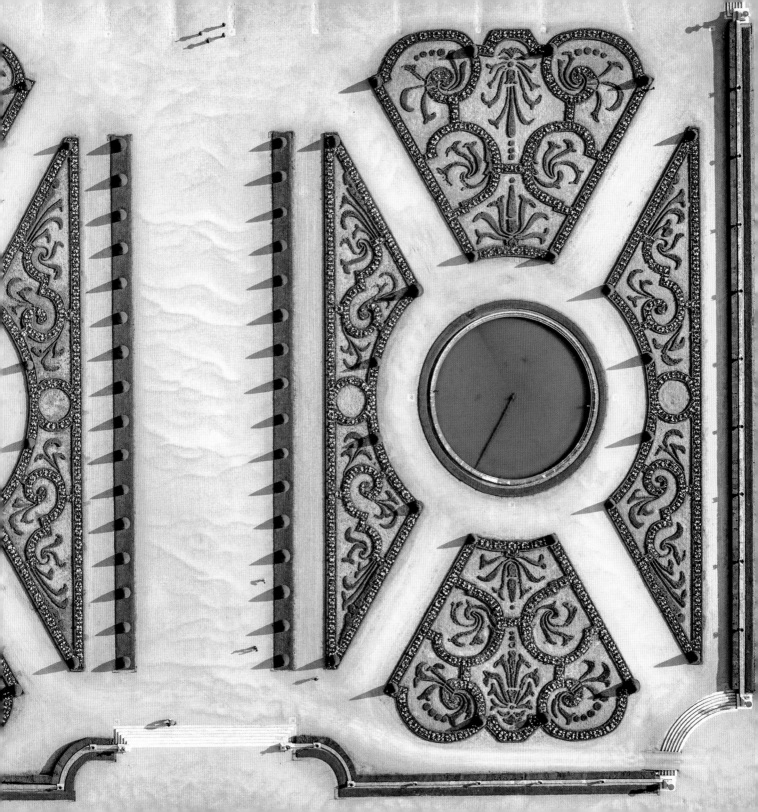

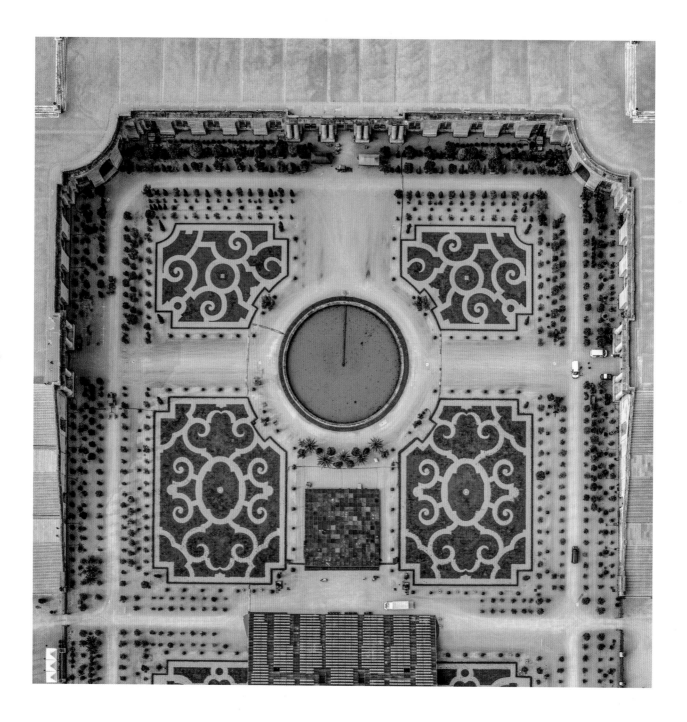

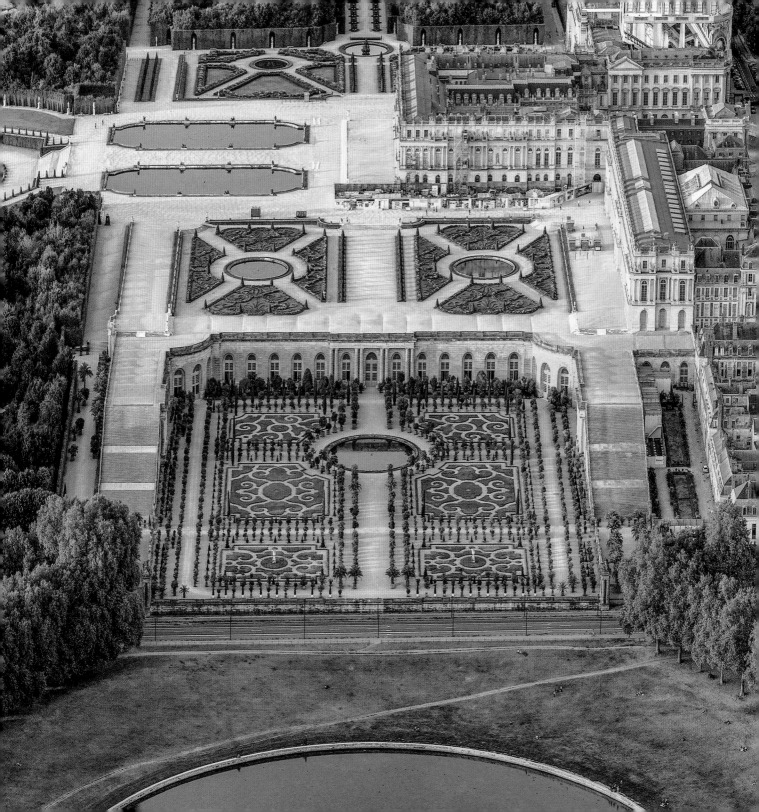

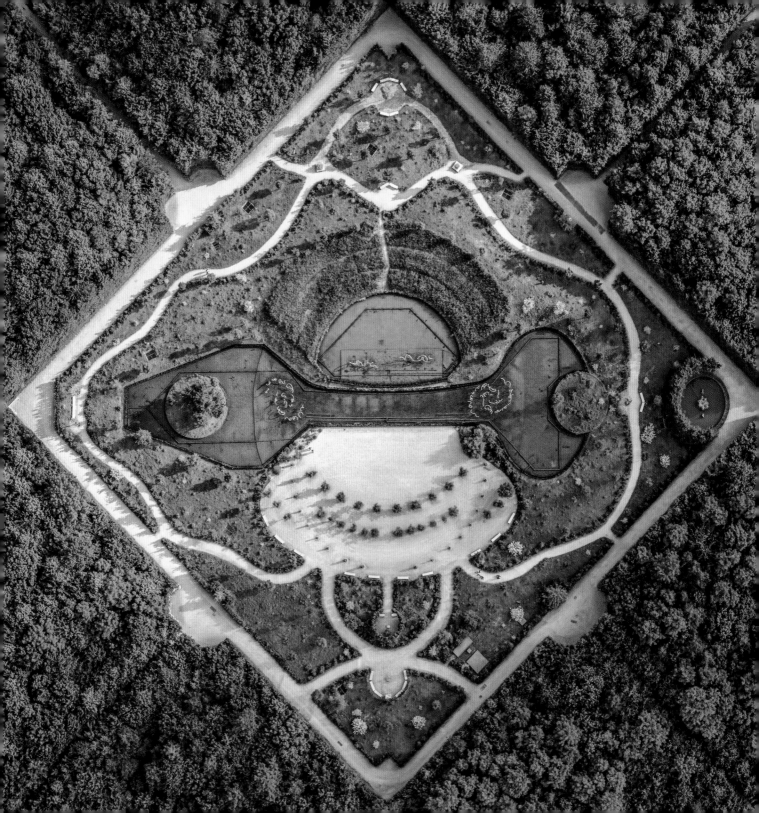

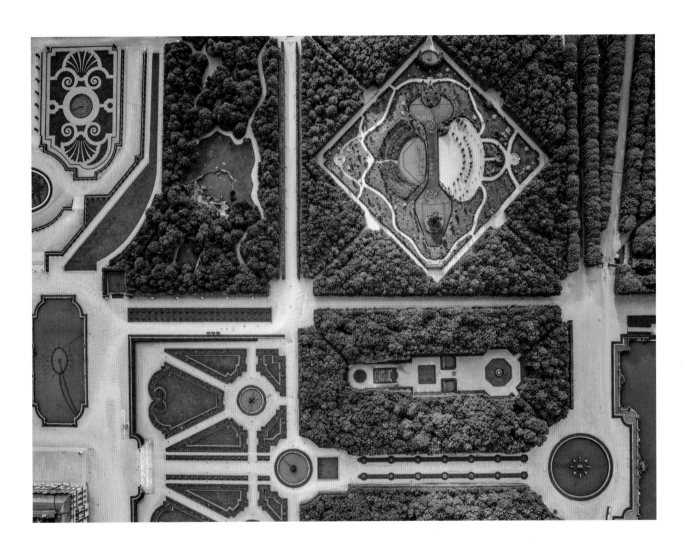

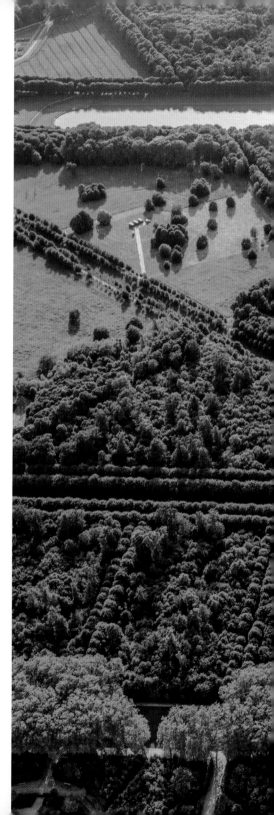

180 **178–179:** Water Theatre Grove and Three Fountains Grove
 Opposite: Water Parterre | **182–183:** Water Parterre, details

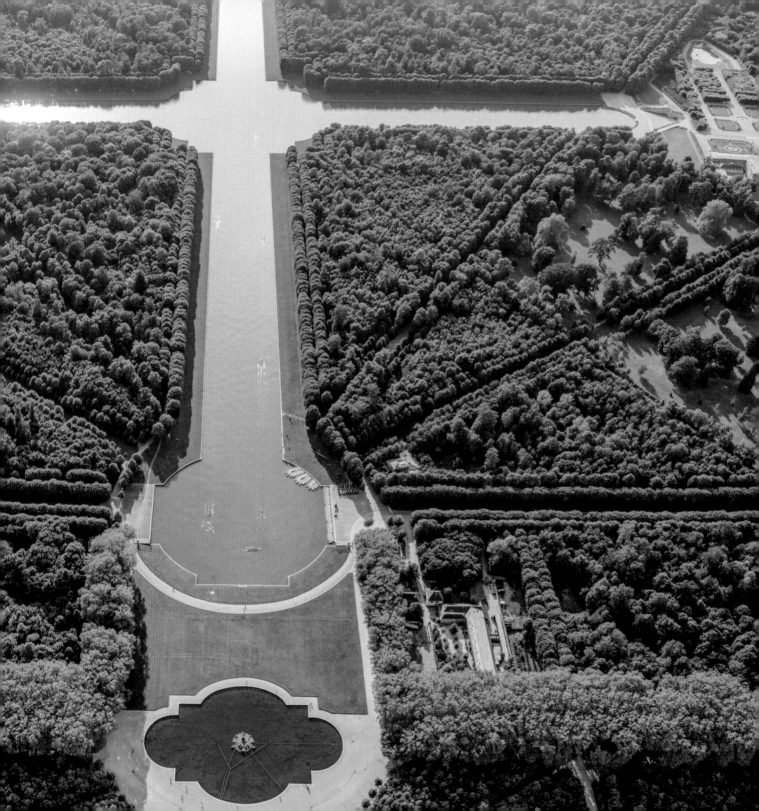

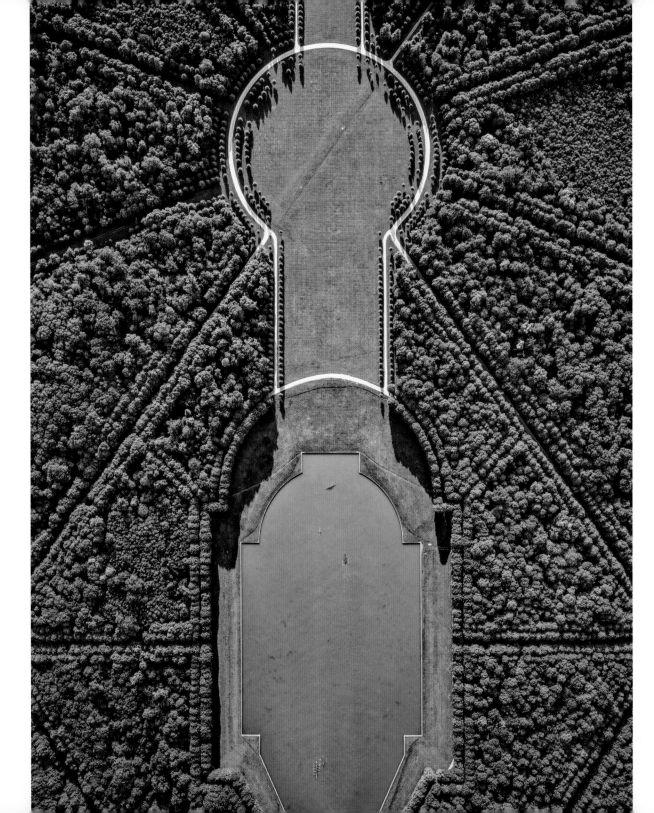

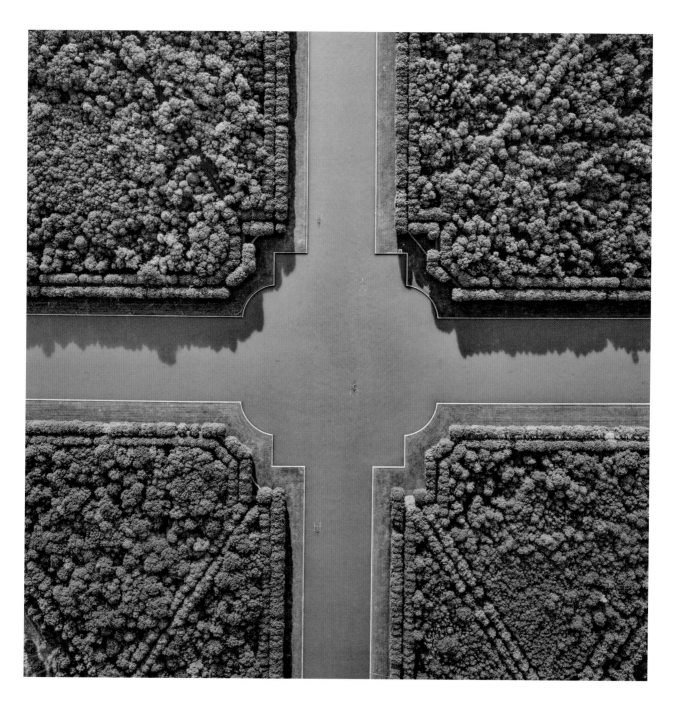

184 Grand Trianon

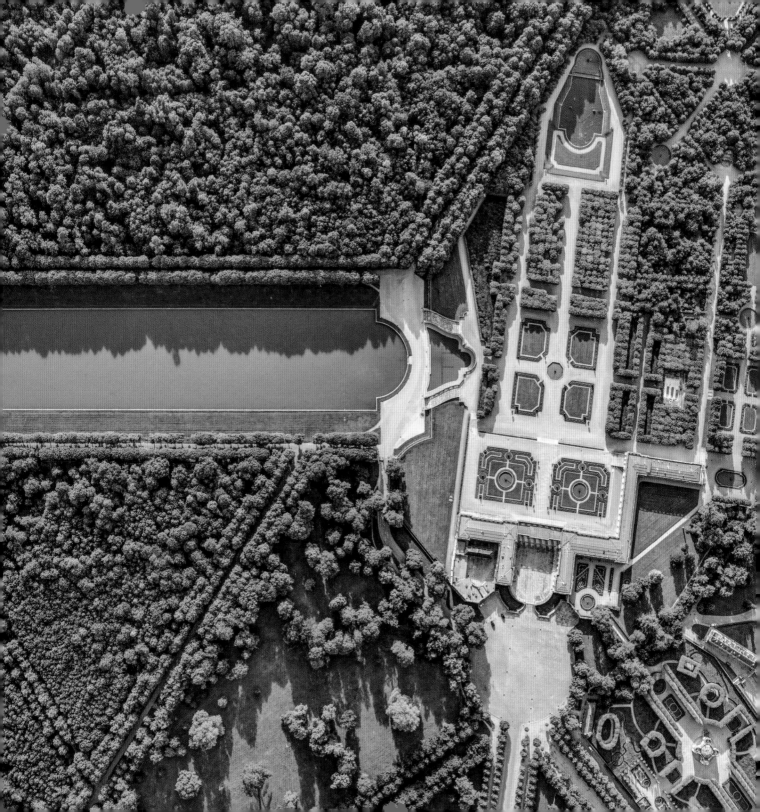

186 Overview of the Château de Versailles, with the King's Garden in the foreground

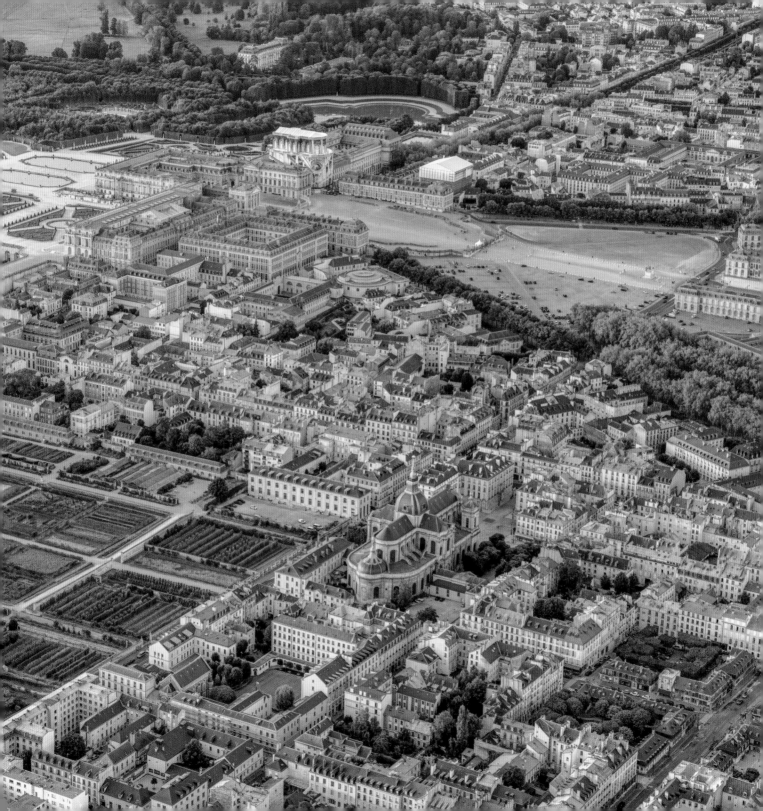

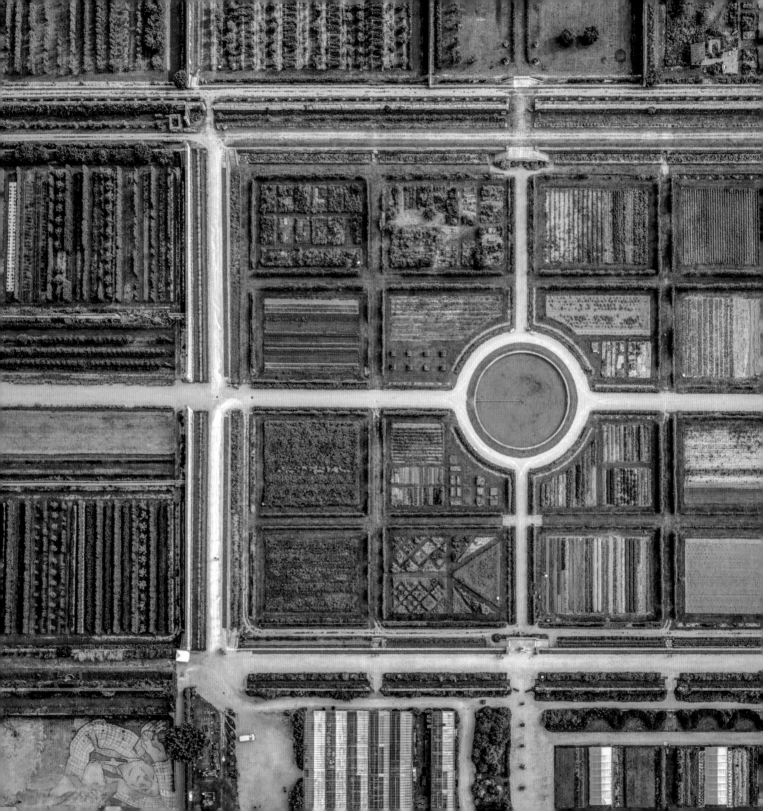

King's Garden, detail 189

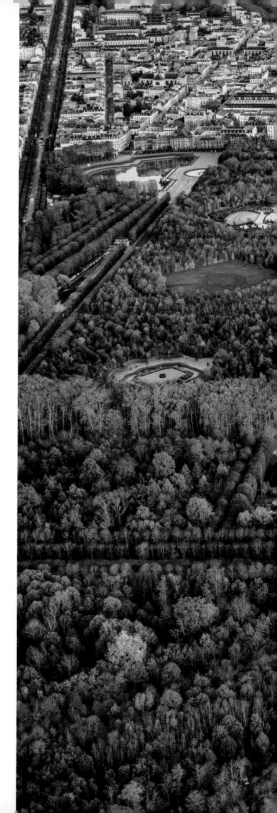

190 **Opposite:** Château de Versailles in autumn | **192–193:** Château de Versailles at dusk | **194–195:** Château de Versailles at night

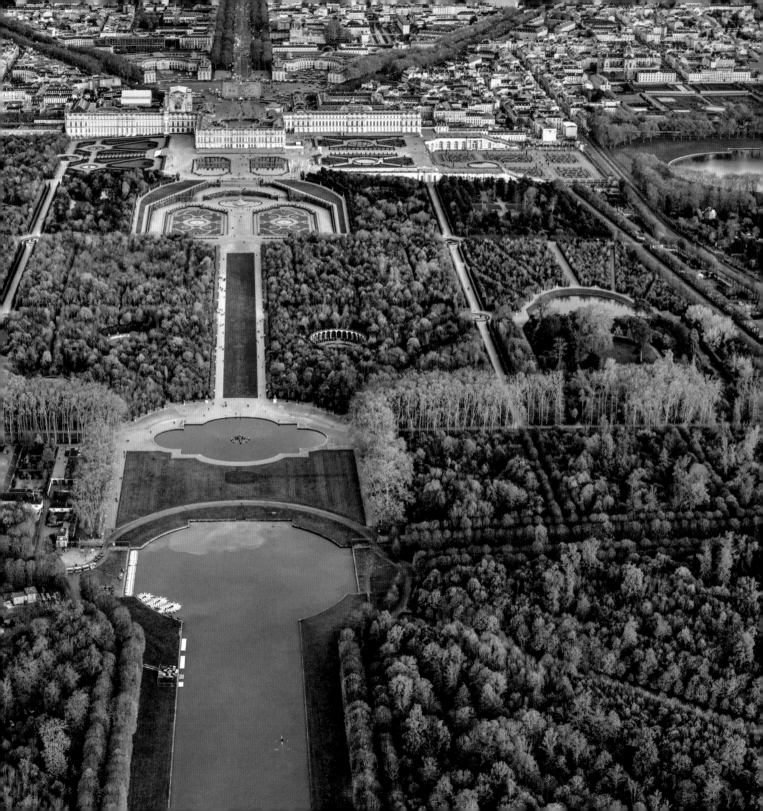

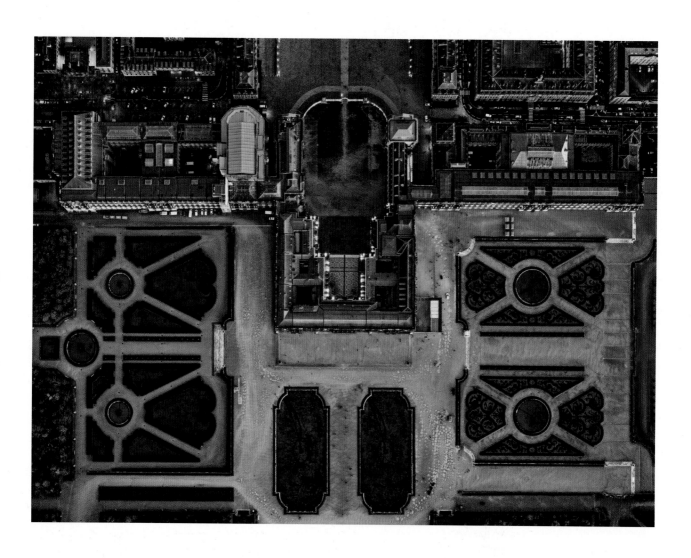

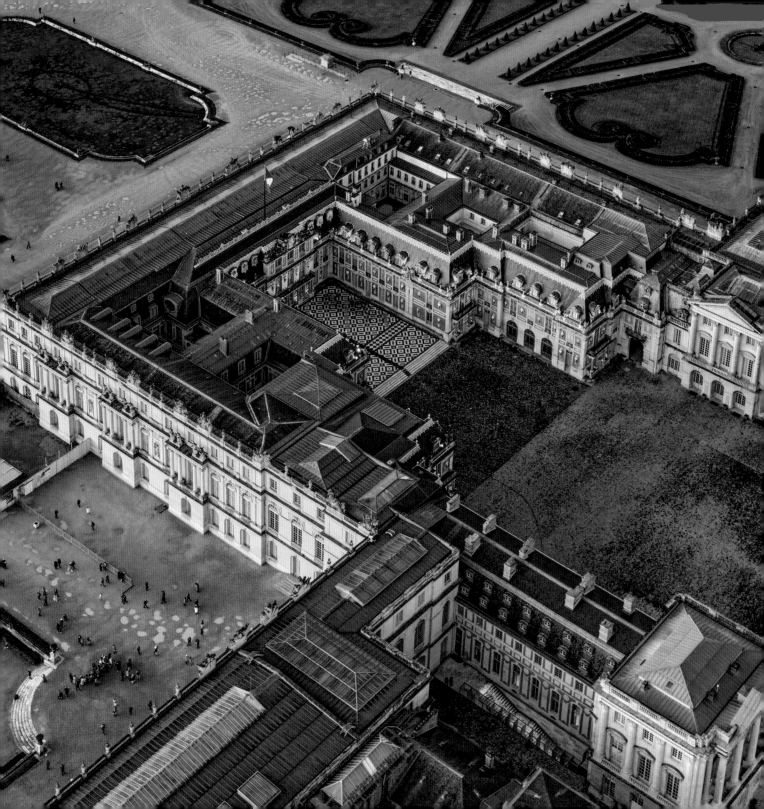

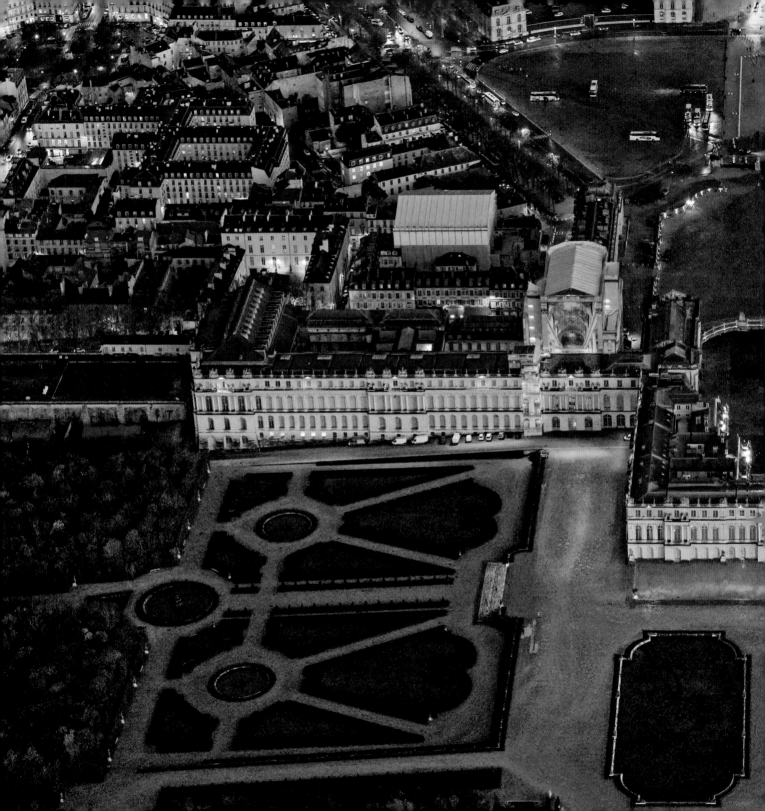

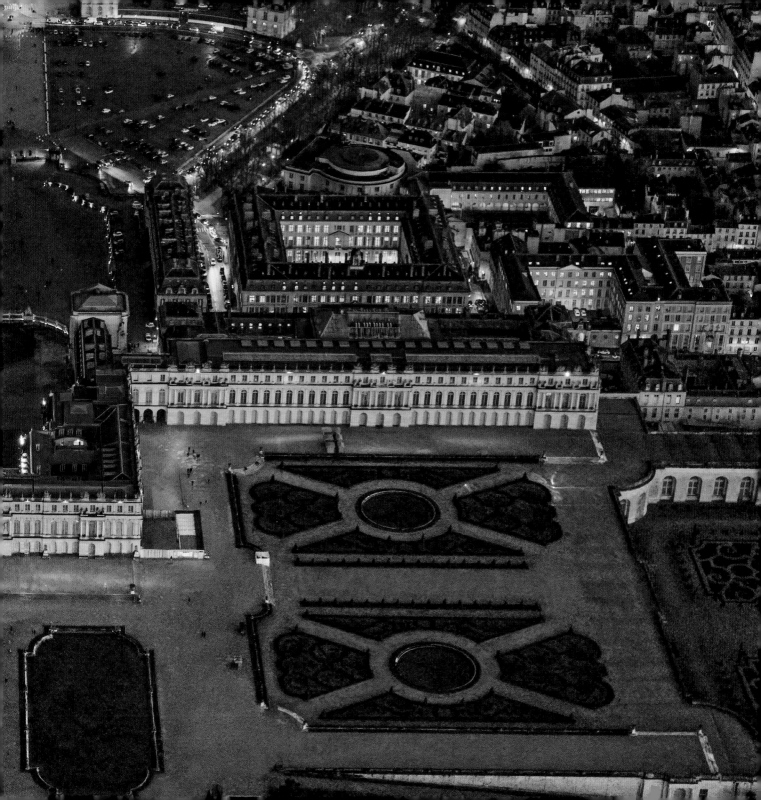

ARTIST'S STATEMENT

Jeffrey Milstein

As a boy growing up in Los Angeles in the 1950s, I had two primary interests: flying and art. I built and flew all the model airplanes I could afford and drew and painted pictures of the stylish jet airliners of the day. When I was young, my father would take me to Los Angeles International Airport (LAX), where I would stand just outside the fence at the end of the runway and watch the planes coming in low over my head as they were about to land.

I was determined to fly myself, so in 1960, at the age of 16, I began taking flying lessons at Santa Monica Airport, paying for them with money I earned from an after-school job. Within a year, I had passed my written exam and had the 40 hours of flying time that qualified me to take the pilot test, which I passed on my 17th birthday, the minimum age. While still in high school, I would sweep out the hangar in return for an hour in a Cessna 150, and I would fly over Los Angeles, taking pictures of the city with an 8mm movie camera I received as a present. I loved the freedom of being above it all.

In high school, I studied art with an excellent teacher who, among many other things, introduced me to the Bauhaus, that great pre–World War II German school of design, where some of the foremost contemporary painters, graphic artists, and architects taught. I wanted to study art after graduating, but my immigrant parents told me that artists starve, and I needed to have a profession to fall back on. I went to the University of California at Berkeley to study architecture, but I also took classes in painting, sculpture, and printmaking. And I began making photographs with a secondhand Argus C3 35mm camera.

After practicing architecture for about a year in San Francisco, I moved to New York City to continue my internship. After working for larger firms and getting my license, in 1970 I moved upstate to Woodstock, where I struck out on my own, designing alternative build-it-yourself shelters and solar homes. In 1975, I coauthored a book called *Designing Houses: An Illustrated Guide to Building Your Own House*. Later, I came up with a book of classic architectural-style dollhouses the reader could make out of recycled cardboard. After the book was published, I thought photographs of the models would make perfect note cards, so I started my own design/publishing company, Paper House Productions. Over the next 17 years, the little company grew into a much larger company with an extensive line of note cards, many of which were based on photographs that I took.

In 1996, to learn more about photography, I attended a workshop with the highly acclaimed photographer Jay Maisel. Jay inspired me enormously, and I decided that photography would be my third career. In 2000, I sold Paper House Productions and set up a studio near my home.

On a trip back home to Los Angeles, remembering what had interested me as a boy, I headed out to LAX and began photographing aircraft, hoping to capture that exciting moment when the giant jetliners were flying low overhead as they were about to land. My goal was to capture highly detailed photographs in perfect symmetry at the exact moment the jets were overhead. The images, which had the formal look of architectural

or engineering drawings, were widely published online and in magazines, and eventually became a book titled *AirCraft: The Jet as Art*. They were exhibited at a Los Angeles gallery, and in solo shows at the Ulrich Museum of Art in Kansas and the Smithsonian National Air and Space Museum in Washington, DC.

In 2012, more than 50 years after I had first photographed Los Angeles from a small plane, I decided to return to the air with the latest high-resolution digital cameras to photograph cities once more. Over the last nine years, I have made flights in small planes and chartered helicopters over New York and Los Angeles. As with my other work, I am drawn to the single vanishing point of the straight-on photograph, a geometric look where things line up, not unlike an architect's plan. It is a more difficult type of shooting from the air. To achieve the straight-down shot, the pilot has to make steep, tight circles while I lean out as far as I can, hand holding the camera. The door of the helicopter is open or off, and the wind from the rotor and g-force from the tightly banked turns adds to the difficulty of getting

sharp shots. As I frame my photographs, I intuitively look for symmetry, patterns, and balance, harking back to my classical art training, which I find brings a sense of order to the images. In 2017, my photos were published in a book titled *LA NY: Aerial Photographs of Los Angeles and New York* and were exhibited in solo shows at galleries in both cities.

I next began photographing cities in Europe, first London and then Amsterdam. I wanted to turn my lens on Paris because it is one of the most beautiful and iconic European cities, with such a rich history

Jeffrey Milstein at work flying over Gatwick Airport, London

198

of architecture. Throughout most of the city, building height has been restricted for many years, protecting the uniformly classic architecture and creating a human scale with sunlit avenues that connect historic squares, monuments, parks, museums, and public buildings. When I began researching how I could make a photography flight, I discovered that Paris authorities do not allow photographers to fly over the city, and that only a small handful have ever received this permission. When I first contacted Helifirst, the helicopter company I eventually flew with in Paris, I was told I would have to be content with a circle around the city but not over it. I knew I could not get the straight-down photographs that had become a signature of my aerial work this way.

In February 2019, I sent my *LA NY* book to Rebecca Moreau, manager of Helifirst. She told me she could see that I would create a unique view of Paris and said she would try to secure permission. She also told me that it would cost 500 euros just to apply, and that the process would take a minimum of three months. One of the requirements for approval was that the photographs

had to be in the public interest. I enlisted the help of people I knew in the art world, including museum curators and publishers, all of whom wrote letters of support. Hoping for approval, I optimistically planned a trip to Paris for May 2019, which was three months from when I applied. May came and I still had no permission, but I decided to go to Paris anyway, hoping that it would come through. On the last day of my stay, as I was about to go home, the permission finally came through; the prefecture of police in charge of flight agreed to two flights directly over the city. I extended my trip and was able to do the first flight at the end of May, and then returned in June for a second flight, plus one over nearby Versailles. One condition of my permit was that I could not photograph the Cathédrale Notre-Dame, which was covered with scaffolding due to the tragic roof fire the year before. As of this writing, I have learned that Paris is no longer allowing any photography flights over the city.

This book also includes photographs of Versailles. While not in the city, the palace and gardens at Versailles

are closely connected with Paris. Just 14 miles away, it was Louis XIV's favored residence. I remembered seeing slides of the beautiful landscapes of Versailles in my architecture history lectures, and I wanted to photograph the site from overhead. Versailles also does not allow overflights, but the palace made an exception. I was told it was the first time in 20 years that it granted this permission (the last time was to Yann Arthus-Bertrand). On my second flight, in November 2019, I asked if the building lights could be turned on so I could photograph at dusk. I was thrilled to be able to fly over Versailles, and in return for allowing me to do so I was happy to give the palace a selection of my images for use in its social media.

To fly directly over Paris and Versailles, it is required to use an expensive twin-turbine helicopter. (I am used to small gas-engine helicopters, which are allowed over cities in the United States.) I flew in a Squirrel AS 355N. My pilot, Félix Claro, spoke little English and I spoke little French, but his skill and enthusiasm made up for any communication lapses. We pored over maps, sketching our planned routes and altitudes in the preflight, and did a lot of hand gesturing in the air. We had to work fast, as time and the best light were limited. I get into a kind of zone once I start shooting; everything else falls away and I just move into that moment.

It is a rather amazing experience to fly around Paris like a bird. It is my hope that this book will share this unique view with readers who likely will never be able to experience it themselves.

Left: Milstein at the Issy-les-Moulineaux Héliport
Opposite: Looking northeast over the heart of Paris

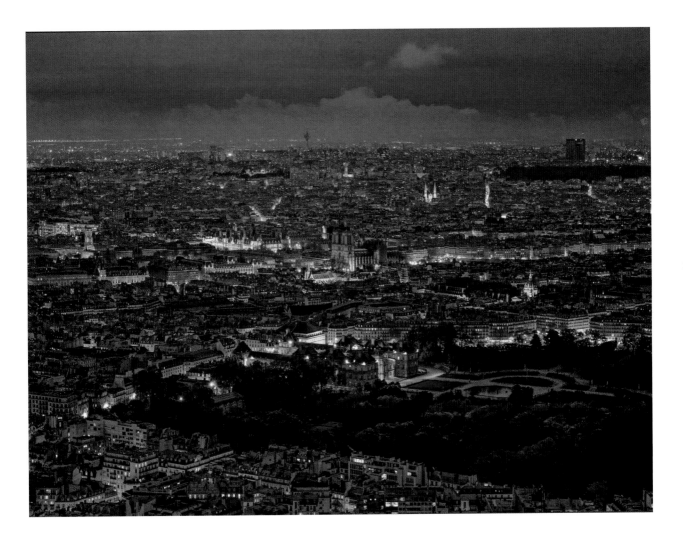

SELECTED
NOTES

Robert Morton

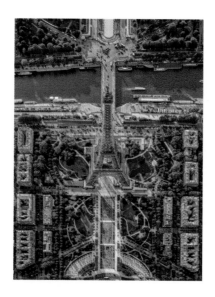

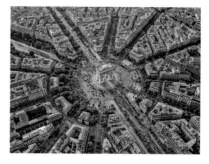

10

The Tour Eiffel, completed in 1889 as the central ornament of a Universal Exposition to celebrate the 100th anniversary of the French Revolution, was intended to exist for only 20 years, but proved so popular that it remained. Widely criticized at first (one wag called it "this truly tragic streetlamp"), it attracted two million visitors during the world's fair. Rising above 1,000 feet, it was the tallest man-made structure in the world until 1930, when New York's Chrysler Building topped it.

See also pp. 16–17, 152–153, 155, 156, and 158–159.

18–19

At the western end of the Champs-Élysées, the Arc de Triomphe rises 164 feet and spans 148 feet in width. Commissioned by Napoleon Bonaparte in 1806 to celebrate his military victories, it was not completed until 1836. Beneath it, the Tomb of the Unknown Soldier, dedicated in 1920, honors unidentified French dead from World War I. Twelve avenues enter the plaza, which was once called Place de l'Étoile, but was renamed Place Charles de Gaulle in 1970 after the death of France's World War II leader. On several levels, the Arc de Triomphe houses a museum, a gift shop, and a rooftop viewing terrace.

See also pp. 20–21, 23, and 24–25.

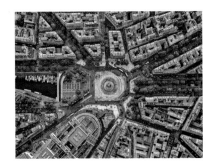

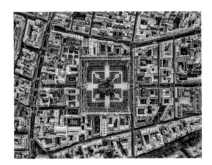

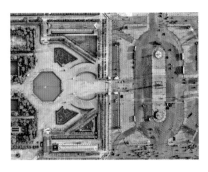

26–27

The modest-looking Place de la Bastille nevertheless asserts its celebrated role in French history as the former site of the infamous prison that fell to revolutionaries on July 14, 1789, fueling the overthrow of the ancien régime. The column at its center commemorates a second revolution against monarchical oppression in 1830. On one side of the square, the Opéra Bastille, an undistinguished modern building, replaced the Palais Garnier as the principal home of the national opera company in 1989. Beside the Place de la Bastille, an open area of the Canal Saint-Martin serves for docking private boats.
See also pp. 28–29.

30–31

The Place des Vosges, previously known as the Place Royale, was once the site of a huge horse market, but in 1612 Henry IV turned it into the largest and most elegant planned square in Paris, the first of its kind. Bowing to the king's wishes, the buyers of all the building sites around the square agreed to order their architects to create identical facades. The square was renamed in 1799, when the regional department of the Vosges in eastern France was the first to pay taxes to support a campaign of the Revolutionary Army.
See also pp. 4 and 28–29.

32–33

At the western end of the Jardin des Tuileries, abutting the Place de la Concorde, two long rectangular buildings once served the Louvre Palace, as an orangery (top) and as a court for royal tennis (bottom). When the Louvre Museum grew too crowded to hang many great Impressionist and Postimpressionist works, the buildings became the Musée de l'Orangerie and the Musée de Jeu de Paume. Most of the great works were later moved into the Musée d'Orsay. Largest of all the Parisian squares at nearly 19 acres, the Place de la Concorde was the site of the famous guillotine of the French Revolution.
See also pp. 34, 35, 36–37, and 38–39.

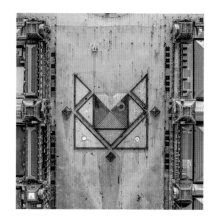

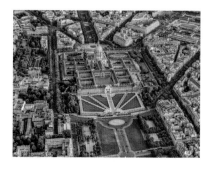

38–39

By 1793, the royal family had left the three main buildings of the Louvre Palace, and it became the museum that it remains, largest in the world in terms of gallery space, displaying some 35,000 works of art from prehistory to today. In time, the Louvre's old public entrances proved inadequate for the crowds, and in 1983, American architect I. M. Pei was charged with designing a new way to receive visitors. He excavated a large underground foyer in the center court to house ticket booths, restaurants, and other visitor services with passageways to the exhibition buildings.

See also pp. 13, 15, 41, 42–43, and 90–91.

41

Topping I. M. Pei's new entrance and admitting daylight to the underground space, a steel-framed glass pyramid stands 71 feet tall and measures 112 feet wide on each of its bases. Three smaller pyramids add more light to the area. The new entrance opened in 1988 and was followed in 1993 with an expansion toward the Jardin des Tuileries and below the traffic roundabout at the Place du Carrousel. There, an inverted pyramid echoes its older brother and admits daylight to the large underground shopping mall that attracts museumgoers and local residents alike.

See also pp. 13, 15, 38–39, 42–43, and 90–91.

44–45

At the heart of the 7th arrondissement, an imposing array of buildings embodies the French nation's homage to its military history—Hôtel des Invalides. Established by Louis XIV as a military hospital and retirement home for wounded veterans, hence the name Invalides, the complex includes a variety of military history museums, a cathedral, and the gold-capped Dôme des Invalides, under which Napoleon's remains were entombed in 1840. At 351 feet, the Dôme des Invalides—modeled after Saint Peter's Basilica in Rome—was the tallest structure in Paris until the building of the Tour Eiffel 100 years after its completion.

See also pp. 46, 47, 48–49, and 50–51.

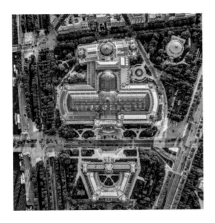

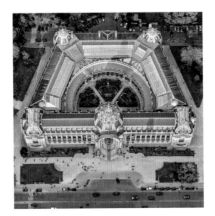

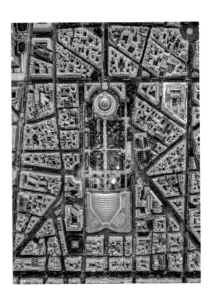

53

The imposing Grand Palais, created for the Universal Exposition of 1900, has a main space that stretches the length of more than two football fields. Inspired in part by London's Crystal Palace of 1851, the hall's design featured a glass roof so that sunlight would amplify the meager electric lights of the day. For many years, it has been home to numerous exhibitions of art, and the west wing contains an important science museum. In 2024, it will host several competitions of the Paris Olympics.

See also pp. 50–51 and 55.

54

This photograph of the Petit Palais gives a better view of the handsome Beaux Arts facade that adorns both this building and the Grand Palais that stands opposite. With its dramatic arched entrance topped by a dome, the Petit Palais, like its mate, was used as exhibition space for the 1900 Universal Exposition, but unlike some such buildings it was intended to remain after the world's fair closed. Today it serves as one of 14 museums of the City of Paris, the Musée des Beaux-Arts de la Ville de Paris.

See also p. 53.

57

Beginning in the 12th century, a large area in the 2nd arrondissement known as Les Halles was home to Paris's fresh food markets. In 1971, the markets moved to a Paris suburb. Since then, the site has seen the construction of an enormous underground transportation center, serving both suburban rail and local metro passengers, and topped by public gardens. Below the entrance, now under a stylish glass roof, a huge shopping mall attracts both travelers and local residents. At the western end of the former market space stands an elegant, round 19th-century building that once housed the Bourse de Commerce, a commodities exchange.

See also pp. 13, 56, and 86–87.

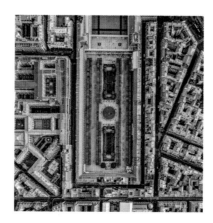

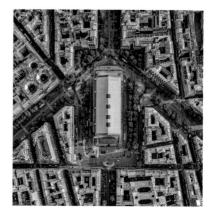

58–59

The circular Place des Victoires and its uniform parade of surrounding buildings was designed in 1685 by the royal architect Jules Hardouin-Mansart to celebrate a major treaty that ended a long series of wars between and among France and various European monarchies. At the center of the square, an equestrian statue of Louis XIV as a Roman emperor was erected in 1828 to replace a series of monuments that followed an original sculpture of the Sun King that had been destroyed during the French Revolution. At the upper right, the Jardin du Palais Royal can be seen.

See also pp. 13, 60, and 61.

61

At the heart of the 1st arrondissement, a short distance up from the Louvre, the simple but elegant Jardin du Palais Royal consists of avenues of precisely trimmed lime trees, flower beds, a fountain, and some sculptures. Surrounding the garden, arcaded walkways shelter some of Paris's most fashionable shops, cafés, and restaurants, including the famous Grand Véfour. On the outer perimeter of the arcades are two of France's most important theaters, where the 17th-century plays of Molière and the music of Jean-Baptiste Lully may still be seen and heard.

See also pp. 13, 58–59, and 60.

63

Running straight up from the Place de la Concorde, the Rue Royale (seen at the top here) meets its end in the imposing presence of L'église de la Madeleine, a Roman Catholic church built in the style of a Roman temple. Erected on the site of several previous churches, the building in this form was intended by Napoleon as a memorial to his Grand Army in 1806, but it was repurposed as a church and finished in the neoclassical style, loosely modeled on the Maison Carrée at Nîmes. A portrait of Napoleon appears in a fresco on the church's dome.

See also pp. 2–3 and 66–67.

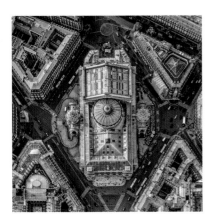

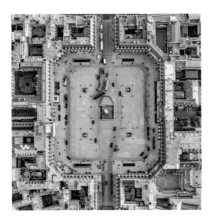

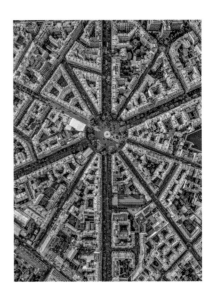

64

Few notable historic buildings bear the names of their architects, but the home of the French national opera company has been known as the Palais Garnier more often than as Opéra de Paris. Designed by a then little-known architect named Charles Garnier—who won a competition over 170 others—the building was a sensation from the moment it opened in 1875 for its magnificent sculpture-laden facade, swooping grand interior staircase, spectacular chandelier, and glittering foyer. It served as inspiration for Gaston Leroux's 1910 gothic novel *The Phantom of the Opera*.

See also pp. 65 and 66–67.

68

Another of the significant designs of architect Jules Hardouin-Mansart, the matching facades of the Place Vendôme encompass a large space connected by a single street to the Louvre at one end and by the Rue de la Paix to the Opéra at the other. At the center of the Place Vendôme, a memorial column with a statue of Napoleon and bronze bas-relief plates depicting his victories has seen a rise and fall several times but has been securely in place since 1874.

See also pp. 2–3, 69, and 71.

73

207

The round shape of Place Victor Hugo goes back to its use as a hippodrome, an outdoor theater offering horse shows and other entertainment. The square had been known by various names, but on May 22, 1885, when the great Victor Hugo died, the Paris City Council voted immediately to name it in his honor. A novelist, playwright, poet, journalist, and politician, Hugo briefly lived in the square that bears his name, but the apartment where he wrote much of his most famous novel, *Les Misérables*, is in the Place des Vosges.

See also p. 72.

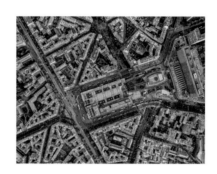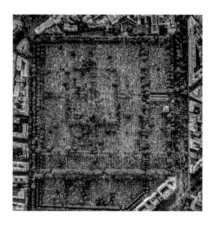

76–77

Situated between the 14th and 15th arrondissements, Gare Montparnasse offers TGV (Train à Grande Vitesse), or ultrafast rail service, to the west and southwest of France. In 1994, a unique public park called the Jardin Atlantique was opened on top of the rail lines as they enter the station itself, unseen in this photograph. Several small themed gardens, a rank of tennis courts, fountains, and sculptures in the park offer inner-city dwellers a green oasis. *See also pp. 78–79 and 138–139.*

78–79

Looking straight down on the Tour Montparnasse (slightly right of center here) one can't tell that it rises enormously high over the common roof height of central Paris; indeed, it was the tallest building in France for 40 years. Opened in 1973, topping out at 689 feet, and dwarfed only by the 1,063-foot Tour Eiffel, the flat-fronted monolith was widely reviled as the ugliest building in Europe, referred to as "the box left behind when the Tour Eiffel was delivered." *See also pp. 48–49 and 138–139.*

81

Some of France's most illustrious citizens of the last two centuries, as well as an unusual cast of international celebrities, have found their final rest in the 14th arrondissement, just above Boulevard du Montparnasse. Nearly 50 acres in extent and holding some 35,000 plots, the Cimetière du Montparnasse shelters Alfred Dreyfus, Charles Baudelaire, Jean-Paul Sartre, Simone de Beauvoir, actresses Jean Seberg and Michèle Morgan, playwright Samuel Beckett, and American author Susan Sontag. Second only in size and its honor roll of illustrious dead to Paris's Père Lachaise, the cemetery attracts many tourists each year.

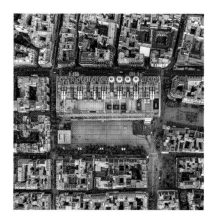

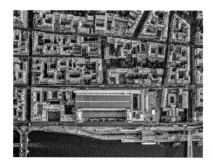

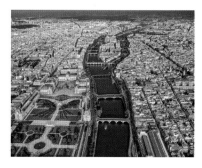

83

Named for France's president in the late 1960s, Georges Pompidou, the nation's first museum and library for contemporary art—also known as the Beaubourg after the area in which it sits—opened in 1977. Almost all of the Centre Pompidou's structural and functional elements—including climate control ducts, electrical cables, water and sewage pipes, and a major escalator—are on the outside, leaving the interior spaces free and clear. Each of those services wears a different color, enlivening the exterior in the fun-loving manner of pop art, credit for which goes to architects Renzo Piano and Richard Rogers.
See also pp. 84–85 and 86–87.

88–89

The building that now houses the Musée d'Orsay was erected on the Left Bank as a railroad station to serve the 1900 Universal Exposition. Over the years, it became too small to be useful and was scheduled to be demolished, until the Ministry of Culture decided in 1974 to convert it into a museum to house Impressionist and Postimpressionist works from other institutions, thus filling the gap between the Louvre and the Centre Pompidou. By 1986, architect Gae Aulenti had redesigned the interior to accommodate some 2,000 paintings and 600 or more other works dating between 1848 and 1914.

90–91

The river that winds its way through the heart of Paris rises some 175 miles away, near Dijon, on its way to the English Channel at Le Havre/Honfleur. Slow moving and about 30 feet deep through the city, the river is navigable year-round by goods-transport barges and tourist boats (the so-called Bateaux Mouches—literally fly boats—because they buzz back and forth). Since 2002, from mid-July to the end of August, the riverbanks in the central city and the Villette area of the 19th arrondissement have been turned into virtual beaches, where umbrellas, deck chairs, and swimming pools have offered Parisians warm-weather diversions.
See also pp. 16–17 and 134–135.

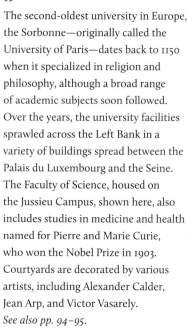

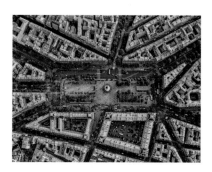

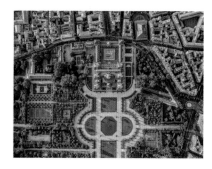

93

The second-oldest university in Europe, the Sorbonne—originally called the University of Paris—dates back to 1150 when it specialized in religion and philosophy, although a broad range of academic subjects soon followed. Over the years, the university facilities sprawled across the Left Bank in a variety of buildings spread between the Palais du Luxembourg and the Seine. The Faculty of Science, housed on the Jussieu Campus, shown here, also includes studies in medicine and health named for Pierre and Marie Curie, who won the Nobel Prize in 1903. Courtyards are decorated by various artists, including Alexander Calder, Jean Arp, and Victor Vasarely.
See also pp. 94–95.

96–97

Bordering the 3rd, 10th, and 11th arrondissements, the Place de la République announces its name in a monument dominated by a bronze statue of Marianne—personification of the French Republic—erected in the 1880s to celebrate the 90th anniversary of the Revolution. In recent years, the square had been overwhelmed by motor traffic and largely destroyed, but by 2013 it was gradually restored to its original outline. The largest pedestrian space in the city, the square offers a park with trees and flowers, benches, a café, and a toy and game library for children and adults.

98–99

One of the great ornaments of the Left Bank, the gardens of the Palais du Luxembourg serve students at the nearby Sorbonne, artists drifting up from the cafés of Saint-Germain, and 6th arrondissement families and children. In 1612, Marie de Medici ordered the grand palace designed to remind her of the Palazzo Pitti in her native Florence and created an array of ponds and gardens covering almost 50 acres. The large palace building has been the home of the French Senate since 1958; the smaller building by its side acts as a residence for the president of the Senate.
See also pp. 100–101.

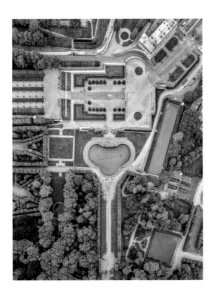

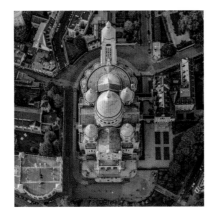

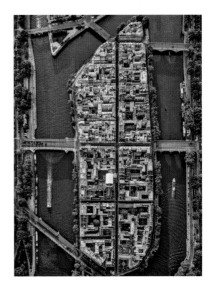

103

Although it lies almost seven miles west of the center of Paris, the Parc de Saint-Cloud lays claim as a city amenity. Once the site of a royal château, destroyed in the 1870 Franco-Prussian War and marked now in outline by a rectangle of yew trees, the park's design by Louis XIV's great horticulturist, André Le Nôtre, distinguishes it. At lower right in this photograph, the top of a spectacular flight of fountains known as the Grande Cascade leads down to the Seine.

104

The Basilique du Sacré-Cœur stands on Butte Montmartre, some 427 feet above sea level, about four times higher than the city itself. Not ancient, the basilica was only completed in 1914 and consecrated in 1919. Because of its height above the city, Sacré-Cœur ranks high among visitor attractions, but the Montmartre area around it deserves equal interest for its role in the lives of many of the great artists of the late 19th and early 20th centuries—from Monet, Degas, Renoir, and Pissarro to Modigliani, Picasso, and Van Gogh—who lived, worked, or painted nearby.
See also p. 105.

108

Paris's ancient history focuses on two islands in the Seine: the larger Île de la Cité, home of the Cathédrale Notre-Dame de Paris, and the Île Saint-Louis, shown here. Both islands appear to have served as places of worship from pre-Christian times, but after the late 12th century Notre-Dame took precedence and the Île Saint-Louis became known for important residences of important people. Numerous bridges connect both islands to the city banks, including the ironically named Pont Neuf, the oldest standing bridge crossing the Seine, but, once upon a time, the newest.
See also pp. 106–107 and 109.

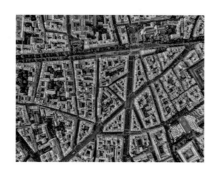

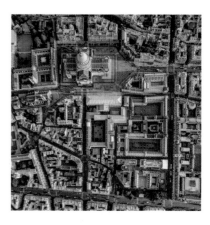

118

The streets between the Palais de Chaillot and the Arc de Triomphe, an area that takes the name Chaillot, feature some of the most expensive residences in Paris, numerous foreign consulates, and several exclusive hotels. Among them, the Hotel Peninsula—the renovated form of a historic 1908 hotel called the Majestic—offers diners at its top-floor restaurant, L'Oiseau Blanc, a close look at a replica of the airplane of the same name that set out to cross the Atlantic in 1927. Sadly, the plane, with its two pilots, was lost at sea.
See also p. 119.

120–121

This 6th arrondissement area takes its name from the former abbey, Église de Saint-Germain-des-Prés, the oldest church in Paris and its only Romanesque building. Nearby, the church of Saint-Sulpice offers two stunning murals by Eugène Delacroix, who lived in a small square behind the abbey. Saint-Germain-des-Prés has been a magnet for writers, artists, and musicians since before World War I, perhaps for its notable bistros—including Les Deux Magots, Café de Flore, and Brasserie Lipp—which were hangouts for American writers from Ernest Hemingway to James Baldwin and others.

123

On a rise of land at the heart of the 5th arrondissement, the neoclassical domed building known as the Panthéon shelters the remains of some of France's most illustrious men—and a few women—among them Voltaire, Rousseau, Zola, Victor Hugo, André Malraux, and Marie and Pierre Curie. In the area nearby are dozens of buildings of the Sorbonne and other educational institutions, where Latin would once have been as common to hear as French, which is the reason the neighborhood takes the name the Latin Quarter.

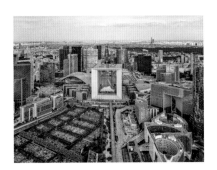

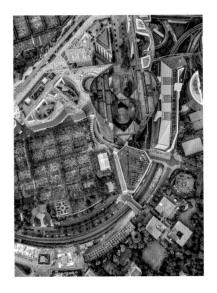

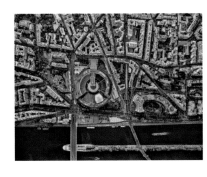

124–125

In the late 1950s, recognizing the need for office and retail spaces, planners designated an area west of the city—La Défense—as a commercial zone with few limits on building heights. In keeping with Baron Haussmann's style of aligning significant monuments, the planners drew a straight line from the Louvre, along the Champs-Élysées, and beyond, and found a site about two-and-a-half miles away. Today, one still can look through the center of the remarkable Grande Arche to see the Arc de Triomphe. Beyond stands the Louvre, all three structures creating a historical axis linking the ancient city and the modern suburb.

See also pp. 126, 127, 128–129, 130–131, 132, and 158–159.

132

Squeezed in by the skyscrapers of La Défense in the village of Nanterre, the Cimetière de Puteaux holds its own, providing space for the tombs of many distinguished local citizens. Perhaps more importantly, however, it offers a memorial monument to more than 1,000 French hostages and resistance fighters slaughtered by Nazi troops during the occupation of Paris in the early 1940s.

136–137

The circular building, fittingly called Maison de la Radio, houses Radio France, home of the seven subject-based networks of the national broadcasting service. It sits beside the Seine in the 16th arrondissement, just downriver from the Tour Eiffel, where some early broadcasts emanated. Radio France programming runs a wide gamut, from straight news and information to programs of regional concern and music of all kinds, from classical to reggae. The service also manages four national music groups, including the National Orchestra of France.

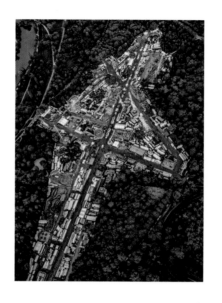

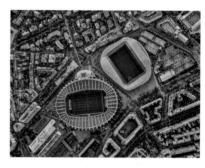

138–139

Located at the edge of the ring road around Paris at Issy-les-Moulineaux, a small airport that now serves only helicopters has a distinguished place in French aviation history. In 1905 and the years following, numerous pioneering aviators—such as Louis Blériot, Henri Farman, and Alberto Santos-Dumont— tested their early aircraft here. Among several helicopter companies operating today, Helifirst was chosen by Jeffrey Milstein for his flights over Paris and Versailles.

142

For more than 1,000 years, the largest funfair in France, called the Foire du Trône, has taken place in Paris, most recently at the edge of the Bois de Vincennes in the 12th arrondissement. Offering more than 350 rides, food stalls, games, and amusements of various kinds, the fair was all set to begin again in late March 2020 when it was canceled because of the coronavirus pandemic and the potential danger for the three million or so visitors who usually crowd the fair for two months every spring.
See also p. 143.

146–147

Located in the 16th arrondissement on a parkland once enjoyed exclusively by the royal family (hence its name), the Parc des Princes stadium (left) seats 48,000 and since 1974 has been the home field of the major French soccer team Paris Saint-Germain (PSG). Adjacent to it, the Stade Jean-Bouin hosts rugby and field hockey and lies within walking distance of the Stade Roland Garros and other facilities of the French Open tennis tournament.

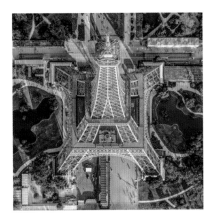

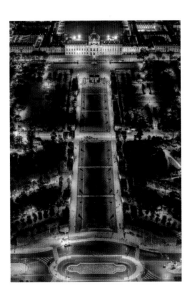

149

The sprawling Palais de Chaillot that exists today was built on the site of the original building erected there, like the Tour Eiffel, for the Universal Exposition of 1867. Unlike the Tour Eiffel, however, the Chaillot structures had fallen into disuse, and in 1937, for another world's fair, it was rebuilt as it looks today. A central structure was omitted in the restoration to provide an uninterrupted view of the Champ de Mars, from the Trocadéro area of the 16th arrondissement to the Tour Eiffel and beyond to the École Militaire, an unrivaled stretch of public parks.

See also pp. 6–7, 16–17, 150–151, and 152–153.

156

Designed and fabricated by the great engineer Gustave Eiffel, the Tour Eiffel was constructed of iron girders—not steel—that were cast at Eiffel's foundry on Paris's outskirts and mostly assembled on-site. Four-man teams used some 2.5 million hot rivets to connect the girders. Eiffel had previously used a similar cast iron structure to support the copper-clad sculpture of the Statue of Liberty in New York Harbor. At the base of the tower, elevators in two of the legs give access to three substantial platform levels that include several restaurants, a movie museum, and various exhibits.

See also pp. 10, 16–17, 152–153, 155, and 158–159.

157

At the head of the vast lawns of the Champ de Mars, on which as many as 10,000 soldiers once drilled, lies the large campus of the École Militaire, France's first elite military academy. In 1750, Louis XV created the facility to train aristocratic young men, especially those who lacked private fortunes. Built by France's leading architect of the day, Ange-Jacques Gabriel, the buildings were designed to outshine in size and splendor the nearby Hôtel des Invalides, which had been erected by Louis XV's father. Napoleon graduated from there in 1785, finishing his studies in one year rather than the two normally taken.

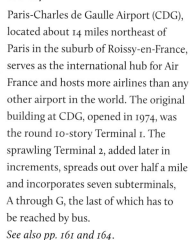

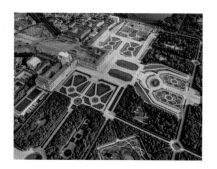

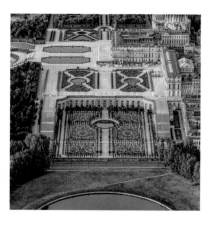

216 166–167

Paris-Charles de Gaulle Airport (CDG), located about 14 miles northeast of Paris in the suburb of Roissy-en-France, serves as the international hub for Air France and hosts more airlines than any other airport in the world. The original building at CDG, opened in 1974, was the round 10-story Terminal 1. The sprawling Terminal 2, added later in increments, spreads out over half a mile and incorporates seven subterminals, A through G, the last of which has to be reached by bus.
See also pp. 161 and 164.

170–171

Landscape architect André Le Nôtre designed the nearly 2,000 acres of gardens, canals, fountains, and secluded groves that make Versailles an outdoor delight. He turned an old pond into a Grand Canal in the form of a huge cross and added 50 fountains and more than 600 jets that periodically bring the water to life. In the Sun King's time, 15 intimate groves shielded by trees dotted the landscape, where fountains, vases, and statues in a variety of styles provided settings for entertainment for the king and his guests.

177

Beside the south wing of the palace lies a deep garden some seven-and-a-half acres in extent. Reached by 100 steps from the level above, this is the Orangery, a special place for Louis XIV's favorite citrus trees—oranges and lemons imported from Spain, Italy, and Portugal—as well as a variety of other trees and plants, including oleander, pomegranates, Eugenia, and palms. Planted in heavy wooden boxes, the trees would be displayed outdoors in summer and then wheeled into a huge gallery about 200 feet long and 40 feet high that never reached below freezing temperatures.
See also p. 176.

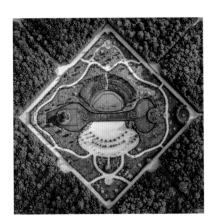

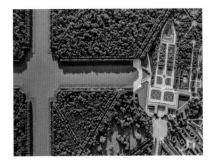

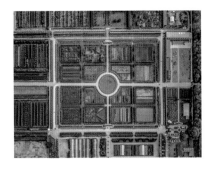

178

Scattered among the formal gardens, sprawling lawns, and water canals of Versailles are 15 groves, each uniquely designed, where members of the royal family and guests could assemble for picnics and entertainment. Originally planned by André Le Nôtre, and with many later modified by Jules Hardouin-Mansart, the groves—with their elaborate fountains, water jets, and intricate plantings—were so difficult to maintain that they were often rebuilt and modified. The most sumptuous was the Water Theatre Grove, which was variously changed and later damaged by storms in the 1990s until it was completely rebuilt by contemporary artists and reopened in 2013.

184–185

Louis XIV found that his magnificent palace was not without its drawbacks. Hemmed in by protocols that demanded certain behaviors and surrounded by courtiers almost 24 hours a day, he longed for a place where he could enjoy simple meals and only the company of his mistress and close family. So he bought a village called Trianon, about a half hour's walk from the main palace. The first building he created there fell into disrepair quite quickly, but in 1687 Jules Hardouin-Mansart built him "a little palace of pink marble and porphyry," which the king called the Grand Trianon.

188–189

Covering some 22 acres, the King's Garden provided about 55 tons of fruit (mostly pears and apples) and about 22 tons of vegetables for the royal court every year. A particular delight of Louis XIV's, the garden was fitted with a monumental wrought iron gate to receive him and his guests after they made a short walk from the palace. Maintained today as it was 200 years ago, the potager encourages visitors to imagine Versailles as Louis XIV and his heirs enjoyed it.
See also pp. 186–187.

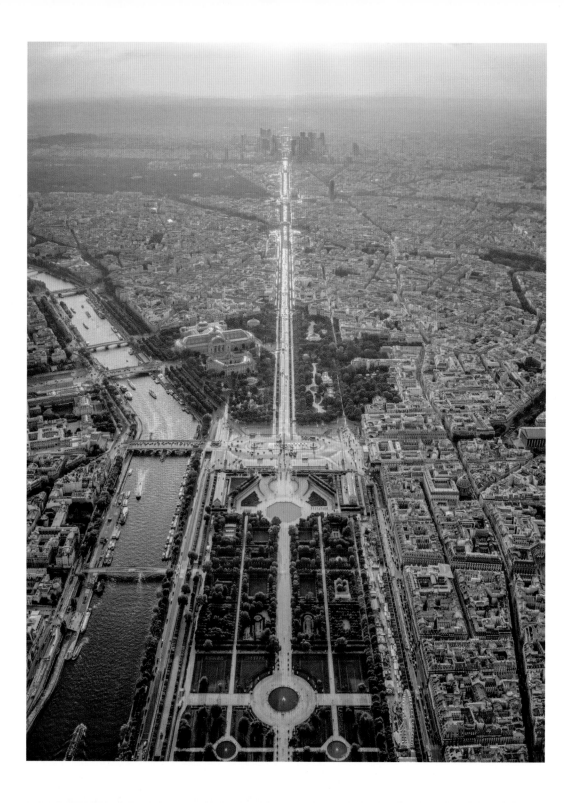

ACKNOWLEDGMENTS

I want to thank all the people who have helped along the way to make this book a reality:

First, Rebecca Moreau, manager of Helifirst, for persevering in getting me the impossible—permission to fly over Paris—and for being the most wonderful person to work with, and Félix Claro, my talented Helifirst pilot, who got me where I needed to be in record time. Thanks also to maintenance manager Franck Blossier for making sure I didn't fall out of the helicopter.

The Préfet of Police of Paris and his team from the Cabinet du Préfet—Pascuala Guaita, Anne-Gaëlle Cottennec, and Christian Nagau—for allowing the flights to take place over Paris.

Catherine Pégard, president of public establishment; Laurent Salomé, director of the national museum of the castle of Versailles and Trianon; and Hélène Dailfard, Versailles Press Attache, for permission to fly over Versailles and for turning on the building lights.

Robert Morton, my friend, agent, and editor, who represented the book, and then made it so much better with his detailed and informative descriptions. James Muschett, associate publisher, and the folks at Rizzoli, for their enthusiasm and support. Gregory Wakabayashi for his excellent design, which adds so much to the book's look, and James Crawford for his delightful and insightful foreword.

My partner and muse Kim Cantine, who kept me company on travels and helped with her great eye for editing; my daughter Lucy, who keeps me young; Jay Maisel, photographer extraordinaire, for inspiration; Jeff Hirsch of Foto Care for equipment support; and Helena Kaminski, my studio manager, who keeps the wheels on the studio bus.

—J. M.

Looking west over the Jardin des Tuileries, Place de la Concorde, and along the Champs-Élysées toward La Défense

First published in the United States of America in 2021 by
Rizzoli International Publications, Inc.
300 Park Avenue South
New York, NY 10010
www.rizzoliusa.com

Publisher: Charles Miers
Associate Publisher: James Muschett
Managing Editor: Lynn Scrabis
Editor: Candice Fehrman
Design: Gregory Wakabayashi
Text: Robert Morton
Foreword: James Crawford

Printed in China

2021 2022 2023 2024 / 10 9 8 7 6 5 4 3 2 1

ISBN: 978-1-59962-162-3

Library of Congress Control Number: 2020946567

Visit us online:
Facebook.com/RizzoliNewYork
Twitter: @Rizzoli_Books
Instagram.com/RizzoliBooks
Pinterest.com/RizzoliBooks
Youtube.com/user/RizzoliNY
Issuu.com/Rizzoli